Richard Jolley

Sam Hunter with Laura Stewart

RICHARD JOLLEY

Project Coordination
Paola Gribaudo

Design
Marcello Francone

Editorial Coordination
Marzia Branca

Editing
Claudio Nasso

Layout
Serena Parini

First published in Italy in 2003 by
Skira Editore S.p.A.
Palazzo Casati Stampa
via Torino 61
20123 Milano
Italy

Printed and bound in Italy. First edition
ISBN 88-8491-416-7

Distributed in North America and Latin
America by Rizzoli International
Publications, Inc. through St. Martin's
Press, 175 Fifth Avenue, New York,
NY 10010.
Distributed elsewhere in the world
by Thames and Hudson Ltd.,
181a High Holborn, London WC1V 7QX,
United Kingdom.

Contents

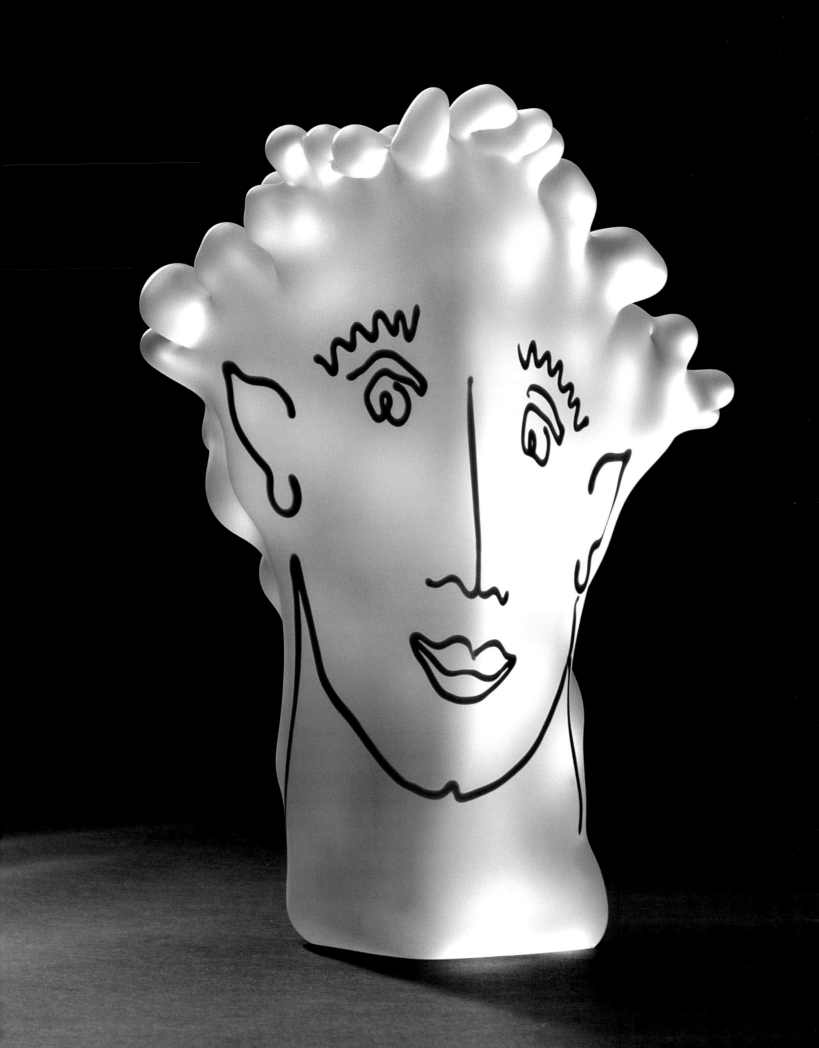

Sam Hunter

Transformations:
Sculpture, Mixed Media, Works on Paper

Introduction

If Richard Jolley's sculptures suggest that a considerable element of alchemy contributed to their creation, this should come as no surprise. From the sensuous nude slinking over the surface of a glowing column in his *Sense of Self* 2000 to the ruby-red birds circling the gleaming sphere at its peak, his colors are brilliant enough to have slipped the bounds of the spectrum and to exist in some entirely separate, highly personal realm. Fragile topaz-hued crystal amphorae are jammed into a metal cage in the upper section of Jolley's *Holding Thoughts*, another work from the year 2000, and the emphatic features of the figure painted on its encrusted lower panel make him appear lost in rueful, all-too-human reflection.

Glass, tinted the cool, luminous blue of the early-evening summer sky, has been transformed into the radiant, fluid material that seems to capture – and, achingly, freeze – the fleeting and inchoate yearnings of the subject in Jolley's 1996 *Torso*. A classic universal human, Jolley's "Everyman" initially appears transparent; a closer look, however, reveals the velvety veil that acid-etching has cast over the figure's glass surface and invites both the physical touch and a sense of sheer wonder at its frosty opacity.

The alchemist's mark, the celestial equivalent of the dark transmutation caused by Midas's golden touch, is even more evident in Jolley's luminous new series of paintings on paper, which he calls "drawings." Like enigmatic saints from Byzantium, set against weathered gold-glass tesserae that once signified the glowing, enveloping background of Heaven, the blurred, encrusted figure in *Luminary* appears in a mysterious space that is at once everywhere and nowhere. The work's combinations of pigment, silver leaf and varnish build on a large sheet of heavy paper a surface so densely worked that it could qualify as a luminous low relief in the viewer's mind, as rich as Ravenna's mosaics.

More steeped in both a traditional and an alternative contemporary world view is *Metamor-phosis*, a small 2001 *Tabula Rasa* sculpture through which light flickers and flares. Set on a column of glass that Jolley has worked to resemble hammered metal, the dual-image medallion offers a wealth of vivid associations. From one side, seen in bright light, a human face melted into the shape of a dove is a startling, but satisfying image of psychic transformation. Seen from the other side, the pointed oval sculpture becomes a simple, but satisfying, symbol of essential, ever-mutable nature. A single leaf, large and shifting in hue from ruddy-brown to green as if with the passing seasons, telescoping into one perfect visual moment, rests on its mount like a great faceted gem.

Each piece is a complete statement in its own right; each, however, is only the beginning of what Jolley means to convey in his multifaceted sculptures, drawings and daringly experimental mixed-media pieces. Virtuoso of the various techniques, he draws on the vibrant chromatic potential of the glass medium while depending on the sculptor's tools and touch, applied quickly and surely. As he works the near-molten mass, his assistant adjusts to his slightest nod or gesture in the taut and controlled performance; the mass's form and style energize and reach definition in *Metamorphosis* as well as in other recent small, iconic sculptures and the larger, more diverse works that incorporate glass into an assemblage of metal, wood and stone. The viewer's subliminal awareness makes connections between the radiant tones of *Metamorphosis* and a host of historical antecedents, from the glazed tiles of Babylon's *Ishtar Gates* to the glinting tesserae in Ravenna's S. Vitale or St. Mark's in Venice.

Yet, however appealing, the undeniable beauty of Jolley's jewel-like medium and the remarkably assured ease with which he sidesteps constant danger and works the hot, honey-soft glass to achieve the most refined effects in three dimensions are peripheral to his art's essential aspects. He was drawn to glass from the moment he understood its potential; at the very moment when the art world was suddenly becoming open

Faun
1985
Solid hot formed glass, direct drawing,
etched
H 10 x W 7 1/2 x D 5 1/2 in.
Photo Charles Brooks
Collection of the Artist

to the desirability of stepping out of the old Beaux-Arts constraints of medium, Jolley began his involvement with glass fabrication, and buttressed that concern with constant exposure through workshops, classes and informal word-of-mouth among the vanguard second-generation members of the Studio Glass Movement. He then set himself apart by transcending the usual constraints of glass, appropriating it and its traditions to his requirements as a sculptor. To do so, he first had to learn and become adept at the age-old techniques of mixing batches, heating them to the sticky consistency of searing treacle and shaping or inflating the mass on a blow-pipe. And this had to be accomplished before carrying out the equally precise requirements of cooling and finishing the object in glass.

Since his engagement with glass began more than a quarter-century ago, Jolley has so thoroughly assimilated every aspect of working with glass that it is second-nature to him. The fires are as hot as ever, and the danger of making an individual mark on a surface whose temperature range is just under 2000 degrees Fahrenheit is as great as it has been since ancient times. But when Jolley is in the hot seat – literally, the gaffer's bench that dominates his "hot shop" – he is focused solely on his evolving concepts. He mastered the vehicle of today's work – the vessel, the brilliant individual colors and choreographing of his crew – long ago, and has moved beyond.

Where the typical contemporary glass artist stops, content to revel in the medium's innate coloristic and tactile qualities or to use them to point up sheer technical virtuosity, Jolley treats glass as a brilliant means to an end: as the medium best suited to his sculptural intentions. Glass makes very stiff demands, certainly, and has severe limitations. But as he has developed his distinctive artistic voice, Jolley has found that glass is the ideal medium for his personal expression; nothing else, moreover, could give the same effects or elicit the same visceral reactions.

At the same time, while such works as *Sense of Self, Metamorphosis,* and the tall, wittily repetitive *Tour de Femmes* pieces from the "Totem" series use glass exclusively, other facets of Jolley's expansive *oeuvre* either include glass elements or actually eliminate the medium entirely, while retaining the fundamental transforming stylistic qualities so powerfully expressed in the glass sculptures. It is not the medium alone that makes Jolley's sculpture so compelling, though he develops fully the qualities that are unique to the

medium and central to his artistic intent. Neither does the power of his art depend on the process of bringing a work into being in the studio, the dramatic and necessary collaborative performance that Jolley has referred to as "the fire, the dance" – even as the creative act informs his sculptural forms.

Rather, the artist's personal vision, the interior ideals with which Jolley struggles to bring form into being, sets his work apart. This demanding balancing act between unusually exacting technical proficiency and the *kunstwollen*, or "will to make art," brought Jolley to the blow pipe and blazing reheating chamber – the "glory hole" – in the first place, a confrontation that is replete with paradoxes. In order to make on glass the sort of deft, characteristic gesture that remains a solo act when he begins drawings like the layered *Luminary*, Jolley sets an entire, methodically structured engine in motion. Yet the result, the delicately uplifted feather on the bird in *Metamorphosis* or the alert eyebrows in *Listening Post*, a columnar construction made in 1994, retains the fleeting impulse and freshness that give it life.

However technically demanding the material may be, and no matter how laboriously it has to be worked to achieve Jolley's expression, that expression is what matters most. "I have a love for my materials, and my first love was glass, which is a modern material for sculpture," he has said. "There is the visceral impact of color in glass, and when you first set out, working in glass is all very spontaneous. It is highly collaborative, with the dance between the fire and the tools for shaping the sculpture, between the idea and the image. In a way, the work itself is a frozen moment; there is always the element of time in my work. The work itself becomes embedded time, a series of acts that have been arrested and preserved, as they are in *Luminary* and the other new two-dimensional pieces. All of my work is about the human experience, in the end. What I always do is put the poetry first, and let everything else fall behind it."[1]

The creative process has occupied Jolley continually, and it is one he has learned to channel throughout the 27 years since he first set up his studio in a rural landscape a few miles west of Knoxville, not far from his childhood hometown of Oak Ridge, Tennessee. In his early days in the studio, which was then the renovated two-car garage of his young artist's "crash pad," he worked alone and produced works that reflected that fact

Kiss
1987
Solid hot formed glass, direct drawing
H 10 x W 9 x D 4 1/2 in.
Photo Charles Brooks
Collection of the Artist

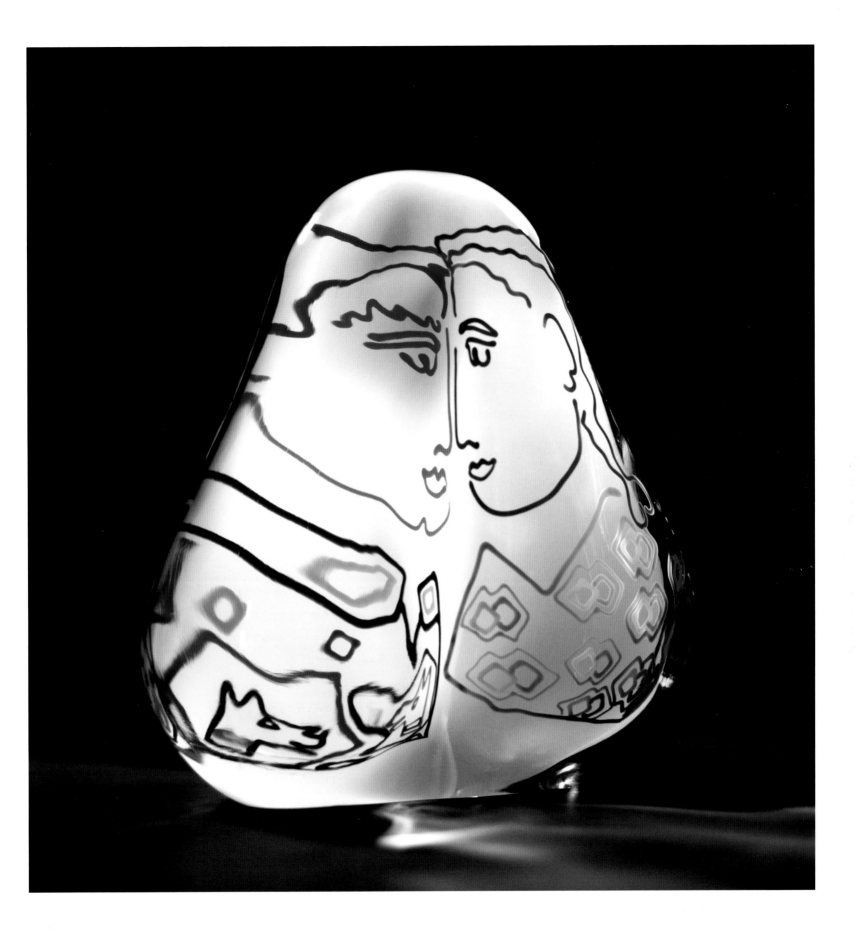

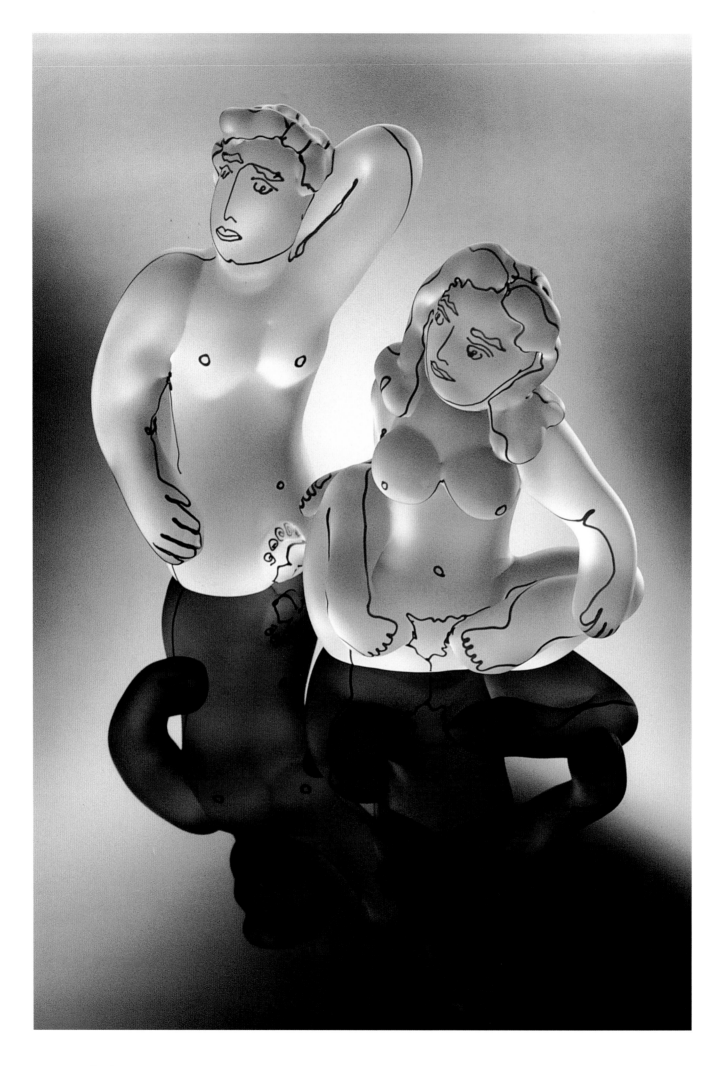

in their limited scale and traditional approach. Today's larger, heavier, and more complex works require the aid of a team of four or five trained assistants in the "hot shop," the section of his studio where batches of glass that he creates from a flour-like powder of silica and other base substances are heated in a fiery kiln and nimbly, swiftly spun into shape by the artist and his assistants.

As fires blaze, keeping various containers of molten glass simmering at just under 2000 degrees Fahrenheit in rows of crucible furnaces to the side of the shop and flaring out of the main furnace's glory hole when it opens briefly, the ritual dance begins in earnest. To transform a globular "gather" of glass into the characteristic lozenge-shaped format of his newest pedestal-mounted sculptures, the *Tabula Rasa* series, Jolley seats himself on the glassmaker's bench he designed and built, and he takes up his water-soaked wooden tools.

Shooting tiny sparks, the viscous glass rotates at the end of the long, slender but heavy blow-pipe that one assistant spins, rolling the metal pipe back and forth quickly on metal arms to either side of the bench's worn leather seat. As he works, Jolley continually dips the broad, wooden paddles into the metal bucket to wet them and keep them from igniting as they shape the hot glass. From his bench, a variant of the classic glassmaker's chair that was invented around 1600, he manages the subtle mutation, taking the glowing gather though a time-honored sequence of choreographed motions and steps and turning it into a carefully shaped slab of brilliantly hued, very hot and malleable material.

Over the next few days, before Jolley places the piece into the annealer to slowly cool to room temperature, he is engaged in a paced process that involves the shaping of masses softened in the reheating furnace and later, for more refined articulation, again and again returned to malleability in key spots with precisely applied blowtorches. As Jolley and his assistant apply this heat briefly and selectively to the slab's surface, images begin to appear. There are the broad whorls of a leaf on one side, the delicate features of a human face and the winged symbol of peace blurring into a single entity on the other as if to show symbolically or reaffirm the man's pacifistic ideation. The techniques Jolley employs instinctively after so many years of experience are a blend of the ancient, the personal, and the reinvented, performed with an array of tools that includes those used in Rome and Torcello, as well as those the artist devised himself, to meet his specific needs.

The moments of greatest intensity come as the artist pulls the delicate features out of the pliant glass, the curl of a nostril, the reflective contour of a leaf in *Metamorphosis,* the delicate twist of a minute, single strand of hair caught in motion and frozen forever in place. As he works, setting aside primitive-looking tongs and procuring a long metal pick in a fluid motion, quick and sure from a thousand similar gestures, Jolley embodies the paradoxical tensions his works articulate so eloquently. Moving rapidly to shape his characteristic material, which stiffens as its temperature falls in the studio's ambient air, he indicates with a clipped nod that he needs one assistant to apply a burst of the torch to a finely detailed element – the eye's contour, perhaps, or a mouth just on the verge of curling into a secretive smile. But the burst of fire must be only for that split-second, or the glass will become too fluid and lose its fragile articulation.

Tensions abound in those blink-of-an-eye motions that embed time in the material of Jolley's sculpture: between master and apprentice; between glass and tool; between fire and glass; and, most of all, between Jolley's steady hand and his evolving, intuitive apprehension of his artistic intention and vision. He begins with a concept – the repeated forms of nudes resembling a Golden Age Aphrodite that are stacked in the 1994 *Tour de Femme I,* for example. The nudes' slightly different sizes, poses, colors and luminosities as they appear one above the other, from the largest at the base to the smallest at the top, underline their blend of witty allusions to popular or vernacular American culture and, ironically, the joyous, pretentious classicizing quality that gives them a particularly anti-antiquarian juiciness. The concept is playful at first, and offhand, as Jolley develops it, element by element and his alchemy takes form to express his subtler central idea, one that revolves around the understanding of "woman" as an archetypal power source.

The dance continues throughout the creative process with the performance aspects shaping the multifaceted event. As the work unfolds and reveals itself and its relationship to Jolley's intended statement, other, less physical tensions come into play. One is the gap between what can be seen and the final issue. Glass that appears dark at withering temperatures will spontaneously change its color as the heat subsides. The process

occurs in darkness, unseen and undisturbed as the object rests in one of a row of insulating fire-brick-walled annealing – or controlled cooling – ovens set along the rear of Jolley's studio. The annealers cradle the fresh sculpture as its contained glass drops from just under 1000 degrees Fahrenheit to the heat level of the ambient atmosphere; it is a measured and crucial transition, since any unevenness or abrupt change in the temperature might fracture the material, and destroy the sculpture.

The space in which the process occurs is as fascinating as the events themselves. The first floor of Jolley's main studio contains literally thousands of objects and tools. There are the primitive wooden paddles and blocks that soak, scorched but intact, in pails of water, and, opposite, there is the windowed wall lined with the panels of sophisticated pyrometers, gauges that control the annealing furnaces' steady decline from searing heat to room temperature. Just as the artist's range of work, from sculptures drawing on the characteristics unique to glass, to site-specific mixed-media installations that incorporate glass elements, to paper-based relief "drawings" that resemble glazed images is wide-ranging and multi-faceted, so too are the spaces and equipment that transform his concept into radiant, cohesive form.

Illuminated by flickering fire from the open glory hole and accompanied by the steady hum of machinery maintaining the temperatures in annealers and furnaces, even the discarded, damaged works in the gloom of Jolley's "bone yard" appear touched by an air of serious concentration. Everything here has been geared toward the safe handling of inherently dangerous materials, toward forming jewel-toned sculptures from ordinary, unremarkable white powders by subjecting them to heat, manipulation and inspiration.

It's a different story on the second floor of the studio, a space reached by open wooden stairways at either end of the ground floor: here Jolley makes his large-scale "drawings," paintings on paper that are conceptually related, but very different in techniques and in materials from the sculptures produced in the glass studio. In the back of the second-story print shop, or painting studio, is a small room that in many ways is central to Jolley's art. Large jars of powdered acrylic pigment crowd onto a shelf on one wall, and the prints that led to such new works on paper as *Luminary* lie in file drawers or on tables, and also hang from walls.

There are deep shadowboxes here too, inhabited by enigmatic animal or human forms destined to remain forever unknown and unknowable behind opaque frosted-glass surfaces, as well as an intriguing array of images and elements that appear and re-appear throughout Jolley's *oeuvre*. Among them are the stark, metallic silhouette of a grackle, raven or other predatory bird; impasted fragments of paintings whose translucent, thickly layered surfaces catch the light and shimmer like layers of gilded-glass tesserae; and, always, the solitary figures of the Everyman, an elusive presence who is – and is not – the poet-artist himself, Jolley.

"One of the most appealing things to me is that making sculpture from glass is like dancing with fire, and one of the most exciting things about working in glass is that you define a moment with it – the process is an almost Duchampian one that involves spontaneous series of decisions, corrections, decisions, corrections," he has said. "The process is a very good one. It teaches you to be a good sculptor, to get into that 'making zone,' but it also is a controlled choreography that involves the modernist aspects of accident. I start with my general concept and gradually make it look right, to me.

"It's always a matter of pushing the boundaries, of stretching the limits. You can never function at a hundred percent. The ideal is to transcend technology with the statement, to move beyond the materials and the process. That's true in music too – often people talk about the concept of the virtuoso, of mastering the technique. But what's important is the music, or the work of art itself. What I'm trying to do is achieve humanistic sculpture, humanistic art."

History and Background

Richard Jolley started working with glass in 1971, fascinated from the start by the potential of a material that in America only recently had begun to emerge as a novel medium apart from its long-held popular association as a functional item or with the "decorative arts." For the young artist, as for contemporaries who were willing and, indeed, eager to experiment with a variety of unconventional mediums to find a satisfying expressive means, glass offered exciting possibilities for exploring modernism. While the history of glass was not unknown, Jolley considered it uninteresting for the most part and turned to it not for traditions that seemed lim-

Kneeling Nude
1988
Solid hot formed glass, direct drawing,
etched
H 12 x W 8 x D 7 $\frac{1}{2}$ in.
Photo Charles Brooks
Collection of the Artist

Seated Female
1989
Solid hot worked glass, direct drawing,
etched
H 13 $\frac{1}{4}$ x W 11 x D 5 $\frac{1}{2}$ in.
Photo Charles Brooks
Collection of the Artist

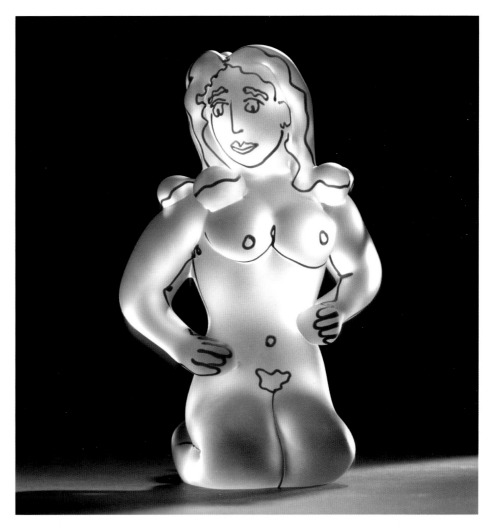

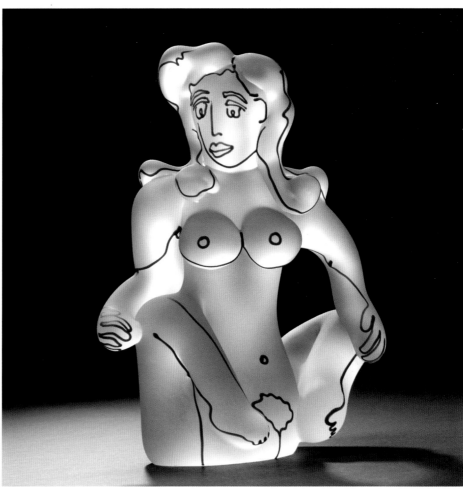

Double Bust (male side)
1990
Solid hot formed glass, direct drawing,
etched
H 17 ¹/₄ x W 9 ¹/₂ x D 4 ¹/₂ in.
Photo Charles Brooks
Collection of the Artist

Double Bust (female side)
1990
Solid hot formed glass, direct drawing,
etched
H 17 ¹/₄ x W 9 ¹/₂ x D 4 ¹/₂ in.
Photo Charles Brooks
Collection of the Artist

Swaying Figures
1990
Solid hot formed glass, direct drawing,
etched
Female Figure:
H 17 x W 6 ¹/₄ x D 6 ¹/₂ in.
Male Figure:
H 17 ¹/₂ x W 6 ¹/₄ x D 6 ¹/₂ in.
Photo Charles Brooks
Collection of the Artist

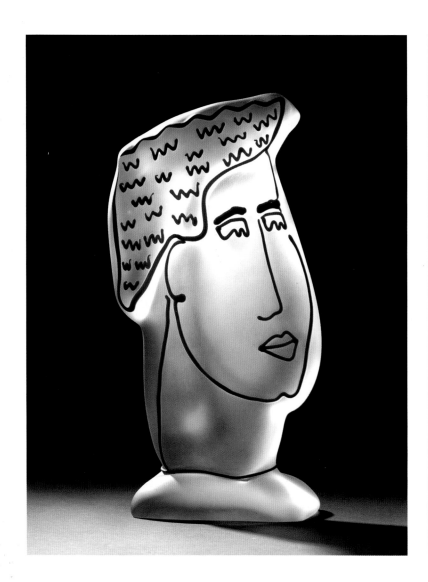

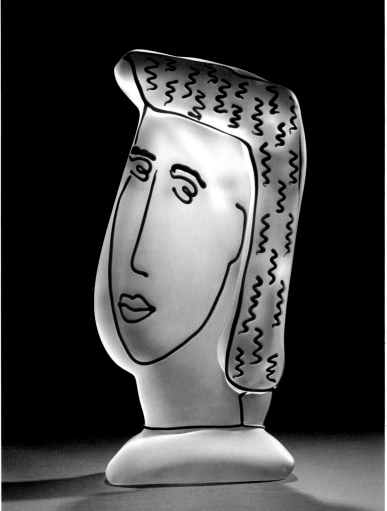

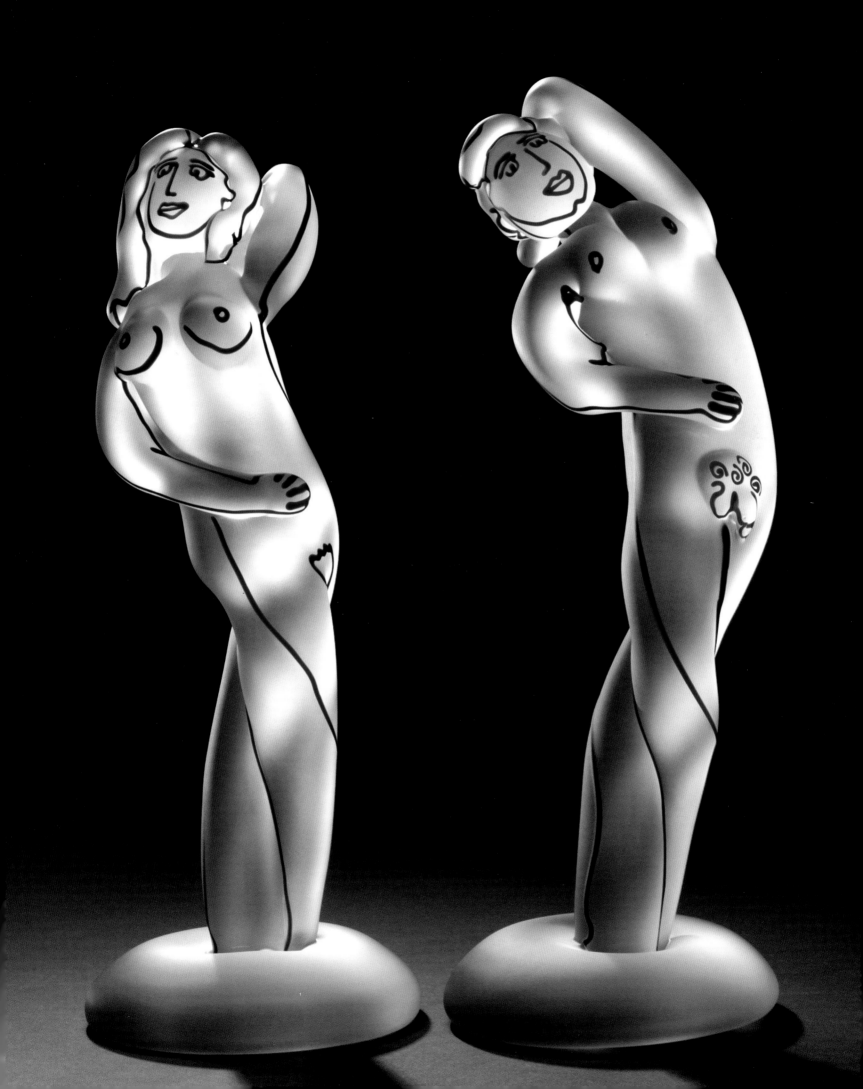

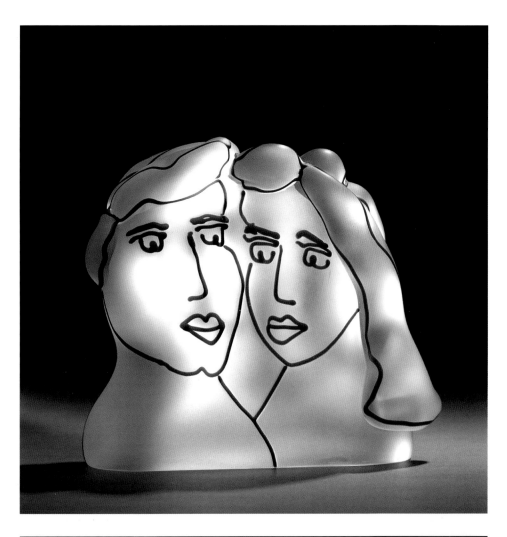

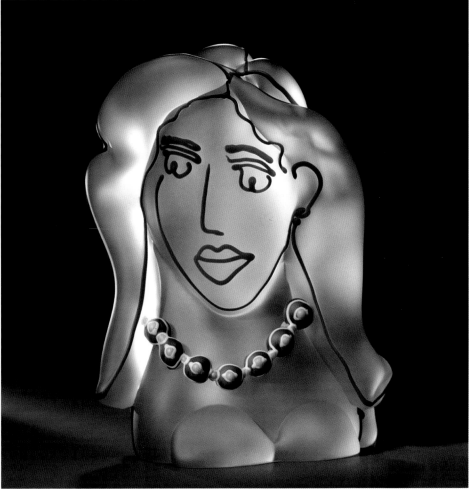

Cheek to Cheek
1990
Solid hot formed glass, direct drawing,
etched
H 9 x W 10 ¹/₂ x D 5 in.
Photo Charles Brooks
Collection of the Artist

Female Bust with Beads
1990
Solid hot formed glass, direct drawing,
etched
H 12 ¹/₂ x W 10 x D 6 in.
Photo Charles Brooks
Collection of the Artist

iting but rather for what he saw as the medium's wide-open potential.

"The issue of my working with glass is, to a certain extent, a matter of luck," the artist has said. "The artists who came of age in the mid-sixties and seventies lived in a difficult time politically, with the events in Vietnam, the shootings at Kent State, and all that. We were affected by the revolutionary atmosphere. For us the issue became one of asking ourselves, 'If you're not going to be corporate, what do you do?'

"I was a student, and I bumped into glass as a second-semester freshman in 1971. I became a studio major in glass and worked in the early 'hot shops' at Tusculum College and, later, at George Peabody College, where I helped build the first glass studio," said Jolley. He graduated in 1974 and became a part of the first wave of "poet-artists" who started their own studios and worked as had the Abstract Expressionist painters in relative solitude.

The opportunities available to a young artist pioneering in glass at that time were limited, a fact that had clear advantages and disadvantages. For Jolley, choosing to work alone in a relatively remote rural studio meant being forced to develop at his own highly individual pace and in unique, unpredictable directions; at the same time, it allowed for crucial, unlimited experimentation. The allure of glass and the freedom that went with the medium were irresistible, as was the appeal of being part of the broader contemporary movement to break down outdated, artificial divisions between "art" and "craft" and to liberate the concept of pure creativity.

That experimental impulse had begun at mid-century and sparked vigorous dialogues during the pivotal era when Jolley blew his first forms and built his first small furnace. It was a courageous move, and one well-suited to Jolley's adventurous nature. The leap from choosing to explore the unique qualities of glass – its translucency, opacity, colors that are both surface and innate, and vast tactile variety – to achieving a mature, unique modernist voice in a medium with daunting technical and historical challenges would be wide and daring.

Yet this leap would have been almost impossible at any stage before glass emerged as a valid, highly promising medium for serious artists. Glass itself has undeniably rich roots and wider historical associations, from the fragile Roman vessels with their rainbow surfaces that fascinated Louis Comfort Tiffany at the end of the nine-teenth century to his own revival of that effect with the creation of his "favrile," or hand-made, glass. Its history stretches back at least to the Egyptian New Kingdom, and possibly to Assyrian sources. The roots of glass-working in the West are lost in myth, but even during its heyday in Imperial Rome it sparked romantic speculation for generations.

During the Renaissance, however, Venice set the standard for high-quality glass of every sort. Innovations, both technical and artistic, were many, and Venetian glass set the fashion throughout Europe. Decorating glass by engraving with a diamond was perfected around 1560, for example, and spread quickly. In 1575, an ingenious Venetian living in London, Jacopo Verzelini, filed a patent in his adopted city so he could make "drynkynge glasses such as be accustomablie made in the towne of Morano [sic]," and Europe looked to Murano for such innovations as *calcedonio*, glass that mimicked jasper; *cristallo*; variations on Roman *millefiore* techniques; *lattimo*, milky-white glass; *vetro a filigrana*, with its complex patterns of opaque threads of glass; crackled ice-glass; and the luxurious *avventurin*, with its effects of sprinkled gold dust.

But by the early seventeenth century, when Venice's political power declined and such books as Antonio Neri's instructive 1612 *L'Arte Vetraria* provided the formulae for crystal and other types of glass, artists and scientists elsewhere were able to develop their own techniques, and to probe glass's mysteries. Neri's text was translated into English in 1662, and into German in 1677; within two years, Johann Kunckel unlocked the secret of ruby-red glass, drawing on his own translation of Neri and his background in chemistry, pharmacy, and alchemy.

For two centuries, as the demand for fine glass expanded on both the scientific front, with the need for specialized lenses, and the artistic, foundries were established by Northern European nobility eager for a steady supply of tableware, mirrors and other decorative objects. Louis XIV's finance minister, Colbert, tried to build a glass industry in Paris, and England's interest in fine glass had been fervent even before Elizabethan times. In 1567, a royal monopoly was granted to the glassmakers who claimed to have mastered the "art, feate, or mystery of making glas such as is made in Fraunce, Lorayne and Burgondy."[2]

During the seventeenth century, when English glassmakers were firing furnaces with pit-coal rather than charcoal, their monarchs followed the

Maxilla
1990
Solid hot formed glass
H 13 ³/₄ x W 7 x D 8 in.
Photo Don Dudenbostel
Collection Charlotte and Burton Zucker

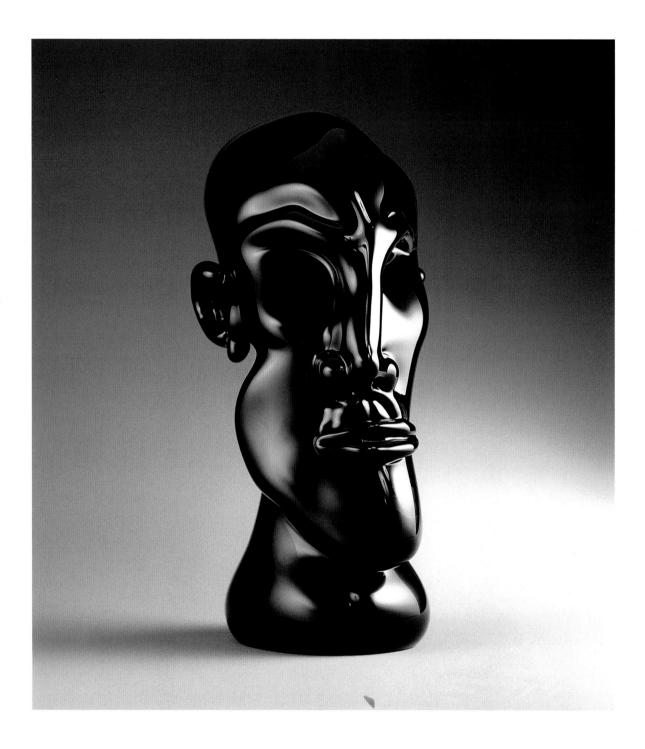

Flat Top
1993
Bronze on steel base
7 feet high.
Photo Charles Brooks
Collection Ann and Steve Bailey

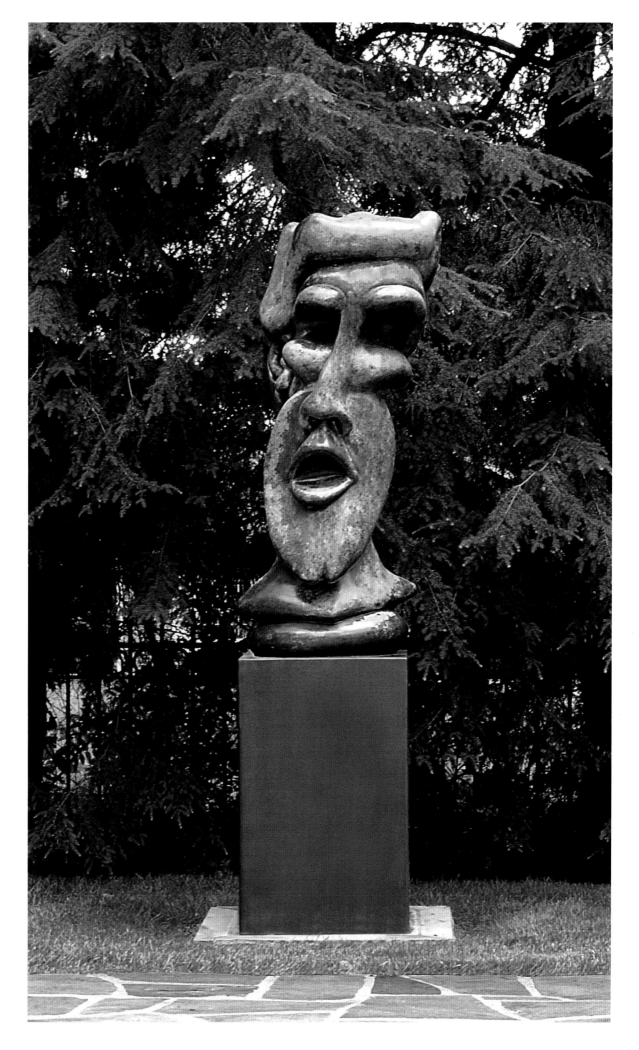

French lead in trying to control the glass industry. Even as Venetian *cristallo* was being imported, innovations abounded. In 1674, George Ravenscroft petitioned the King for a patent on English *cristallo*, and in 1676 introduced lead into "flint" glass; he made the first true "crystal," and paved the way for cut-glass techniques that eighteenth-century England perfected.

The impact of the Industrial Revolution on glass production was less dramatic than that of other manufactured products because its division of labor, established 1800 years earlier, was set and immutable; mass production of mundane items was possible, however, and pressed glass, mold-blown glass and decorative processes were somewhat streamlined. Glass designed for a mass market could be turned out in great volume, and was by the mid-19th century, yet it could not satisfy the demand for art glass, which was particularly intense during the Art Nouveau era.

Emile Galle's new art glass, in free-form and possessing surface effects that could not be produced by machines or factories, set the style in Europe; in America, its leading figure was Tiffany, whose studio produced iridescent "favrile" glass objects and stained-glass that became enormously influential. Art Nouveau was the antithesis of factory work, and its leading artists looked back to the origins of glass for inspiration and information. Tiffany in particular was influenced by the colors and age-induced opalescence of Roman glass; working with glassmakers from Venice, he analyzed ancient glass and replicated its shimmering surfaces.

Tiffany's work fell out of favor in the early twentieth century, and would remain in the shadow of modernism for decades. Nonetheless, his interest in artifacts that embraced the values of genius and craftsmanship was shared at the end of the nineteenth century by both the Aesthetic and the Arts and Crafts movements. The spirit of these movements was revived a half century later when a new generation turned away from what it saw as the dispiriting, dehumanizing twentieth century to find a new appreciation for individual genius, as well as for the handmade object. In the period between the World Wars emphasis had been placed on work that celebrated the machine, and the personal touch slipped into the shadows of sculpture, painting and architecture that echoed a modular, linear Bauhaus ethos. But at the end of the Second World War and with the emergence of New York as the art center of the world, the primacy of mechanization was thrown once more into question.

Even with its daunting technical requirements, glass became a newly challenging medium just as the New York School expanded and sought fresh, experimental ground. Glass suddenly offered new possibilities, like other materials embraced by the American Craft Movement. It found a wider forum in America after 1962, when Harvey Littleton revived the mouth-blowing technique at the two workshops at the Toledo Museum of Art, with the assistance of Dominick Labino. Before that time, the emphasis had been placed on cutting and fabrication, on melting and reforming glass, painting on glass or simply continuing the stained-glass tradition that Tiffany had championed.

The timing was right, Littleton's travels to Italy in the late fifties had shown him that the process used in its small glass-shops could be adapted to the needs and intentions of modern American artists. A sculptor could work alone in his studio, executing concepts in glass just as a painter or sculptor might do, or he could create a collaborative team to translate his concept into form. The sixties were a time of unparalleled freedom, when the artificial, antiquated divisions between the Beaux-Arts, or the "fine arts" of painting and sculpture, and the so-called crafts – weaving, potting, metalworking and other forms of expression – finally broke down, and disappeared.

At a time when influential artists declared that putting pigments on canvas was elementary, that "what you see is what you get," as Frank Stella famously put it, they also came to the conclusion that it was essential to work in the gap between art and life, following the advice and example of Robert Rauschenberg. An artist's medium could come from industrial sources, could be nothing more than a concept with documentation, could even be the earth itself. In the spirit of the times Littleton began working with the ancient "new" medium after his return from Italy, melting small batches of glass in his own ceramic vessels, using his clay kiln. He presented his findings at the American Craft Council's third national conference in 1959; in 1961, at the Council's fourth meeting, he displayed works made by cutting and polishing the forms from his crucible and kiln, thereby creating faceted-glass sculpture.

Once the movement was underway, it developed quickly. The Toledo Museum underwrote a week-long workshop in hot glass, and in March

Crescent
1993
Bronze
H 22 x W 7 x D 8 in.
Photo Don Dudenbostel
Private Collection

Beatific
1993
Solid hot formed glass, acid etched
H 13 xW 10 x D 8 in.
Photo Don Dudenbostel
Collection Nancy and Alan Lasser

Ruddy
1993
Solid hot folmed glass, acid etched
H 16 x W 8 x D 8 in.
Photo Don Dudenbostel
Collection Sharon and Larry Dubin

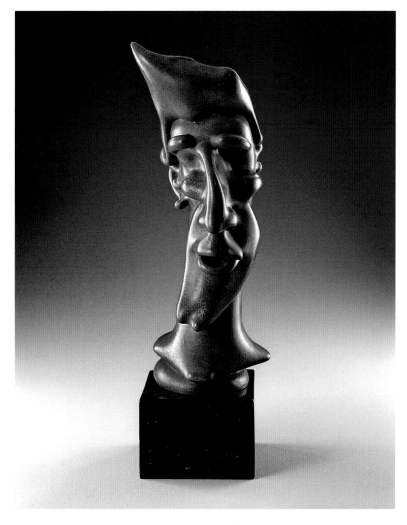

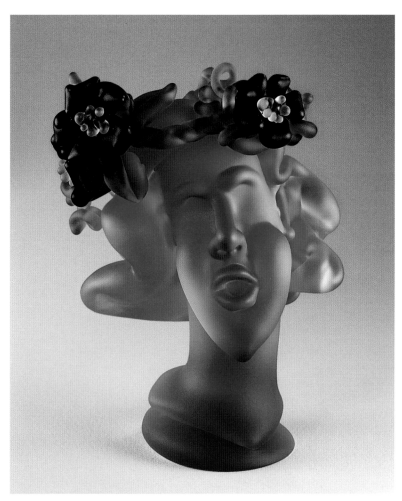

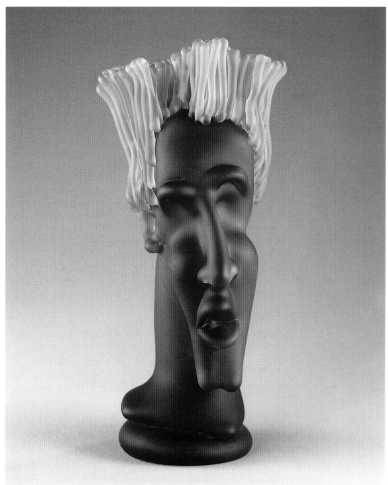

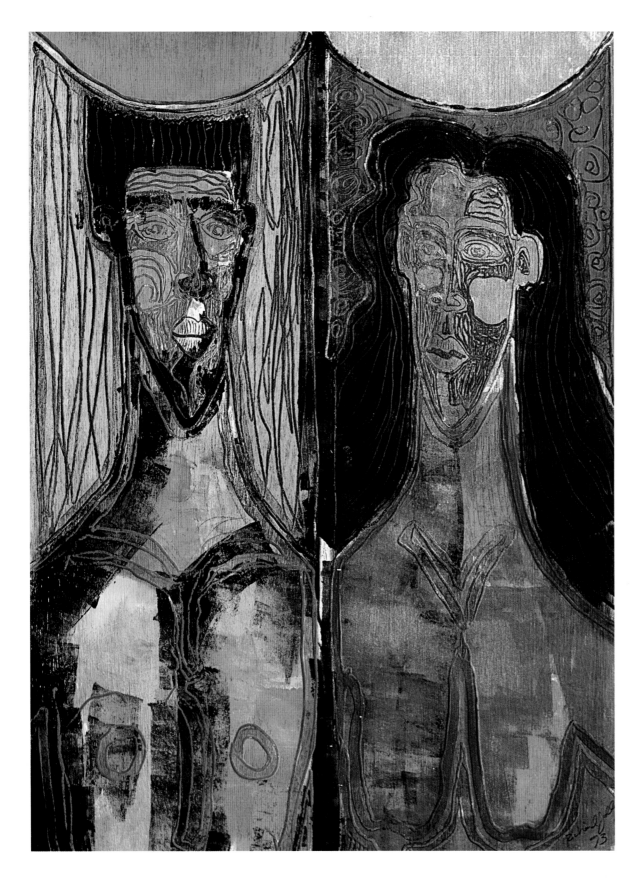

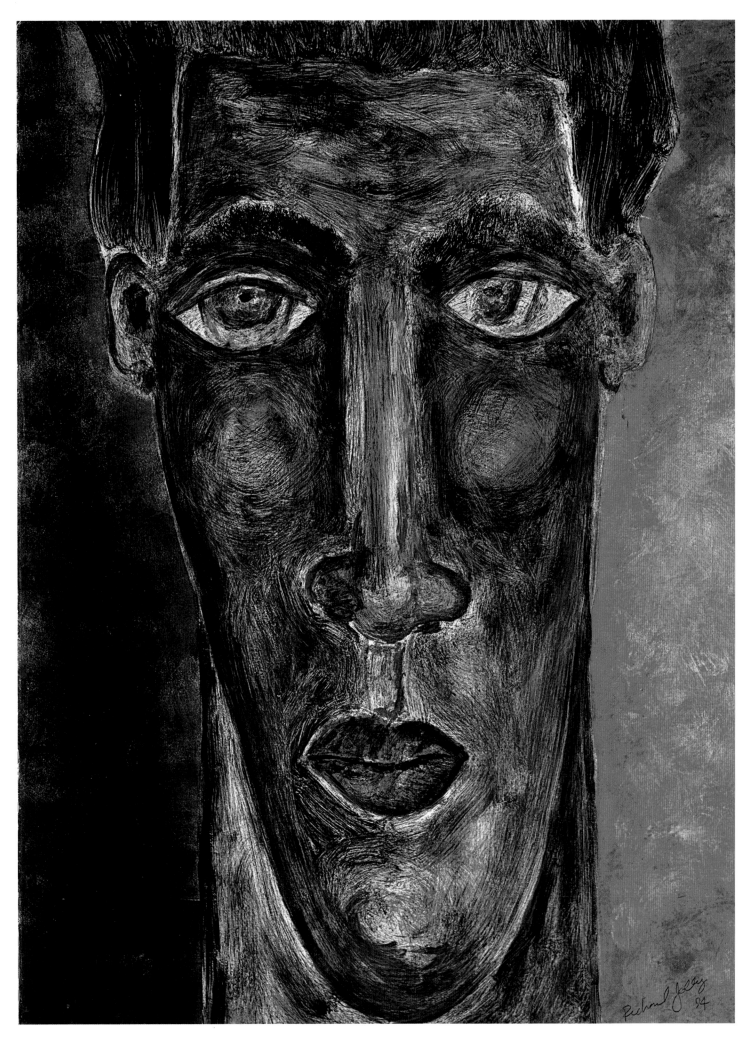

1962 the group of artists who became the nucleus of the Studio Glass Movement gathered there. They met in order to demonstrate that it was possible, indeed, desirable to melt a low-temperature formula in a furnace designed – and then redesigned – by Dominick Labino. Their experiment was unsatisfactory, however, and the team met again in June for a longer session, which included lectures on glass as well as glass-working demonstrations by key figures in the emerging Studio Glass Movement.

In the fall Littleton opened a glass studio to a handful of ceramics students one day a week. Among them was Marvin Lipofsky, who would set up the glass program at the University of California, Berkeley and lead the California College of Arts and Crafts' influential glass department. Within a year, Littleton had built an off-campus studio in Madison, funded by the University of Wisconsin, and opened the first university-level hot-glass program. He also organized lecture series at various art schools, universities and craftsman groups that generated new interest in glass and helped establish it as a serious artistic development. His proselytizing won converts who applied their own perspectives to the medium; their views ranged from a conservative crafts approach to an acceptance of glass as yet another, if unusually challenging, mode of expression.

In the late sixties the burgeoning glass programs and artists drawn to them exploded at a time of an enormously expanded student population with a willingness to consider, if not embrace, mediums whose associations with the common man made these pursuits seem revolutionary and right. Lipofsky's glass program opened in 1964 at Berkeley, the year of Littleton's appearance at the World Crafts Congress at Columbia University in New York.

The formation of glass programs at the Haystack Mountain School of Crafts in Maine and San Jose State College in California followed rapidly, as did other milestones. Two early converts whose work is now seen as iconic, Dale Chihuly and Fritz Dreisbach, completed the University of Wisconsin's glass program in 1967; Chihuly went on to expand the Rhode Island School of Design glass department that had been founded in 1965 and later established the Pilchuck School in Stanwood, Washington near Seattle. Dresibach helped to create glass programs at the Toledo Museum and Penland.

The groundbreaking "Objects USA" exhibition opened at the Smithsonian's National Collection of Fine Arts in 1969 with glass works by 18 artists. A decade later the Corning Museum launched a pivotal exhibition of contemporary work in glass. A similar show held in 1959 at the Corning Museum had attracted works by fewer than 200 artists. There were a thousand entrants in 1979, and for every industrial entry there were nine from artists inspired by the Studio Glass Movement.

When Richard Jolley entered college and turned to art, he "bumped into glass," as he has famously observed. But when the college freshman stumbled on his métier, there actually wasn't much to bump into. Jolley found himself at the forefront of the fledgling studio glass movement, as he rolled up his sleeves and helped build the studio that would be his creative laboratory for the next three years. Born in Wichita, Kansas, in 1952, he had moved to Oak Ridge as a child, the second son of an educator mother who encouraged his creative efforts and a father who was a research scientist at the Oak Ridge National Laboratory, a site located not far from his present-day studio.

Jolley grew up in an unusual environment, at a very unusual time. Oak Ridge was a small, intellectual community that offered rich cultural advantages, among them classes in the arts during his school day. But he also grew up in a family that considered the infinite freedoms offered by pure science a given. Not surprisingly, he viewed his father's discipline as an admirable intellectual process, one that might have won him over professionally. Jolley, however, was drawn immediately to the energy and creativity he found in his first studio art class at Tusculum College in Greeneville, Tennessee.

"As a scientist, you are defining yourself in the universe, as an artist does," Jolley has said. In the studio, however, the artist not only can define himself but also give tangible, vibrant form to his theories. Once Jolley began working in his first studio, his future in glass was ordained. It was the spring quarter of his freshman year, and he had signed up for an art course in something novel: studio glass. Michael Taylor had built a rudimentary glass furnace in an extra kiln shed at the art department of Tusculum College, and Jolley was swept up in the enthusiasm surrounding the experiments taking place there, as well as by the process of developing the space for melting and working glass.

The mood of the moment was infectious, as Jolley well recalls. "Predictably, there was igno-

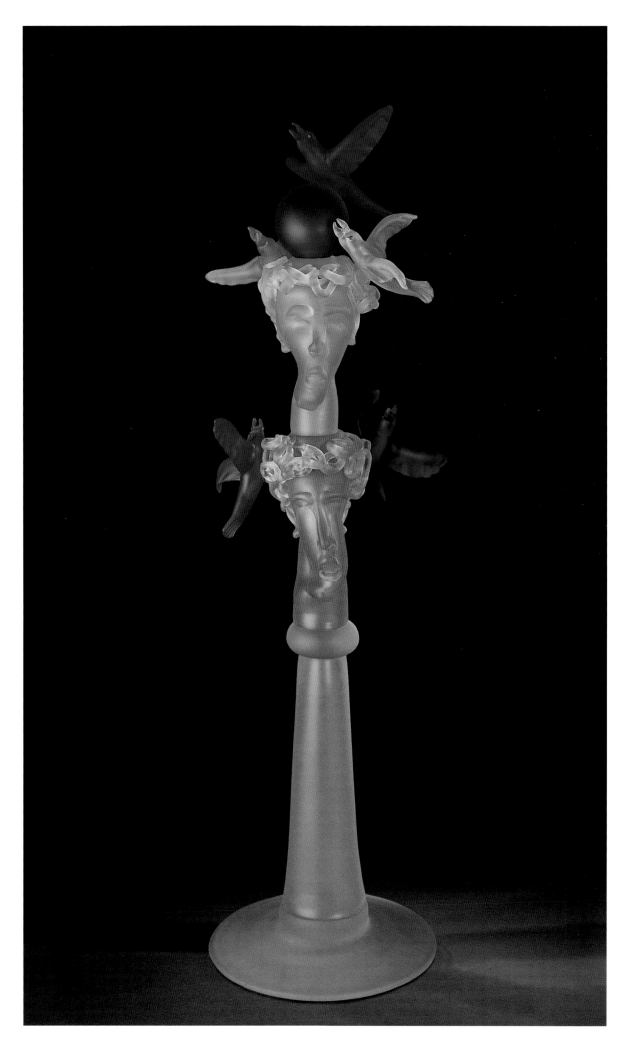

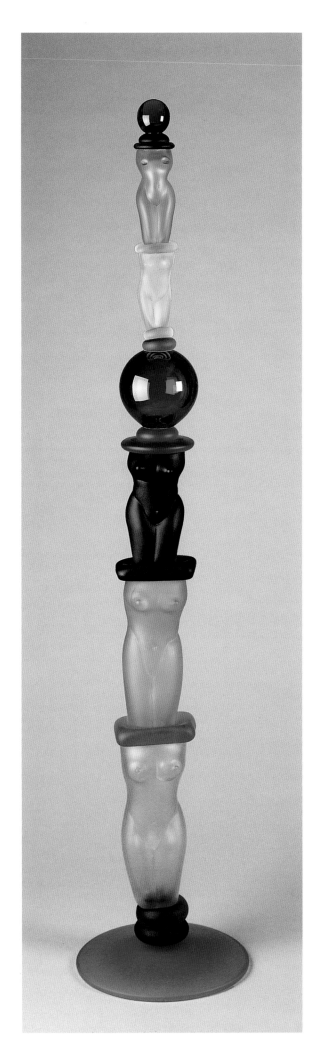

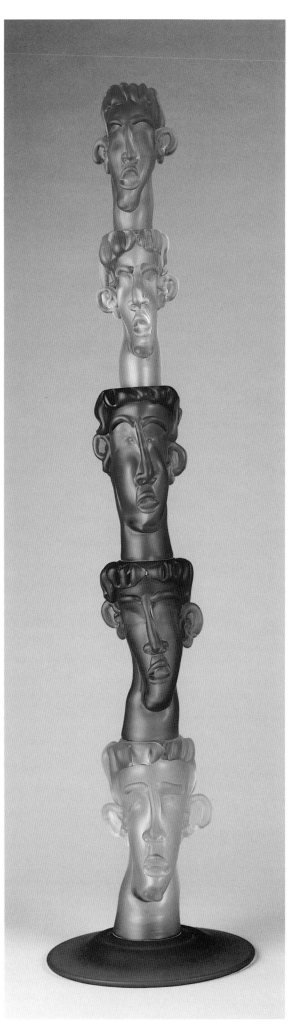

Tour de Femmes I
1994
Blown and hot formed glass, fabricated
and acid etched
H 77 x W 16 x D 16 in.
Photo Gary Heatherly
Private Collection

Listening Post
1994
Blown and hot formed glass, fabricated
and acid etched
H 63 x W 15 $\frac{1}{2}$ x D 15 $\frac{1}{2}$ in.
Photo Gary Heatherly
Collection Lisa and Ron Brill

rance and excitement, and very little skill. In 1971 we were pretty much making blobs. There was very little knowledge available about glass. There were no road maps. There were no rules, so there also was a total sense of discovery, and freedom.

"We didn't know about mixing batches – some people even threw Coke bottles into the crucibles – to get blue, you could toss in a Milk of Magnesia bottle. I worked with scrap plate-glass, and used chemical compounds like cobalt to get blues. Definitely in most schools at that time, you made stuff one day and it came out of the annealers the next day. This is what you knew: the glass is in the tank; you sat on the bench; there was a blowpipe that was hollow and there were pontils, the steel rods for lifting the glass out of the tank; and you tried to blow glass.

"So much of what we did then was trial and error," Jolley said. "Who taught you to blow glass? The studio did; it was just pure process, just the sheer excitement of doing it," he said. At that early stage in his career, Jolley was fully focused in the present as he looked to Matisse, Dubuffet, the Abstract Expressionists and other giants of modernism for inspiration. In no small part, he was drawn to glass by what he saw as its lack of associations, its formal freshness and requisite mastery of techniques that depended on science, experimentation and innovation. It was a heady mix for Jolley, whose upbringing had fostered a familiarity with scientific principles but whose character was naturally attracted to risk-taking.

The free-wheeling, seat-of-the-pants, anything-goes atmosphere in Tusculum's nascent hot shop was exhilarating, and right on the mark for Jolley and the fledgling glass movement. "In the '70s," Jolley explained, "it was all about experimentation, about art for art's sake, about working with a material that had never had its potential tapped. We were rooted in the present, in the moment and not in the past – we needed to 'be here now,' to disregard all traditions," he said. "We were just making stuff; we were not goal driven. We wanted to make things of better quality, so we asked ourselves, 'how do I get a better quality glass?' and tried to find the answers in the studio.

"We were taken by the issue of idea, and we asked ourselves, 'What do I have to do to execute the idea? It was a matter then of a sense of discovery, of how your work can be personalized, of how you could come up with solutions to the problems. It had the appeal of scientific research,

the enjoyment of the quest for knowledge, for the essence of truth and purity, which is what artists work for too. For myself, the basic interest has always been the touch of the hand, which actualizes the concepts of the mind; it was a rejection of abstraction, period."

The exuberance of those early days, when Jolley and others in the new movement essentially reinvented glass – not only its formulae, equipment and techniques, but also its vocabulary, creating one that drew not on the intricate ornamentation of Venetian Renaissance vessels but on the contemporary aesthetic, on the achievements of the New York School, Pop Art, and an assertive Minimalist ethos. Jolley, however, looked further afield than most, to the School of Paris, Surrealism and other vanguard movements for approaches that informed his evolving concepts. He continued with Taylor at Tusculum until he transferred to George Peabody College in Nashville, Tennessee, now a part of Vanderbilt University.

Taylor had gone to Peabody that year to start a glass department, and Jolley became his assistant as the studios took shape, doing everything from teaching to building furnaces and other essential equipment. Even at Peabody, however, Jolley found himself on the frontiers of contemporary glassmaking; at first, he did not find readily available stores of powered silica and alkaline flux for mixing batches, nor were there prepared admixtures such as metallic oxides for tinting the glass. Throughout the decade, experimentation remained key, as artists exploring the mysterious potential of glass were melting shards of plate glass, bottles and other scraps into batches.

By the early '70s, however, Jolley was working in a more sophisticated manner, particularly in light of the fact that his batches were formed from pure chemical formulas. After earning a bachelor's degree in studio art in the spring of 1974, Jolley went on to graduate studies at the Penland School in Penland, North Carolina. Later that year he took a sabbatical to visit friends in Colombia, South America, while he decided on his next step.

He returned to Tennessee and in 1975 settled into the bungalow west of Knoxville to begin his existence as a "poet artist" in earnest, and facing the challenges that went with establishing not only his own studio, but also finding his distinctive voice and building a reputation. "When you first start out, there are a tremendous amount of problems to solve that have nothing to do with the poetry of glass," Jolley said. "You have to dis-

Beacon of Desire
1994
Scorched wood, oil paint and prismacolor
H 8 $\frac{1}{4}$ x W 12 $\frac{5}{16}$ in.
Photo Gary Heatherly
Collection of the Artist

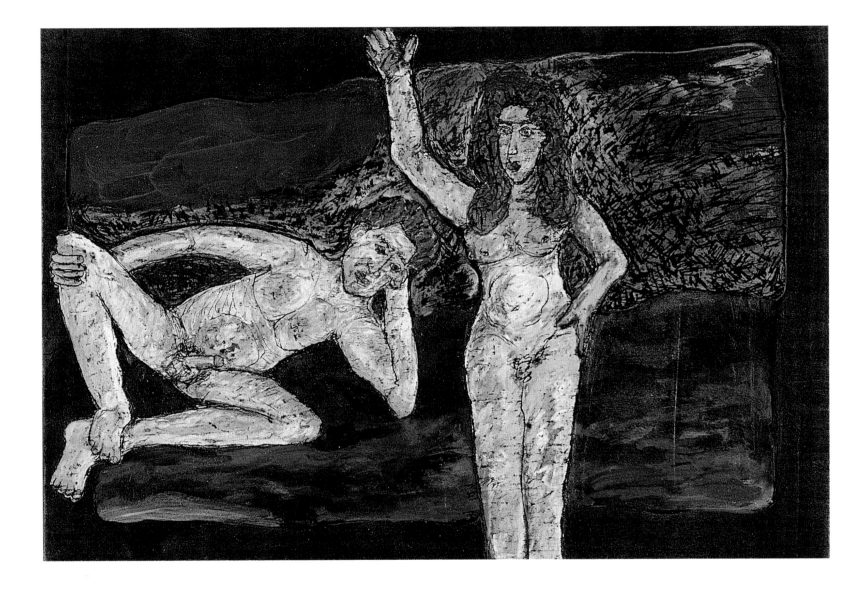

Male Figure
1994
Scorched wood and oil paint
H 5 x W 4 ¹/₂ in.
Photo Gary Heatherly
Collection of the Artist

Remembrance of Innocence
1994
Scorched wood and oil paint
H 8 ³/₄ x W 12 in.
Photo Gary Heatherly
Collection of the Artist

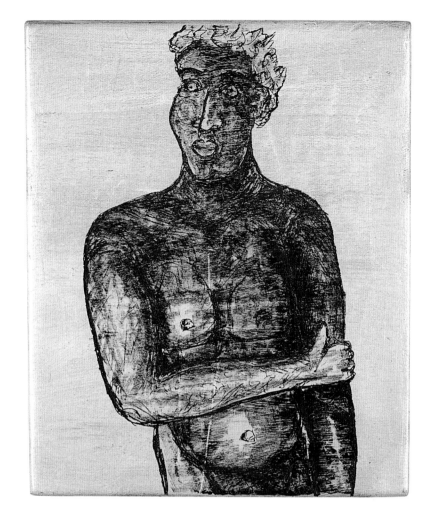

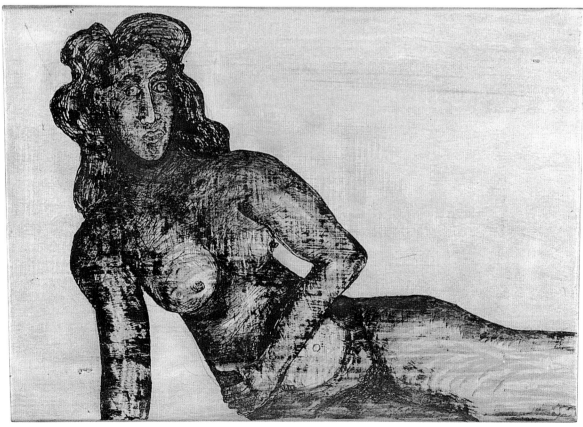

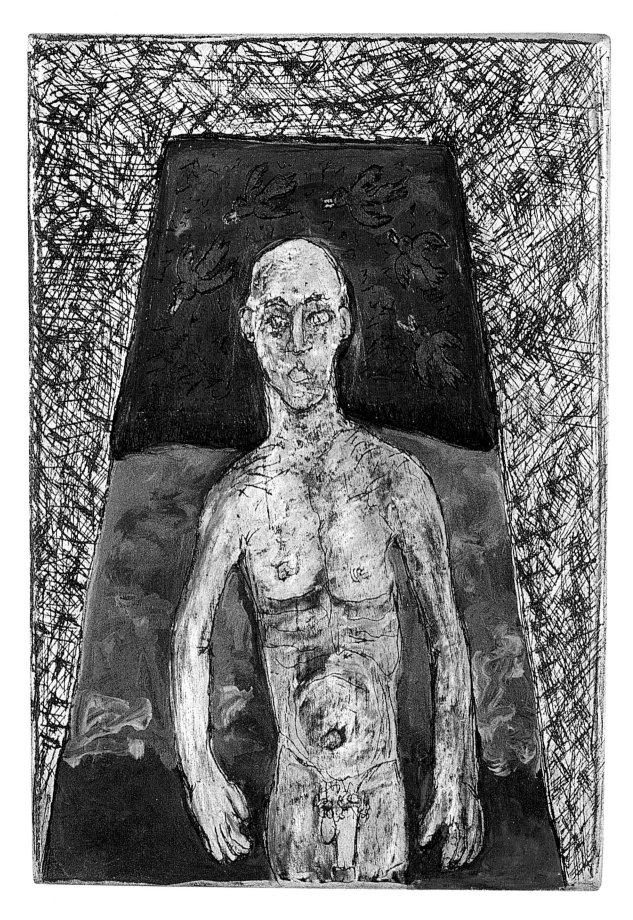

Archway
1994
Scorched wood, oil paint and prismacolor
H 8 x W 5 ⅝ in.
Photo Gary Heatherly
Collection of the Artist

cover how to build a studio, how to build a furnace. The transition from student to artist meant a tremendous amount of work. I started out with a single furnace and a couple of annealers.

"Then I just went out and did it. For a long time, it was a matter of repetition, and my finished objects didn't transcend their material. I think of the period from 1975 to the early eighties, when I began making translucent "Monoliths" like *Kiss*, as my 'lost years.' I was learning how to work with glass by experimenting and trying to develop a lyrical style and mode of expression."

The studio stayed open, in the converted two-car garage down a steep slope from the little frame house. Today it is crammed with work from all of Jolley's series, as well as shelves of graceful, colorful vessels by the artist who worked with him in the studio in the early eighties and whom he married in 1988, Tommie Rush. The space now also serves as their office, with computers, copying machines, light tables and masses of slides, as well as the place where Jolley and his four or five assistants retreat for a break. Although the hillside cottage hasn't been the artist's "crash pad" for several years, it retains a homey feel. But instead of cozy furniture, radiant glass fills every small room, and the white porcelain farm sink that stands beside a large, curvaceous fifties-vintage cook stove is likely to be crowded with glassware that dates from one or the other of Jolley's experimental stages. There are tall crystal goblets that rise above clear-glass tumblers on which delicate blue lines trace elegant, Matissean figures as well as other pieces that reveal Jolley's deft, distinctive touch.

Here, down the crumbling cliff-like staircase to the old garage, just off a dusty road that winds around a sharp corner to the highway, Jolley transforms his concepts into solid form. From the single furnace and duo of annealers he started with in the drafty garage, he gradually expanded his working space, team, and range of mediums.

The first of these expansions in medium certainly, were glass forms that marked his growing expertise as they increased in size and sophistication; at the same time, he began to explore related themes and imagery in his two-dimensional pieces – both wooden reliefs and works on paper – and he traces these forms back to constructed wooden sculptures of the seventies, which are no longer extant. But it was those early vessel-formatted works that preoccupied Jolley during those intense, solitary "lost years," allowing him to develop the deftness with which he handles glass today, and to turn away from the wider world and look inward as he found his voice and launched himself on his highly personal path.

Three: Into Three Dimensions

When he chose his combination "crash pad" and studio in 1975, Jolley couldn't have known that the Knoxville region would develop as it has. Nonetheless, he chose his home and workplace so well that today, much expanded, the studio continues to serve its original purpose admirably. As the cottage became crowded with art and his working team grew in tandem with his assimilation of complex techniques and the ambition to create larger-scale sculptural forms, so did the studio and, soon, the studio complex. The original studio grew with the addition of a loft for Jolley's solitary work in two dimensions, an area of exploration that continues to fascinate and inspire him.

Beyond the garage studios is another, larger multi-purpose studio whose high ceilings and wide doorways allow Jolley to work on a much grander scale, to have completed pieces photographed, to have work packed for shipment to galleries and collectors, and to move elements of monumental sculptures and huge bags of silica and other glass-making fundamentals in and out on a fork lift. An immense printing press stands in the center of the main working space, ready whenever Jolley takes his current series of works on paper to the next size. It is a process he expects to begin during the summer of 2002, though he's always prepared to set aside such tentative plans if he finds himself actively engaged with an unanticipated or prolonged formal exploration like the one that occurred in the early eighties, when he stopped blowing glass and began using it as a material to shape sculpturally.

Jolley had mastered the vessel form, and a myriad of techniques that could be used to add interest: embedded forms, bubbles and colors in increasingly sophisticated sculptural formats. As the size and scale of his art expanded, he began to move toward approaches that quite literally would fuse the linear and two-dimensional with the sculptural, blurring any remaining distinctions between the two and anticipating his heroic totem forms of the mid-nineties. By that point

in his ongoing evolution, Jolley came to view glass as the ultimate malleable, transformative medium, one that could evoke ancient forms – those of the classical glassblower as well as those of the humans who had left their marks on Neolithic stone, animal horn or bone and cave wall – while incorporating fundamentals of modernism, such as a luxuriously Matissean line or minimalist luminosity.

The promise of that enrichment is vibrantly present in the crystalline *Kiss*, a free-form sculpture whose sleek glass surface encases an intricate sketch. The profiles of a man and woman, Jolley's prototypical Adam and Eve or, perhaps, self-portrait with his wife Tommie Rush, appear in a burst of overlapping lines in primary colors, facing one another like prints in a double picture frame. The drawing can be seen from front or back, and as the sculpture is turned slightly the linear portraits shift too: seen head-on, they are side-by-side and turned toward each other; seen from an angle, their faces meet in a kiss and then flow together as the viewer moves closer to the edge of the brilliant study. Jolley's achievement in the seemingly simple, luminous sculpture is remarkable, and prescient in its summation of the work that had preoccupied him for more than a decade and at the same time, points to the work that would follow *Kiss*.

The lines are seemingly "sketched" in a painstaking process that involved softening canes, or glass rods, of each color with a hand torch and then applying them one by one at precisely the right near-molten temperature to the clear surface of a relatively small, solid mass to which Jolley had just given a flowing organic shape. Despite its suggestion of the artist's dashing, impressionistic stroke, the process involved as many as forty or fifty individual encounters between torch-softened cane and searing sculptural surface. As it took shape, Jolley proceeded steadily, if episodically, toward the realization of his interior vision.

While still almost as hot as the honey-like crystal in the glass-melting crucible from which it originally had been dipped, the smaller "drawing" was then plunged back into the blazing crucible and coated with additional layers of clear, brilliant glass to encase the "sketch." Again, the "fire dance" – the interplay between artist and material, between intention and execution – required far more than the conceptual spark and coordinated, instantaneous response that is the usual modernist act.

In the studio, as *Kiss* evolved, Jolley juggled the demands of an ancient yet very modern medium, one whose properties and requirements had become second nature to him by the mid-'80s, along with his urge to produce a fleeting, idiosyncratic gesture in glass. That gesture was one he could, and did, make in sketches on paper. The seemingly simple gesture was, nonetheless, one that in layered, ornamented glass-on-glass demanded exquisite control at every stage of its development. From its initial shaping to the timing and temperatures in the annealer as it cooled, Jolley's technical goal was to successfully avoid the internal cracks that would have destroyed *Kiss*, landing it in the studio "bone yard."

As this work, and others related to it, emerged from their annealers intact, Jolley was ready to take his new, very personal sculptural direction to the next level. The initial encased sketches certainly are sculpture, solid masses of luminous glass the artist worked manually into final form, marking them with his calligraphic and completely characteristic touch. But they also are statements in glass, their imagery incorporated within the medium, and as such serving as stunning sculptural stepping stones to Jolley's remarkable subsequent crossover statements. Among them, most significantly, were the blue-line drawing series that blurred the boundaries between the two- and three-dimensional work and, in their elegant and elegiac plasticity, erased it.

The blue-line drawings of 1985 are like sketches that spring into curious, quasi-dimensional existence even as they remain rooted in their divergent sources. The spare features of *Faun* lend specificity to an otherwise indefinite, if rather bust-like mass of frostily acid-etched glass, delineating the pointed ears and rigidly stylized eyebrows of the mythical creature and gently animating it.

"The technique of drawing directly onto the glass was appealing to me," said Jolley. "Each piece was individual, and each resulted from the touch of the hand. They weren't multiples, but rather a series of unique forms. The material allowed me to develop and articulate my voice in works like *Faun* and *Cheek to Cheek*. Their forms appealed to me, but the linear quality made them more interesting to me, just as the human form was of great interest to me.

"Between about 1975 and 1985, I honed my technique and refined my voice. The drawings and the other two-dimensional works of the mid-

Same Skin Different Color
Blown glass
1994
H 16 x W 7 ¹/₂ x D 9 in.
Photo Don Dudenbostel
Collection Francine and Benson Pilloff

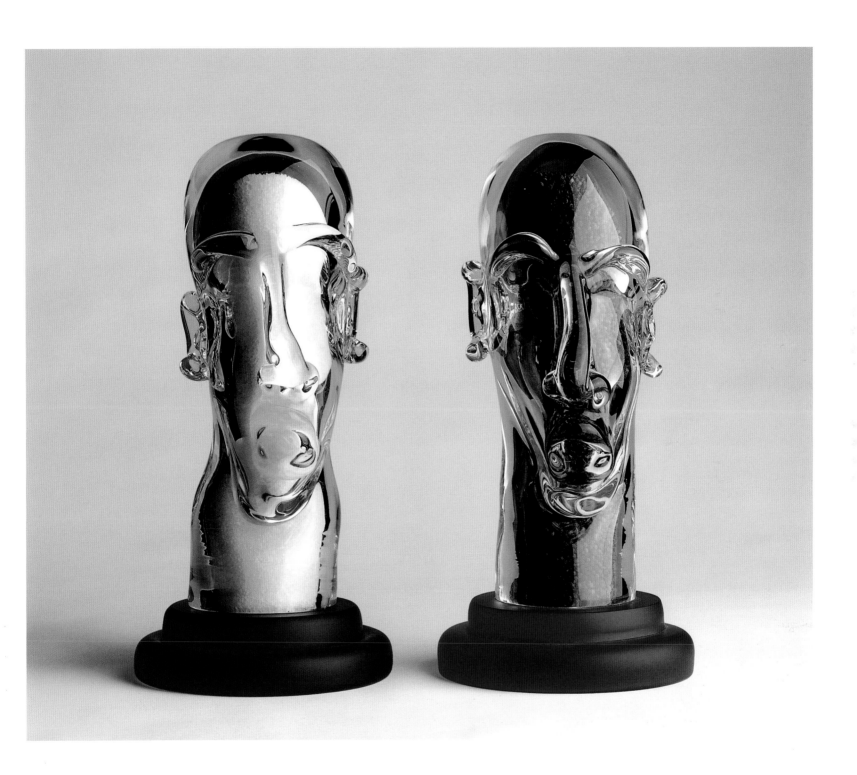

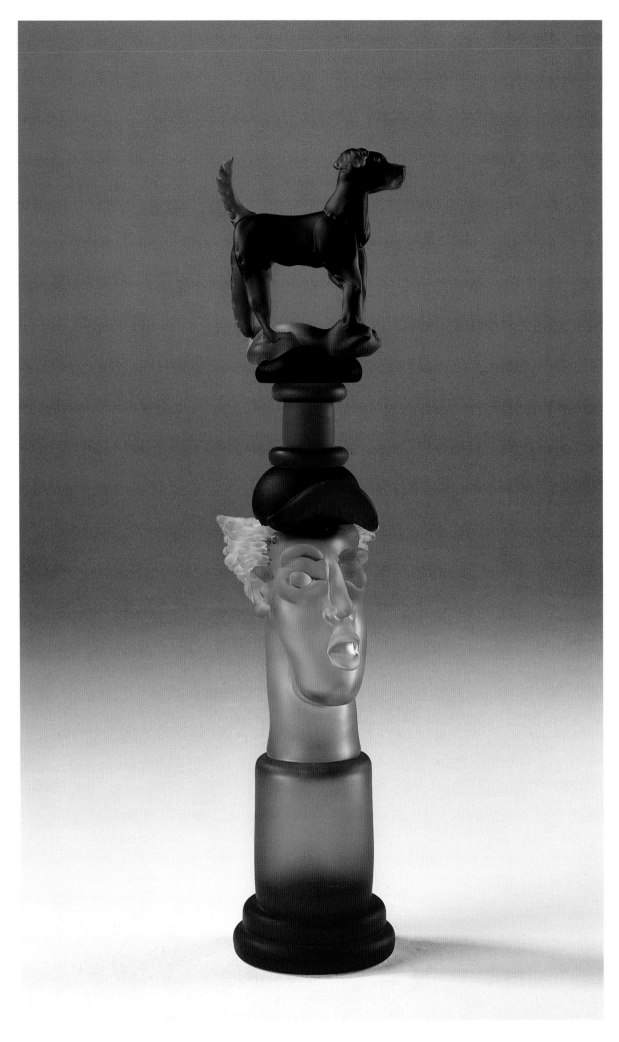

Simple Bond
1995
Blown and hot formed glass, fabricated
and acid etched
H 38 x W 9 x D 11 in.
Photo Don Dudenbostel
Collection Bernice and David Stearman

Torso
1996
Hot formed glass, acid etched
H 16 $\frac{1}{2}$ x W 11 $\frac{1}{4}$ x D 4 in.
Photo Charles Brooks
Collection of the Artist

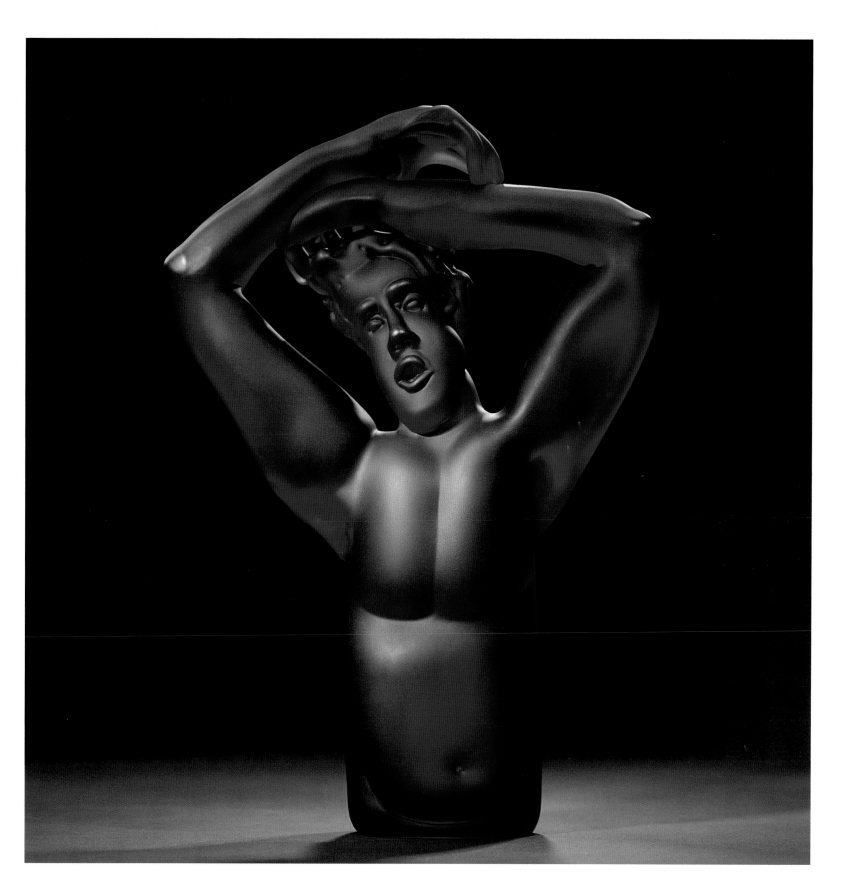

eighties brought the direct line onto the glass, which I saw as making a human mark the way people had left their marks on the caves of the Dordogne. The glass's amorphous, fluid surfaces were defined by the line, and I think that the blue-line drawing series were part of a conscious effort at that time to simplify."

Jolley's breakthrough blue-line drawings, however, also represent one of the two poles between which his work constantly fluctuates: the unadorned and the ornate. As his forms evolved, gravitating from the classic vessel to encased lines to humanistic and fully sculptural shapes in the series of the mid-eighties, he narrowed the conventional and wide-ranging ornamental potential of his medium to a restrained, descriptive surface line that pushed his concern for reductive formalism to its visual and technical limits.

The fundamental form was manipulated into a luminous biomorphism and, with the addition of Jolley's fluid architectural line, became a figure, or part of a figure or of a figure group. The line itself, which was originally conceived as a gray to mimic pencil graphite or a charcoal wand, soon morphed into the more electrifying blue. The *Faun's* bust, elegantly elongated and crowned with clusters of softly rounded glass that suggest curls in this context, took on both definition and character, with the zigzag or lightning line of the eyebrows as expressive as the assured curve of the long jaw.

Similarly, such figures of this pivotal period as Jolley's kneeling or seated nymphs – classical in their nudity as well as the surface luminosity that resembles marble – represent a quantum leap from the conventional, vessel-like glass form to sculpture in the round. The forms are uniformly small, monochromatic and playful in tone. Despite their extreme restraint and clear references to antiquity, they foreshadow and lay the groundwork for the outpouring of the large, compound, exuberantly colorful "Totems" that began to appear and that rapidly evolved by the end of the decade. The heavy, long face of the *Faun* appeared and reappeared in sculptural "sketches" and soon became a fundamental element of Jolley's eloquent mature sculptures in glass.

All this can be seen in miniature in the blue-line "drawings," plastic expressions whose compressed energy and breadth of vision were barely restrained, and actually immense. The gestural strokes delineating the features in *Faun* have more complex, detailed counterparts in the *Seated Nude*, a cloudy acid-etched figure whose three-dimensional body reveals a greater desire to manipulate hot glass into solid sculptural form as well as to give it more specificity and personality by adding the blue lines.

Unlike the figure in *Faun*, whose unruly hair was merely indicated by a tumble of frosty etched-glass curls, the nymphs' long hair is more emphatically and overtly depicted by the blue-glass lines tracing its wavy cascades. And, again unlike the simple bust of the *Faun*, the nymphs' body parts are more explicit, freely shaped in molten glass etched to create surfaces that appear to be tenderly buffed, and defined by the greater complexity of Jolley's fine blue lines.

As such, they are closely linked to a female bust similar in its modeling of hot glass to suggest head, breasts, hair and facial features while executed in a darker, more opaque glass and featuring the application of external elements. The colored-glass beads around the neck of *Female Bust with Beads* emphasize her role as sculpture rather than as the likeness of an actual human being, arrested and frozen in time and space.

"Most of my series start with a simple idea, and I try to give them enough space to develop," the artist says. The development in the frosted-glass figures of the blue-line drawing series continued, eventually to include standing single figures that appear to be swaying as if from the intoxicating effects of a bacchanalian revel; figures grouped into units; and both male and female busts.

The couple in one drawing, shown from the shoulders up and posed facing one another as if for a family portrait or, alternatively, for an Etruscan sarcophagus, is outlined in cobalt blue on a colorless and depthless etched-glass surface. The forms in *Cheek to Cheek*, like those in the seminal *Kiss*, appear able to overlap, and the gestural line that denotes individual features is specific enough to suggest that this is more than a generic couple; the man's face, with its boldly cleft chin, is the long one that is constant enough in Jolley's *oeuvre* to become his Everyman, an enduring humanistic note, while the curls in the woman's tumbling hair are as individualistic as her thick, defiantly strong eyebrows.

Above all else, the blue-line series traces Jolley's break into three dimensions. The assured gestural line is nimble, wiry and articulate, despite the sustained ardor of its fabrication and the demanding requirement of the artist's remarkable retention of his original, fleeting impulse. In the Bacchante group of the early nineties, *Swaying*

Dog Time in a Real Time World
1996
Blown and hot formed glass, fabricated and acid etched
H 44 x W 13 x D 13 in.
Photo Gary Heatherly
Collection Lisa and Ron Brill

Both Sides
1996
Blown and hot formed glass, fabricated and acid etched
H 46 1/2 x W 12 x D 12 in.
Photo Gary Heatherly
Collection Mint Museum, North Carolina

Avian Dreams
1996
Blown glass, fabricated, acid etched
H 54 x W 13 x D 13 in.
Photo Gary Heatherly
Private Collection

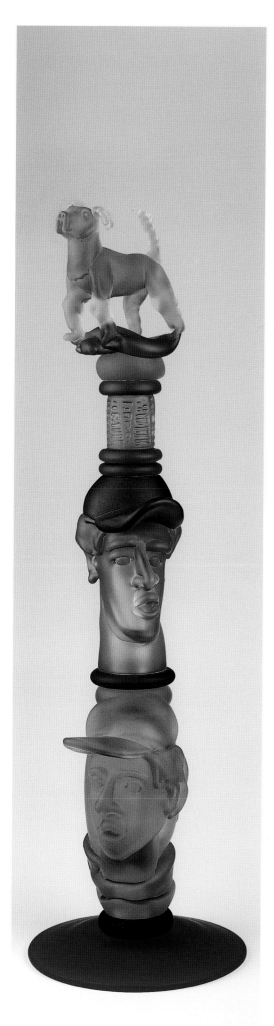
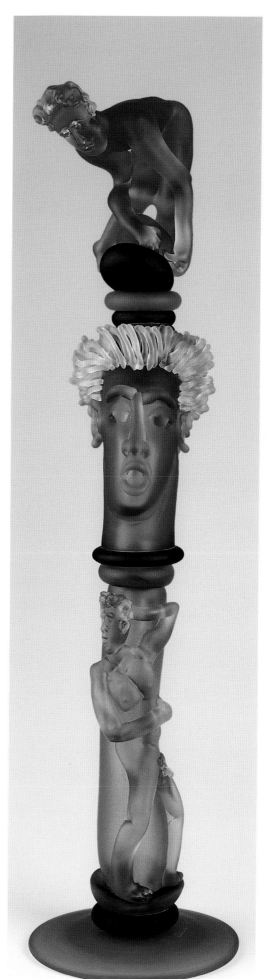
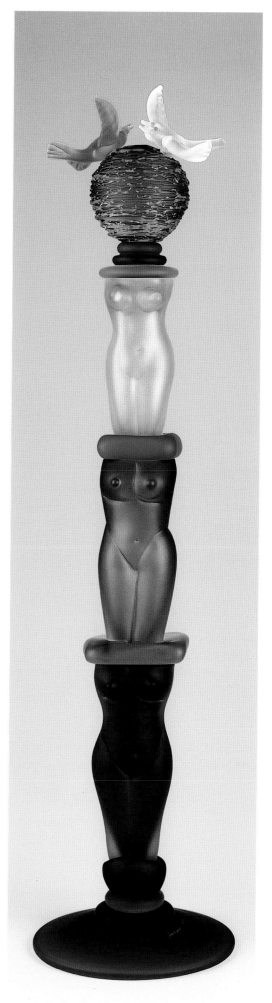

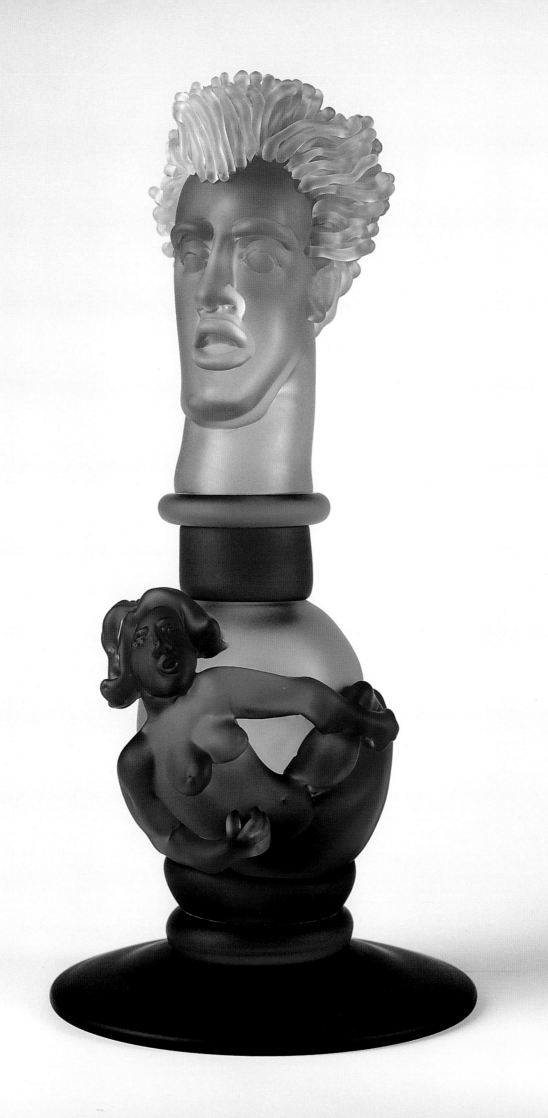

Remembering the Night
1996
Blown and hot formed glass, fabricated
and acid etched
H 27 x W 12 ¹/₂ x D 12 ¹/₂ in.
Photo Gary Heatherly
Private Collection

Figures, however, the sense of repressed dynamism is pushed to an extreme. Curving lines emphasize the springy twist of overlapping legs and athletically carousing bodies in both figures and, in each, indications of gender are emphasized.

The linear articulation is precise and firm, contouring the woman's soft chin, full breasts and long, loose falls of hair, while the flattened torso of the muscular male sets him apart stylistically and formally from his counterpart. The figures, set upright on circular bases to restate their sculptural roles, are similar in basic concept. Like the others in the blue-line series, they are formed from glass that retains the touch of the artist – both as a sculptor shaping the molten mass and as draughtsman, delineating its details. Here, and throughout this pivotal early series, the maker's mark informs the work.

In *Double Bust*, which is larger than *Faun*, Jolley's concern for three-dimensionality reaches a new level of complexity, with its frontal blue-lined articulation and lines that "bleed" through the translucent glass body of *Double Bust* from the "drawing" on the other side. Formal in its restrained blue-and-white palette and the cool, distant gaze of its attenuated, heavy-lidded face, the head is also very much of the moment. Its crisp hair is indicated by regular rows of spiky lines, which are variants of the *Faun's* eyebrows and hug the head like a knitted cap above the arrangement of fluid blue-lined gestures. Other lines spell out lips, a long and noble nose, and deep-set eyes, all with their whispered overtones of the decadent, erotic and enormously evocative colossal statue of Constantine, the late Roman Emperor.

The bust, by contrast, suggests an enduring, generic aesthete, observant but also emotionally disengaged – except for the disturbing hints of a second set of features that are just barely glimpsed behind and, rather eerily, through the first. Janus-like, the bust has two faces, yet unlike Janus, the Roman god who could look back on one year and ahead to the next, this unsettling figure's very veracity is cast into doubt by his shadow image. A novel, postmodern Janus, he seems to see not ahead and behind but through himself, in a confusion of identities that is both affecting and clearly narcissistic. This feat would have been impossible with any medium other than glass, with its ability to permit, to diffuse or even to refract and distort colored light, shadow and line.

Poised on the brink of Jolley's interest in sol-id sculptural form and incorporating figuration with the artist's characteristic dichotomous mark, *Kiss* opened the door to further progress. The "lost years" of the decade from 1975 to about 1985 provided Jolley with tools for his breakthrough sculptures, *Faun* and the tremendously individual, influential *Kiss*. And those sculptures, innovative and original, pointed the way to more elaborate explorations in which the artist would begin to use his malleable and infinitely mutable material almost unconsciously, as a particularly evocative and multifaceted expressive means.

In *Kiss*, separate figures embody the notion of elective affinities, so empathetic that they can become a single being. The man and woman are clearly individuals, with distinctive color combinations; they are necessary, opposite sides of the human coin. She wears a graceful set of jewelry, while he is in formal tie and collar. Delicate and ephemeral, facing one another in the heavy pear-shaped crystal body that encases their images, the couple can meet and meld optically. It's an obvious, oddly joyous feat, so simple that it delights us with its rich variations in much the same way that a stereopticon viewer must have amazed and thrilled viewers a century ago with its sudden and unexpected three-dimensionality. The potential for overlapping images, exclusive to Jolley's transparent and flexible material, led to *Kiss*.

It is a fresh conceit, and one with impressive overtones. In Jolley's capable and determined hands, glass was used by the early nineties to achieve three-dimensional effects not dissimilar to those rendered in other, more traditional mediums. And, at the same time, Jolley was employing his very modern medium in ways that allowed him to draw on its inherent qualities to produce effects that even surpassed those achieved in bronze, marble, clay and such unconventional and vanguard materials as fluorescent tubing, soil, wood, fibers or other fabrics, as well as combinations of those mediums. As he worked glass still molten from the furnace, patiently and with an intensity that translates, paradoxically, as fleetingly deft and inspired, Jolley transformed glass into a pliable material that incorporated not only color and light but also ambient atmosphere, all-too-human emotion, and rich textures.

"I'm not interested in multiples, but I am interested in surfaces," he has said. "When you look at my work as a whole, I'm always doing figurative pieces. I'm looking at glass as a serious material for sculpture. I have a love for my materi-

als, and I've always had it. When you first start out, it's all very exciting and spontaneous. At its base, at the core of its existence, the impact of glass's color is visceral and emotional.

"In the blue-line drawings, I tried to simplify, to use the narrowest of means to break through to sculpture. And since then, I've fluctuated back and forth in my work, between the simple and the complex, the two- and three-dimensional. But in one way, there is always a frozen moment in my work; there is always the human figure, the humanism, and always the element of time."

Works On Paper

The impulse toward simplicity and spontaneity that animated Jolley's blue-line drawings in the mid-eighties and set his path into three-dimensional exploration also expressed itself slightly later in a different way.

The series of drawings on wood and paper that he began soon after he moved into his solitary studio in the mid-seventies and that took the form of studies on fragments of wood veneer, resurfaced a decade later with the flatter, more colorful versions of *Male and Female Relaxing* 1987 and other minimalist forms. In a progression that reflects the blue-line drawing series, and more recent work, what began simply soon evolved into larger and ever more complex layered "drawings," both figurative and near-abstract. That impulse continued into mixed-media pieces that offered dramatic new paths for exploration of both form and iconography.

Yet, however varied and large in scale the expressions *Male and Female Relaxing* spurred, the impulse remained firmly fixed on Jolley's essential humanistic concerns, and on his finely balanced blend of tactile, palpable sensuality and the more intellectual implications of time – past, present and future. A man and woman, who are closely linked in concept and style to the 1987 blue-line drawing, *Male and Female Relaxing*, appear in *Beacon of Desire*, a small woodcut from 1994 whose precisely incised lines and textural painted surfaces were never meant to be inked for transference onto paper.

Instead, this iconic study is a tinted and fire-seared drawing, as highly stylized, mysterious and hieratic as Gauguin's Tahitian woodcuts a century earlier. Its rather minute male and female nudes are engaged in an enigmatic but clearly erotic activity, despite their distance from each other and apparently mutual indifference. Adam sprawls on a lush Edenic lawn, legs wide apart in a pose both eagerly priapic and awkwardly resembling a leaping frog, and gazes at his primal Eve adoringly. Her back is to him, but she turns her head slightly, subtly aware of his attentions but unwilling to be obvious about it.

The coy couple belongs to a mutual admiration society that is closely related to the earlier glass sculptures, notable for their tight, wiry line and characteristically mannered figures – faces long and torsos as heavy, full, and self-consciously indolent as their possible prototypes, the Northern Renaissance "Adam and Eve" paintings by Lucas Cranach or Albrecht Durer that they so powerfully suggest.

However, there is greater physical depth in Jolley's *Beacon of Desire*. The figures are two-dimensional but given a convincing solidity by their setting and a modeling that was impossible in the opaque forms of the acid-etched glass sculptures of the blue-line drawing series; they occupy implied space and time. However traditional their activity, they embody a sense of sustained desire or lethargic, leisurely lust that seems immediate and energizing. Two other works of the same year, the almost monochromatic scorched-wood *Male Figure* and *Remembrance of Innocence* also capture a mood whose depths are emphasized by Jolley's unusual technique. Charcoal lines and shading are not superficial in the studies of isolated nudes, alone and vulnerable; they are integral, formed during a process that uses fire quite differently than that used for Jolley's glass sculptures.

"Scorching is a non-traditional way to get my touch onto the piece, to make the human mark, like the handprints left on the walls of the Dordogne caves," the artist has said. "I'm not interested in making prints or other multiples with these works, but I am interested in their surfaces – the burning and the Prismacolors. My first attraction was to glass, but going all the way back to when I was a kid, I liked whittling wood. My grandfather was a whittler, and I'd whittle with him when we went on family camping vacations."

Relying again on his early woodworking skills with associations that range from the tactilely primal to Americana allowed Jolley to step aside from his years of mastering glass as a sculptural medium and experiment with new ways of expressing his humanistic concerns. It was not only his style, materials and technique that occupied fresh territory, however; for as his glass expanded in size and complexity, he became de-

Cairn
1997-98
Stone and glass
H 17 x W 12 Ft.
Photo Judy Cooper
Private Collection

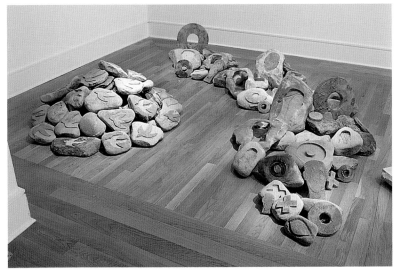

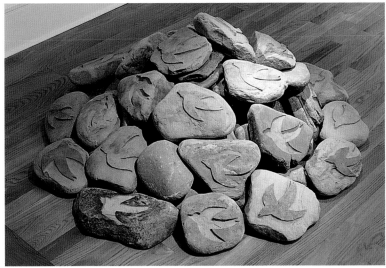

Cerebral Hemisphere
1999
Wood, glass, and paint
H 42 x W 42 x D 5 in.
Photo Charles Brooks
Collection of the Artist

Lunar Coexistence
1999
Aluminum, steel, copper, glass and silver
leaf
H 96 ³/₄ x W 48 ¹/₄ x D 6 in.
Photo Charles Brooks
Collection of the Artist

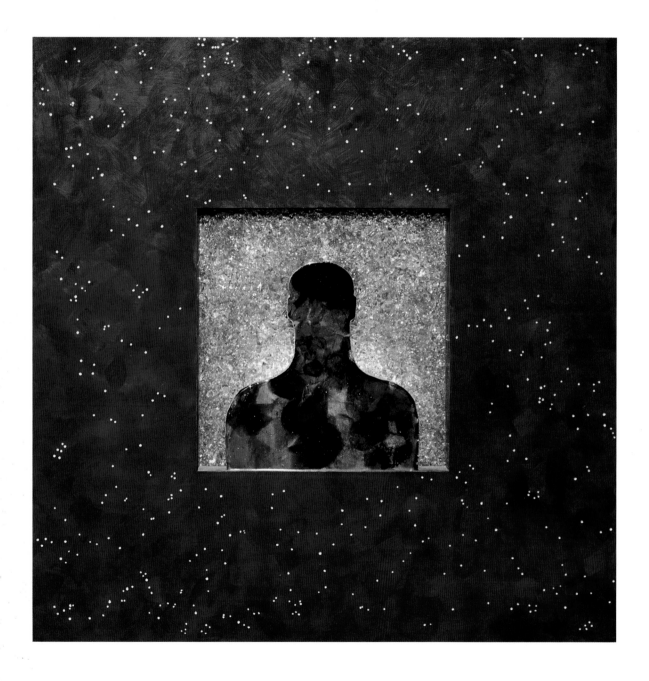

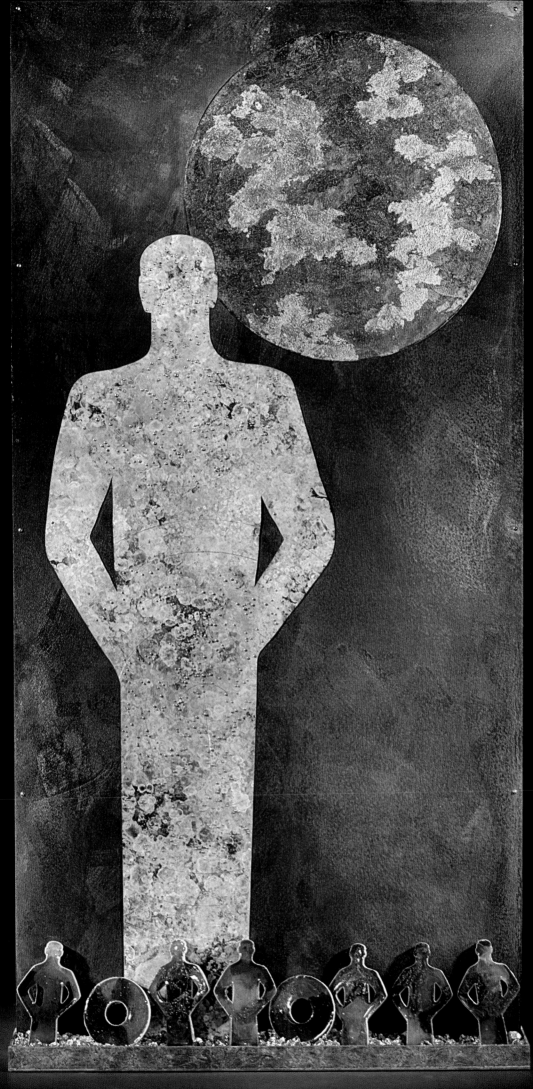

pendent on assistants to achieve these works. His creative energies had to be adjusted to the demands of other timetables and abilities, to collaborating, to communicating and to interacting even as he was moving intuitively toward his goal.

These collective efforts require a delicate balancing act and become inevitable at the lofty levels Jolley has reached in his field. But the process has imposed restrictions on creative energies that may require greater freedom, fewer crucial processes and interactions. Most of Jolley's workshop is dedicated to his medium's exacting, unrelentingly precise requirements and science. Implements rest in buckets and barrels and on tool trolleys, and walls are lined with gauges and other instruments. Tall, slender blowpipes and other pieces of equipment lean into corners throughout the vast warren of contiguous spaces that grew from his two-car garage, and each of two crucible furnaces cradles three large ceramic bowls in which Jolley melts the powdered glass that forms his sculptural palette.

The studio's tabletops are crowded with fragmentary glass forms in every color of the spectrum and then some, glittering or glowing as light touches its smooth or etched skin. The forms vie for space with other key items of the studio: kilns for controlled cooling, or the annealing of forms; unfinished fragments of glass sculptures in their final stages; wheels for polishing or shaping forms; the essential glory hole and, opposite it in regal central position, the bench where Jolley sits to shape and work molten glass.

At either end of the studio, though, there is a rough and steep open staircase leading to a second story. There, flanked by shelves loaded with jars of acrylics and other supplies and businesslike metal chests of long, wide drawers filled with prints, drawings, and other works on paper, Jolley steps away from the constant hubbub of the glass studio to delve into a medium he can explore in solitude. The groundbreaking woodcuts from 1994, colored or starkly black-and-silver, hang alone on an *ad hoc* plasterboard wall above a passageway leading to a workroom overlooking the tangled foliage of the rural Tennessee countryside.

The woodcuts are sentinels, pointing the way to a series that parallels the work for which Jolley is best known, work they complement and round out. From the single-figure woodcuts, made at times when the glass shop was unoccupied or when its materials were being transformed laboriously from powder-fine sand to a honey-

thick consistency, the artist developed his ideas rapidly, in a flurry of sketches: the lonely figure of a male nude in a narrow doorway led to *Straight Ahead*, the 1994 monoprint of a stern-faced, staring man.

Straight Ahead is six times the size of the wraith in *Archway* 1994 and is without its architectural frame; the richly textural mix of scorched wood, oils and Prismacolor adds to an already tense, brooding atmosphere. Nonetheless, the unornamented face in *Straight Ahead* is that of a man held tightly in place. His gaze is level and his features are fixed, as if to repress the internal turbulence implied by the densely worked, patterned planes of his face and the mottled red that surrounds him. The tentative aspects of the man in *Archway* have been replaced by a ferocious assurance, a steely determination unmarked by even the fieriest passion or the deepest shadows.

The fire in *Straight Ahead*, unlike that used to shape the set of busts in *Same Skin, Different Color*, glass sculptures also made in 1994, flickers over the man's face and colors his backdrop. Working alone, often in the silence of the night, Jolley pushed his two-dimensional medium to its limits over the next eight years and eventually moved into the current series based on silver-leafed sheets of heavy paper and a concurrent series that incorporates elements from every series.

Even now, it's difficult for the artist to define just what he is doing in the upstairs studio, and to draw distinctions between his two-dimensional series on paper and sculpture shaped from molten glass. "I call them drawings solely because they're on paper," Jolley said. "But they're actually more like paintings. And when I'm working, I don't actually know how they will turn out – I apply pigments fairly thickly, and sometimes it crawls." From the 1994 woodcuts, all miniscule in scale by comparison and limited to tensely posed figures in muted or monochromatic tones, to the larger 1994 monoprint, *Straight Ahead*, Jolley focused on a limited repertory: the human form, clear at first and making contact but later in greater scale and ever-softer focus, along with a menagerie of birds, geometric symbols, solar or lunar discs and other totemic forms.

Jolley combines his images on sheets of paper, neatly torn from an immense roll of 300-weight Reeves BFK that hangs from a thick pipe in the apparatus he rigged up to serve as an oversized paper-towel holder. In one loosely sketched study, the simmering emotions that had been

Look Within
1999
Steel, Glass, aluminum and copper
H 30 x W 42 x D 36 in.
Photo Charles Brooks
Collection of the Artist

Veiled
1999
Copper, glass, silver leaf, stone, steel,
and wood
H 19 $\frac{1}{2}$ x W 15 $\frac{1}{2}$ x 6 $\frac{3}{4}$ in.
Photo Charles Brooks
Collection of the Artist

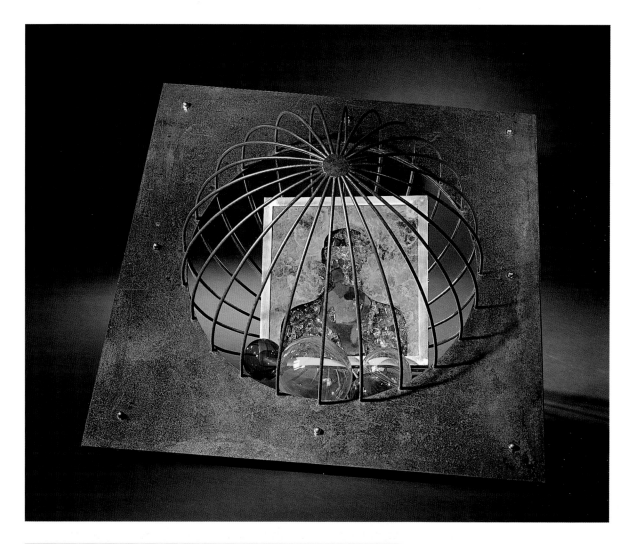

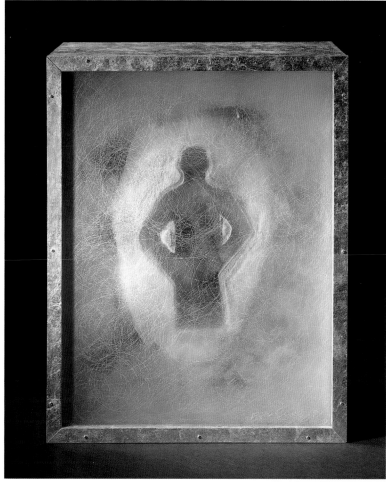

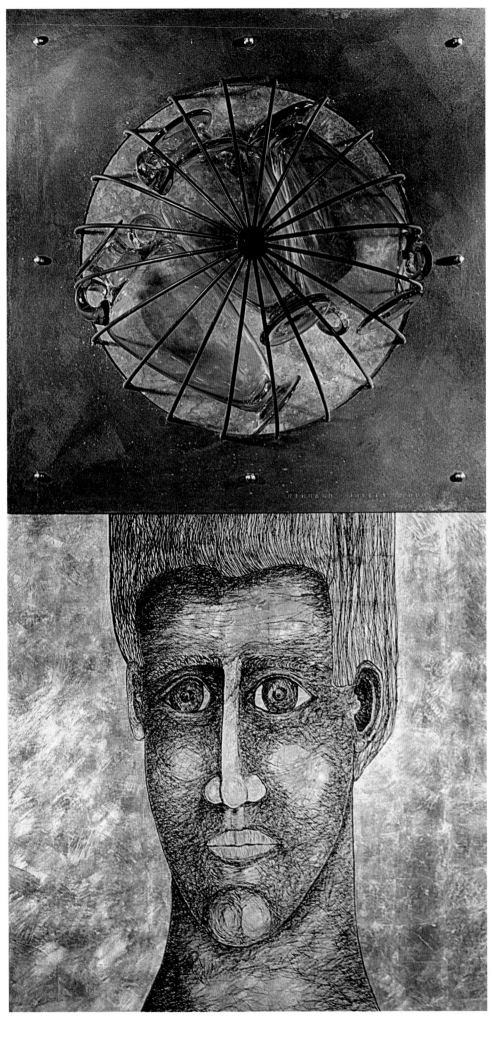

Holding Thoughts
2000
Wood, glass, steel, paint and silver leaf
H 72 x W 36 x D 14 in.
Photo Charles Brooks
Collection of the Artist

held in check in *Straight Ahead* fragment the skin and force the eyes wide open, aligning dense textures into stylized regular lines that might be parallel, as in the hair, or become tight, frantic concentric circles, as in cheeks, which seem to belong to some mysterious tribal artifact.

The currents of lust crackling between the reclining satyr and preening, self-absorbed nymph in *Beacon of Desire*, which are energized versions of the cool acid-etched glass couple of the 1987 *Male and Female Relaxing*, have been formalized in a subsequent 1993 woodblock print, *Adam and Eve*. Here, rigidly upright in narrow vertical panels and expressed in disciplined shades of blue, green, and brown, the couple has been abstracted from their earlier classicizing languor and transformed into a rueful, inwardly agonized couple in the Garden of Eden.

The archetypal male bust, elongated as if by irrepressible inner forces that twist and distort, is treated cubistically in one stark print. The figure's broad features are outlined in chalky white and jagged, linear contouring reminiscent of the free-flowing blue lines in the seminal series of the mid-eighties. The rigid lines, broad shading and thinly applied pigments that gave Jolley's *Adam and Eve* figures a mute attitude of stunned surface submissiveness reached their zenith in more recent paintings. Among these pieces is a recent series that Jolley created by layering varnish over a densely worked, but ultimately veiled surface whose subject is invariably the human form, most often the head of a man rendered several times larger than life-sized.

The latest stage in the painterly series, despite its different medium and technical demands, is closely related conceptually to the sculptures Jolley was making during the mid- to late 90s. Each piece is the result of a painstaking series of steps, all of which allow for serendipitous accidents like the "crawling" of varnish that may occur on humid days. Each glows with a rich inner light as its impasted base layer is transformed by the addition of forty to fifty layers of varnish, which cast a translucent golden-tinged veil over the original image. Far larger than the tinted or scorched woodcut drawings that began the series and, literally, more opaque in subjects and implications, his new works on paper are as much about process as about the object itself.

Yet, as in his contemporary sculptures and the mixed-media environmental pieces he began in the late nineties, Jolley's humanism always remains at the forefront. In the earlier stages, the human figure, which is a constant, tended to be crisply depicted in dense passages of acrylics in intense saturated colors that Jolley calls "garish." As the series progressed, the figure has gradually fragmented and lost substance until it's now merely a broad outline resembling the contours of the earlier blue-line drawing *Faun*. The artist develops his image, working and reworking the bright pigments to his satisfaction before moving to a second step: covering the painting with a thin, shimmering layer of silver leaf that allows only its textures to persist visually.

It's an intriguing paradox, and one that pervades Jolley's *oeuvre*: a great deal of thought and methodical effort go into aspects of works that will be obscured with equal attention to detail, and thus made invisible. As he buries or veils his image, obscuring both its appearance and meaning, he creates an inner, secret theme that is integral to his process. Jolley seemingly embeds time itself in his work in a process that is the reverse of the process of discovery, of uncovering and deciphering a theme. However simple each painting may appear when complete, and however much it might resemble "field" paintings by Jackson Pollock in its intermediary stages, it encompasses an ongoing *sotto voce* dialogue between artist and viewer, as well as between the past and present, between subdued surface and turbulent content and, most strikingly, between reality and illusion.

In *Range of Sight* 2001, a dove like bird sits on the shoulder of a long-faced man with a pointed chin, the heir to Jolley's glass busts and to the sober figure in *Straight Ahead*. He gazes to the side, his eyes fixed on some startling vista as if unaware of the bird and of the stylized leaves behind him on a backdrop that appears gilded; he even seems oblivious of the viewer. The perspective is an enigma; the man's blank, vulnerable stare emphasizes his lack of attention, as if he's focused on an interior vision forever closed – and thus a mystery – to his observer. Tactile and very lushly worked, the male figure, bird and leaves stand out particularly sharply against the luminous golden backdrop that suggests Byzantine roots: the figure, a classic Everyman, is set against the sky of Heaven, a luminous space that is anywhere and everywhere at the same time, visible only to the elect.

Little of the clarity that characterizes *Range of Sight* is found in *Luminary*, from the same year. Here the form of man and bird remain, but only vestigially in relation to the smaller *Range of*

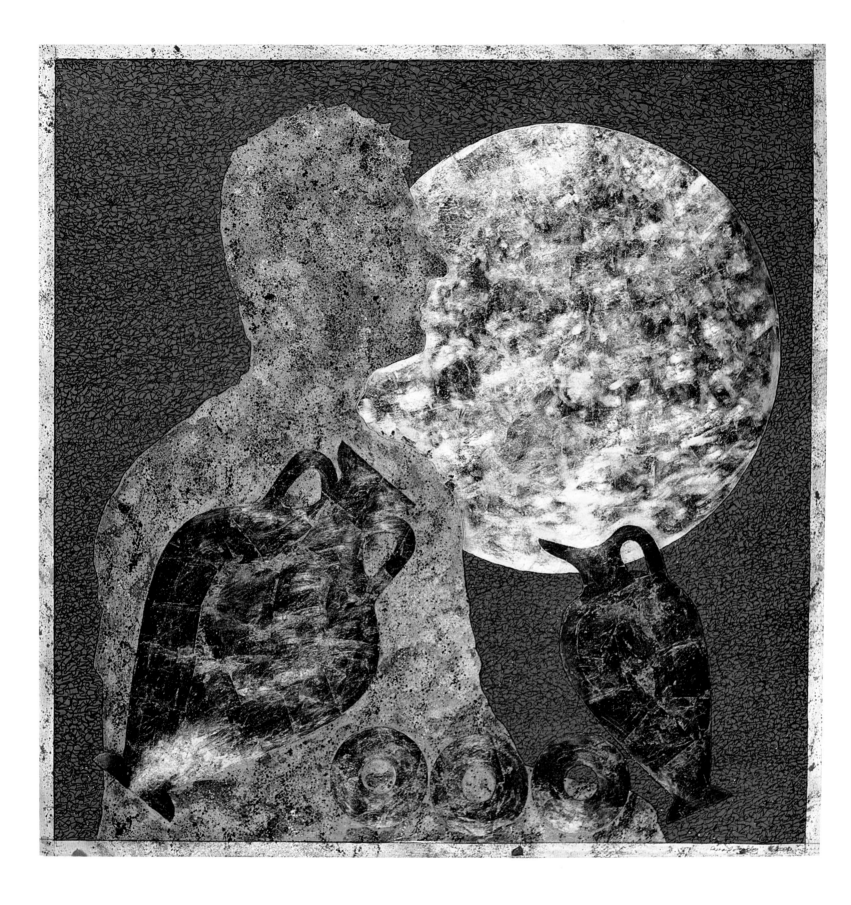

Idea Amphora
2000
Paint, graphite, gold and silver leaf
H 50 x W 50 in.
Photo Charles Brooks
Collection of the Artist

Illusion of Illumination
2000
Glass, copper, silver leaf and aluminum
H 40 x W 48 x D 4 in.
Photo Charles Brooks
Collection of the Artist

Power to Imagine
2000
Glass, copper, steel, aluminum, and silver
leaf
H 48 x W 48 x D 4 in.
Photo Charles Brooks
Collection of the Artist

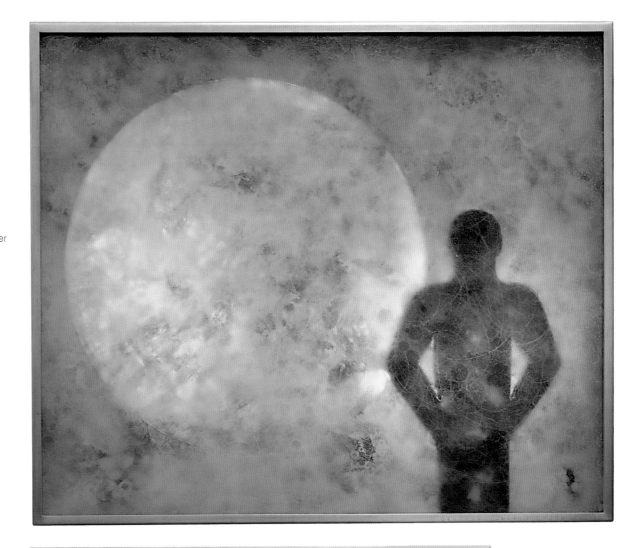

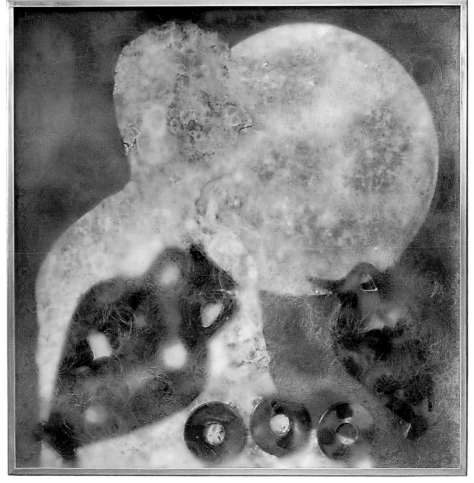

Sight. Here, the surface seems eroded, worn and weathered to such an extent that the surface naturalism of *Range of Sight* is a nearly forgotten memory. *Luminary* is, in essence, a study in dematerialization that pushes at the boundaries of abstraction. The red human form, like the yellow bird, appears hammered against a backdrop whose gilding or mosaic integrity has been scarred and pitted by the passage of vast amounts of time. The composition conjures up antique images — a heroic classical bronze pulled from the ocean after millennia, an enigmatic funerary mask from a Mycenaean pit grave, or a portrait in a forgotten Etruscan tomb.

In the current series of paintings on paper, particularly in the works that began to appear in early 2001 and to expand to incorporate a human figure based on Jolley's own silhouette, the humanism that informs his work is brilliantly modulated to accommodate his other consistent concern: texture, or tactile appeal. Particularly in the larger and more ambitious "drawings," Jolley works out ideas in solitude, and explores fresh directions at a purely personal pace, in an atmosphere of greater freedom than is possible in the glass studio. He is able to work intuitively here, without an outline or final target for a work's final appearance and completion, with the work remaining indefinitely open to random accidents, to fortuitous occurrences.

At the core of each piece and covering the human form, is an abstract tangle of bold color which the artist creates by dripping or pouring paint onto paper in a mannered act reminiscent of the fevered rites of Pollock. Jolley creates and then obscures images and symbols that are, in their turn, given a thin layer of icy silver leaf and transformed gradually into an illusionistic *tour de force*. Once the forty or fifty layers of the varnish's natural wood tones give the composition the honey-hued "kick" Jolley desires, it becomes an opaque, elegant object whose appearance is not unlike that of medieval enamel or even, despite the wet sheen of its dense surface and its abstraction, an eroded form pulled from the ocean or a pit grave.

"When I'm working on the drawings, I don't actually know where they will take me," Jolley explained. "I apply the very bright, colorful base layers of acrylic fairly thickly, adding atmosphere as I go. The shadow of the Abstract Expressionist painters' process is part of what I'm doing in my drawings, certainly. I don't agree with all of it, but the unconscious drive is there. Above all, the appeal is in the process, the excitement of doing it, and in the end, seeing where it takes you."

Mixed Media – Metaphysical Musings

By the mid-nineties, as his glass sculptures gained in stature and complexity and his interest in two-dimensional "painted" works on paper developed at an equally dynamic pace, Jolley began merging the two impulses into a third, still more meditative body of work. Like his "Totems," the attenuated combinations of humans, globes, columns, animals and other forms through which his vocabulary was growing more textured and compound, his mixed-material pieces brought together diverse, highly charged fragments that added up to far more than the sum of their parts.

The elements of *Cairn*, a free-form site-specific assemblage that occupied Jolley from 1997 to 1998, sprawl over a staggering two hundred and four square feet of gallery space. Its archetypal form, an Everyman resembling the artist himself who also can be seen in his most recent "paintings" on paper appears to have been stamped into a sheet of stone resting on the gallery floor. The human outline is demarcated firmly by the indentation scooped out of the stone and filled with a sleek blue-green layer of crushed glass. It's a strangely provocative image, resembling a frozen human-shaped lake in miniature.

A pile of rocks, each imprinted in similar fashion with an enigmatic symbol made of gleaming glass, stands nearby, as does a smaller mound across the gallery, on the other side of the man's recumbent figure. The composition seems at first literal: the fallen man, petrified after countless eons in the stony earth, lies between the piles of stones that once were a cairn marking his resting place. That cairn has been disturbed, and what emerges from the earth isn't a skeleton but something more perplexing: the shadow or imprint of a generic human, whose exposure to light transforms his already mutated silhouette into an even more troubling entity: a mirror shaped like a man.

In other words, the myriad unknown beings that lie unobserved in the folds of the earth are the mirror-images of today's man, contemporary versions of what Baudelaire called "mon semblable, mon frere" (my counterpart or reflection, my brother). Yet the implications of *Cairn* are both troubling and reassuring; as in his "paintings" on paper and the masterful glass "Totems"

Lunar Realm
2000
Aluminum, copper, glass, silver leaf and steel
H 96 x W 49 x D 6 in.
Photo Charles Brooks
Collection Karen Sharpiro

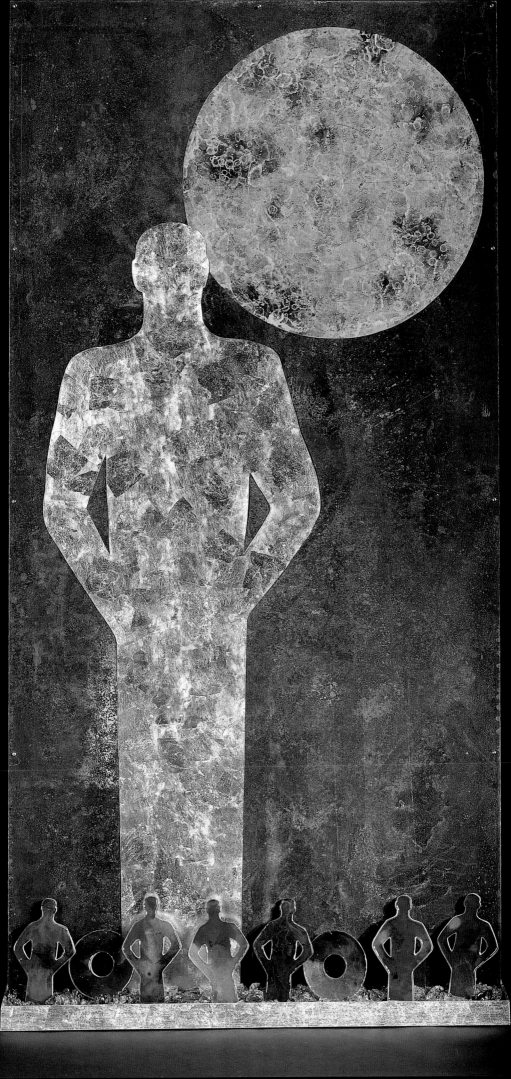

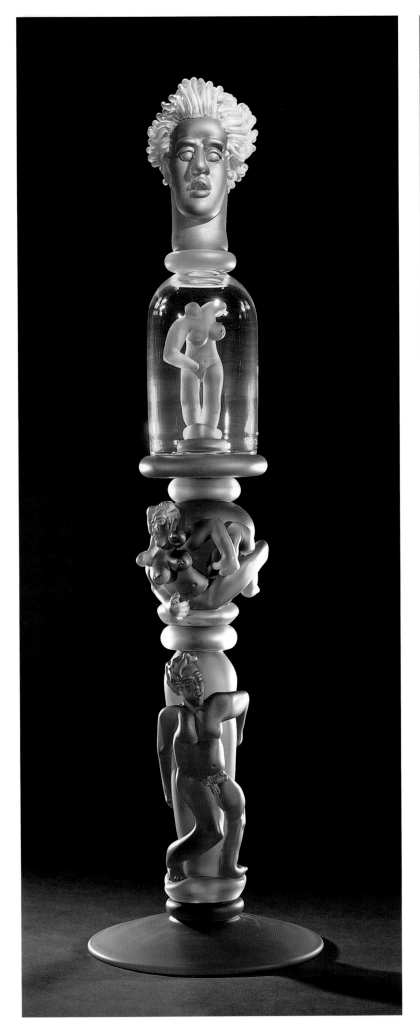

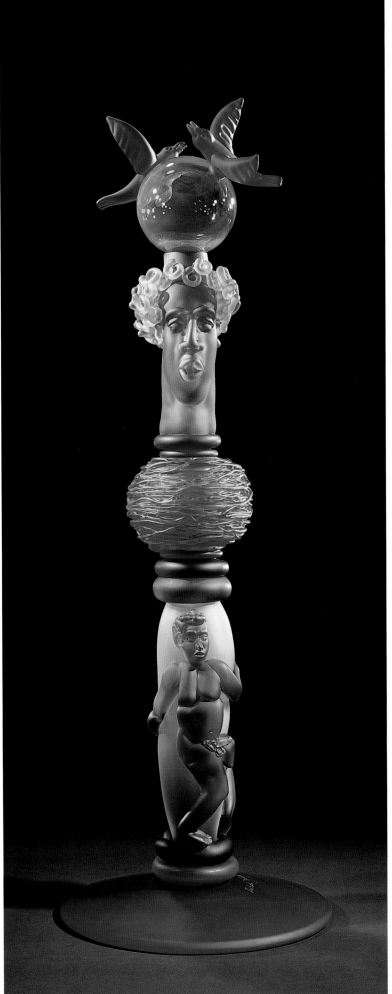

Contemplating Beauty
2000
Blown and hot formed glass, fabricated
and acid etched
H 58 x W 16 ¹/₂ x D 16 ¹/₂ in.
Photo Charles Brooks
Collection Bonnie and Gilbert Schwartz

Sense of Self
2000
Blown and hot formed glass, fabricated
and acid etched
H 51 xW 17 ¹/₂ x D 17 ¹/₂ in.
Photo Charles Brooks
Collection of the Artist

Jolley was in the process of developing at about the same time, the site-specific sculpture incorporates the element of time, embedding atmosphere and associations in glass-inflected forms. But it also acts outside time, creating a sense of the distant past with a ritualistically buried and exhumed figure and then thrusting it into the present, as today's viewer peers into the figure's glass face and sees the most startling image of all – himself.

Jolley, all of whose work deals with humanistic concerns, transcends the advances he makes toward that goal in his "paintings" and "Totems" with the expansive, metaphysical works of his mixed-media series. They vary from the more overt eloquence of *Cairn* and such related pieces as his *Look Within* and *Cerebral Hemisphere,* both made in 1999, to the completely lyrical achievements of *Illusion of Illumination, Lunar Realm* and *Holding Thoughts.*

The most accomplished of these works are the most recent, chief among them the hazy, corrosive *Lunar Shadow* and *In Between Time,* which Jolley completed in 2001. The progression is steadily toward greater simplicity and smaller size, employing the most concentrated energy possible. The allusive, almost narrative expansiveness of *Cairn,* with its glints of aquamarine glass scattered over the gallery area and its familiar, if alarmingly flattened central figure, has been compressed powerfully into the bipolar segments of the slightly later *Holding Thoughts,* both sections upright on the gallery wall, and the fragile, angst-ridden limbo of *Illusion of Illumination.*

With the completion of *Lunar Shadow* and *In Between Time,* Jolley was fully engaged by these curious, mixed-media constructions, and his intention came even more sharply into focus. They provide an interesting exception to the progression evident in his other two main directions, the "paintings" on paper and the roughly contemporary creation of the magnificent, witty "Totems." The "Totems" broad, humorous allusions to Pop culture and Americana themes opened up a new and fertile area of exploration with a rich mix of formal, technical and cultural commentary. As his skills and vision grew more assured and definite, Jolley began the inexorable task of pushing each theme and technical challenge to its limits.

The "Totems" are vertical glass assemblages of prototypical Jolley entities, heads with baseball caps, for example, in the common vernacular. At the same time they serve as inescapable,

humorous allusions to the classical column. These forms gradually grew to maximum height of eight feet, the three-dimensional equivalent of the increasingly monumental "paintings" that also occupied Jolley. In essence, Jolley was continuing to probe indefinite boundaries of mediums whose limits still have not been fully tested.

In *Cairn,* past and present collide overtly. The work's theme of an exhumed man and his formerly sheltering rock piles reasserts a theme that is juxtaposed more bluntly in *Look Within* 1999; here the patinated silhouette of a man is set against a seemingly random bed of rubble and imprisoned in a metal cage bolted at each side as if to underline the impossibility of release. In *Holding Thoughts,* the classical past is once again symbolized, this time by the three golden-glass amphorae that are caged behind metal bars, and locked into the region above a man's impassive face.

The bonds between portrait and the classical allusions of the caged vessels are oblique and multifaceted, yet at the same time clearly stated, in light of the poetic title and placement of the richly associative images. The male head may be taken as modern on one level, but also it surely refers to the age of Constantine and late-Roman sculpture, with its stylized treatment and blank expression. Here we feel the tension of the present, as it struggles with the ideal of the ancient world at the roots of Western Civilization.

Divergent images embodying past and present are more tightly integrated and reaffirmed in the deliberately, effectively ungainly *Holding Thoughts,* in which the heavier, more intrusive elements are mounted over a flat, richly worked portrait. Also indicative of Jolley's rapidly evolving program of joining past and present is his intuitive success in articulating urgent but still disturbingly inchoate ideas and impressions. As an example, the muted luminescence emanating from the three golden-glass vases in *Holding Thoughts* lend an autumnal glow to the strange and mysterious array of objects and containers.

To enhance the effect, that light is picked up and reflected by the silver-leafing Jolley used to build up and define the image, as he does in his "paintings." The man's strong, cleft chin and bold features are also reminiscent of the seminal blue-line drawings of Jolley's first serious glass sculpture, and they continue in softer, vaguer definition in the most recent mixed-media works, veiled to a large extent, however, behind their scratched, etched glass facades. These intriguing combinations of old and new, of history and the

RICHARD JOLLEY 2000

Lunar Shadow
2001
Glass, copper and aluminum
H 32 x W 32 x D 4 in.
Photo Charles Brooks
Collection of the Artist

In Between Time
2001
Glass, copper, gold leaf and aluminum
H 52 ¹/₂ x W 24 ¹/₂ x D 4 in.
Photo Charles Brooks
Collection of the Artist

living moment further enlarge on the notion of time's passage and its corrosive impact on mortal flesh.

However, Jolley's concern is not in eroding flesh or human frailty. In the artist's most recent visual statements, the new sculptural assemblages, he celebrates both flesh and spirit, the human cipher and abstraction, and the full range of enduring qualities that underlie all his varied expressive efforts. The forms are irreducible in *Illusion of Illumination* and *Lunar Coexistence*, both from 2000, and in *Veiled* of 1999. The proud, typically erect male subject is shown in silhouette against a radiant disc, posed either beside it or over it, thereby suggesting the image of the man on the moon. The images capture the romantic aspects of a poetic dream and, conversely, the bedazzled lunatic.

The interplay of disparate images support either reading of the work, and they invite the viewer to revel in the sheer luxuriousness of a silver-leafed backdrop that, paradoxically, has been repeatedly, obsessively over-painted and varnished to obscure its linear crispness of definition, and thus hints at the weathering effects of time.

The disc that appears large, round and bright in *Illusion of Illumination* shrinks to a remote orb in *Lunar Coexistence* and, in a further and more subconscious transmutation, seems to radiate from the generalized human form in *Veiled*. Here it summons up memories of the golden aura or mandala, the almond-shaped full-body halo adopted by the Byzantines for their glorious mosaics and book illuminations.

In 2000, Jolley also explored a related combination of images in a number of new mixed-media pieces, setting aside for the moment his work on glass sculpture. In *Idea Amphora* and *Power to Imagine* Jolley used identical formats – the profile of his seated Everyman, shown from head to waist, with an immense moon-disc in the background and a floating cluster of classical vessels in the foreground – but varied the effects of color palette and size.

The man's profile is firm and crisply delineated in the smaller work, *Idea Amphora*, and its encrusted, patinated surface contrasts strongly with the wine-red background and shimmering, impasted golden moon that looks like a cutout. The gilded vessels in the foreground – the amphora, pitcher, small bowls or circular forms whose purpose is a mystery – are metaphysical notes, as light as air. They drift untethered along the picture plane, hinting at a surrealistic existence, appar-

ent only in the imagination, or, perhaps, as random ghosts of vanished antiquity.

The weightless amphora, pitcher and bowls in the larger and more three-dimensional *Power to Imagine* just as surely contribute to the otherworldliness of the images. The forms are a gleaming, polished black in the larger work, however, and the patination of the man's silhouette appears to be a paler shade of the weathered-green bronze suggested by *Idea Amphora*. The background has faded to a lighter, less emphatic variant of the rich burgundy in *Idea Amphora*, and the moon disc retains its burnished-gold tones.

Yet that lunar form also appears wan and spent, as much an apparition as the mottled gray-green human figure and the smoky survivors of Pompeii or Herculaneum; the vessels. In addition, to contribute to the softening of hue, saturation, shadow and shape that make *Power to Imagine* as much a half-remembered dream as an evocation of a mood, Jolley set the cluster of images in a four-inch-deep shadowbox and closed it off with a scratched, acid-etched sheet of glass, one that frustrates the viewer's natural desire to make sense of what he sees.

The sense of frustration inherent in Jolley's metaphysical mix of forms and materials operates in a way that is impossible in the more obviously sculptural and readily appreciated "Totems" or in the shimmering, enamel-like "paintings" on paper. Only Jolley's cross-over triumph, the synthesis of experiments in a discrete number of different, if related, directions over the past three decades can literally wall off and thus "veil" his vocabulary of symbols and images, giving them a broodingly elusive, provocative presence that makes them so gripping and powerful.

The group of glass-and-stone forms that made up *Cairn* rapidly evolved into the more compact juxtapositions of man against a space that suggests infinite distances. These multiple styles, with their complex associations, support Jolley's variable thesis, incorporating, as they mutated, a well-defined formal repertory. The range of expression includes the cages and their antitheses, fragile bubbles of glass rendered as spheres or made in classical shapes; incised stones inlaid with gelatinous washes of frozen glass; the ancient, eroded face of the moon; and, finally, the simplest of human marks – the circle and the X.

With these daring new explorations, Jolley created a handful of forms that rival his most vibrant "Totems" or his most enigmatic, large-scaled, layered "painting," and explore the mys-

Range of Sight III
2001
Monotype
H 22 x W 30 in.
Charles Brooks
Collection of the Artist

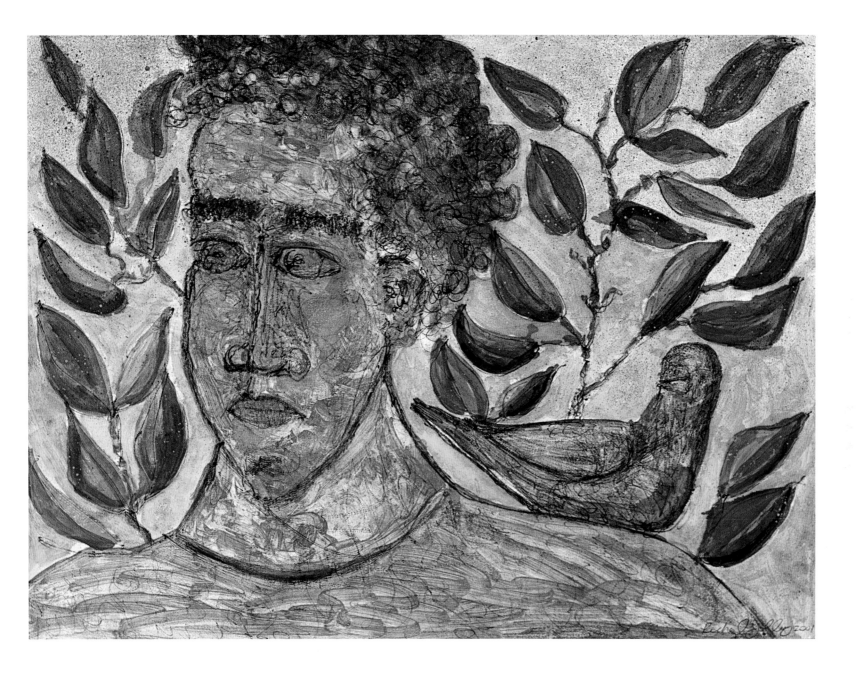

Dual Nature
2001
Glass
H 12 $^3/_4$ x W 11 $^1/_2$ x D 4 $^3/_4$ in.
Photo Charles Brooks
Collection of the Artist

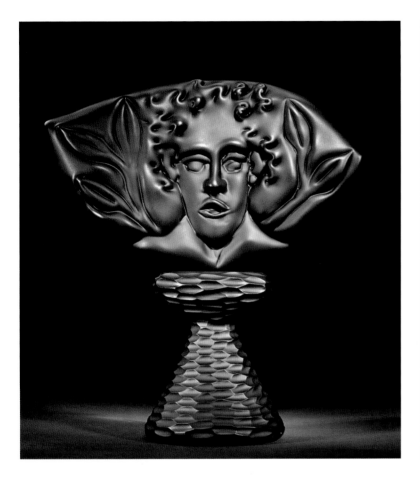
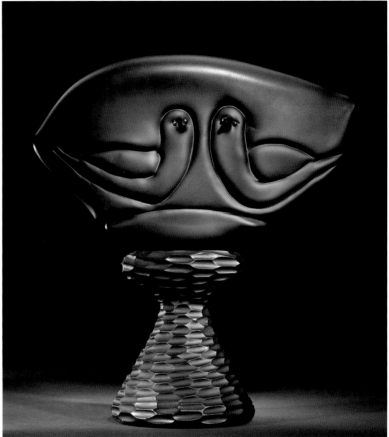

tery of existence. Like someone looking out the window of a lighted room into the pitch darkness of primal night, the generalized figure in a key work of 1999, *Cerebral Hemisphere,* expresses the universal human yearning to find an answer to the ultimate questions which Paul Gauguin posed in his masterpiece, *Qui Sommes Nous? D'ou Venons Nous? Ou Allons Nous?*, or "Who are we? Where do we come from? Where do we go?"

Silhouetted against an encrusted golden backdrop, one that inevitably suggests the glass tesserae of mosaics in Ravenna and the great Byzantine cathedrals, the figure is a blank, an empty shadow that could be anyone: Everyman. His body, though flat, seems composed of a blue-green material that is reminiscent of Jolley's *Cairn* glass, as well as the eroding patina of the figures in *Power to Imagine* and *Lunar Coexistence.*

Framed by the square of his "window," the figure might be facing outward, or he might be perceived to have his back to the picture plane, and thus to the viewer. Whether he is fascinated by the spangled outer frame, the endless vista of gilded pinpoint stars against a velvety blue background which brings to mind the cosmos captured in Joseph Cornell's boxes, icons of mid-century surrealism, or is absolutely unaware of or indifferent to his surroundings, the figure gives no indication of any emotion at all.

It is left to the viewer to put the pieces together, to assemble an intimate and cohesive world-view from contiguous, intensely conjoined scraps that are fragments of the silently, mysteriously moving universe Jolley evokes. Among them are the simple silhouette; densely layered washes of varnish over silver leaf on a flat surface; and the cobalt backdrop pierced by countless metallic silver-painted concave dots to suggest myriad constellations.

Cerebral Hemisphere is, quite literally and also figuratively, a stellar accomplishment, one that synthesizes a considerable number of works, techniques, and above all, the very processes of thought. If this elegant, deceptively simple work seems to have sprung inevitably from a profound urge to create order from chaos, to decipher one's own thoughts, images, and ideas and to then make sense of them before transforming them into novel visual form and offering them as art, that is in fact the perceived outcome.

Jolley also realized that each divergent area of interest had a common thread, and could become part of a fully integrated personal vision. There appears to be no fire, no actual dance in the cool-er, more metaphysical series; Jolley achieved a fine balance between idea and form, concept and execution when he created his most refined mixed-media works of 2001.

"My glass does have a private side. Working in glass requires such choreographed motion that it's difficult to keep the individual concept uppermost," Jolley said. "So I am interested in multiple materials, in the ways certain materials can be articulated, and very much in the gap between impulse and object, between the public and the private.

"Glass is the perfect modern material for sculpture. It can have such transparency, translucency or opacity, such an ability to dematerialize, and it's a very sensual material. But I also like working with acrylics, silver leaf and varnish, on the 'paintings' I make on paper. I like working with all those materials, and I liked combining them in the mixed-material series. You try to push the envelope, to transcend the materials."

That is precisely what Jolley achieved with the remarkable outpouring of works he made during a four-year period, drawing on all of his most vital, experimental powers in full maturity. As he had done with each of his series of glass sculptures, he began small and "simple" and then moved on to greater size, scale, intricacy and complexity in the mixed-material series.

But even as he mastered each step, each stage on his bold, experimental path to new combinations of familiar images and materials, Jolley compressed and focused his concepts in the free-wheeling series, allowing them to achieve their own tense forcefulness. The refining process is nowhere more evident than in *Lunar Shadow* and *In Between Time,* recent works that encompass vast expanses – both micro- and macroscopic – but manage to confine them in the most taut and clearly articulated structure imaginable.

In Between Time features the silhouette of a raven hovering above a large golden disc, its stark, stern black imprint softened by the cloudy effects of scratching and acid-etching on the inside of the plate glass covering the work's narrow shadowbox. At the base of the disc, as if to anchor it, is the looming head of a man. As in *Cerebral Hemisphere,* the viewer sees only the head and shoulders of the figure; here, too, one can't know if the figure faces inward, outward or anywhere at all. Jolley presents us with merely an essential human outline, unidentifiable as to gender, age, ethnicity, emotion or any other conventional marker. Yet the figure's rich surface, given an even

greater sense of texture by the random erosions and hazing of the glass covering the frame, begs for engagement. It commands the eye to trace its every nuance and try to make sense of what its fleeting effects of light and shadow might mean.

The same process and result apply to the bird image and the luminous disc, both of which seem vague because of the viewer's inability to see clearly into the space Jolley carved, shaped and left open to random atmospheric effects. In much the same way, Robert Rauschenberg made his blank white paintings "airports for light," as his friend, the vanguard composer John Cage, later observed. The shaded background in Jolley's piece is a neutral-toned crackled surface that appears to be crumbling plaster, about to expose more ancient and eroded graffiti or masonry. Its unstable appearance heightens the work's inherent anxiety. In age-weakened state, *In Between Time* seems to teeter between ages: the barely seen, but intensely felt present, and the lurking, ominously invisible past.

Still more ominous and powerfully evocative is the repressed emotion conveyed by *Lunar Shadow*, a mixed-media piece that reveals a cloudy orb drifting just off-center as a bloody fireball. The familiar human silhouette occupies the left foreground of the flattened composition, this time tinted a mottled red-gray, and is either facing the immense, blazing orb or turning his back on it. The work is pure, serene, and utterly formal. Despite familiar forms in a combination so simple it seems at first glance almost bare, there initially is no specific content to be gleaned from *Lunar Shadow*, no sense of feeling or content.

But in due course its essential nature asserts itself, along with luscious textures and powerful thematic implications: Jolley gives his viewer a solitary figure, quintessentially human, and gives that Everyman a particular resonance and context. He exists, whether by day or night, and he embodies the human condition in his stark, existential situation: face to face (or back to back) with the forces of nature, vast, glorious and forever indifferent to the image and impact of mankind.

Mature Works – The Totem Series

Although Jolley's explorations into two-dimensional and mixed-media statements succeeded in expressing concepts central to his enduring and fundamental interests, it was only in the mid-nineties, with his series of compound totemic sculptures, that he found a fully articulate voice. That series of mature works, which culminated with such eloquent assemblages as *Sense of Self* and *Contemplating Beauty*, both from 2000, drew elements from the sequence of vividly articulate figurative sculptures that began with Jolley's blue-line drawings and, literally, built upon them.

If those blue-line drawings were as simple as Jolley could make them, the massive and robust "Totems" are statements that have achieved maximum volume and complexity, as well as a distinctive vernacular ease and expressiveness. In *Contemplating Beauty*, the translucent golden-red bust that rises above a vertical series of twisting, writhing, posing figures appears stunned by all the activity below his neck. It's as if the various coherent images described in each segment of the columnar arrangement of individual sculptures have taken the place of his body and made pointed allusive statements that both explain the head's predicament and poke fun at it.

As the lyrical title suggests, the theme in *Contemplating Beauty* is one involving a conscious awareness of the female figure, one whose roots stretch from classical antiquity to Ingres' Odalisques and on into the twentieth century with Matisse's languid, luxurious nudes. From the classicizing headless torso encased in a bell jar to the reclining nude who seems to struggle to free herself from a tangle of bent, intertwined, sensuously elastic arms, thighs, knees, and legs, Jolley's work is fully animated. At the base of the compound sculpture, in hues just as vivid as those that sprout from the swollen column to which he clings, is a full, slightly flabby male nude, staggering resentfully beneath the psychic – and, surely, physical – baggage overhead.

That baggage is, indeed, a daunting burden – and one that recapitulates in visual shorthand the history of figurative ideals. The overwhelmed male at the sculpture's base is rendered in a cobalt blue that is the solid equivalent of the sketchy blue lines on the amorphous face of *Faun*, with their overtones of the night sky. His supporting column is a watery turquoise transformed into a velvety haze by Jolley's surface treatment, a smooth acid-etching. Like an Atlas in the act of lifting and supporting Earth, the base figure seems to stumble, allowing his muscles to slacken and the nudity that would be noble in a classical work to slip for a moment from godlike to merely human.

The figure is bearing, after all, not only the

Metamorphosis
2001
Glass
H 14 $\frac{1}{2}$ x W 11 x D 2 $\frac{3}{4}$ in.
Photo Richard Jolley
Collection of the Artist

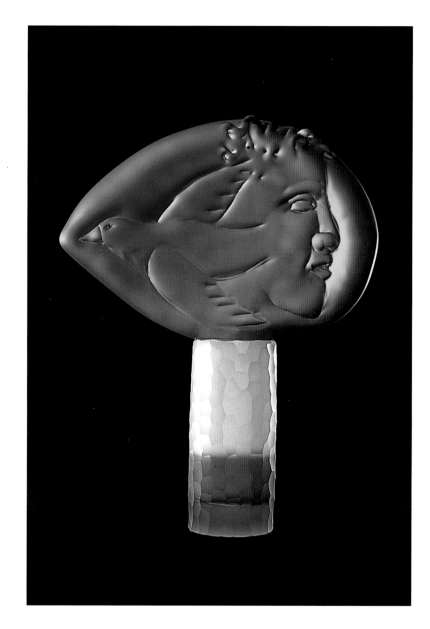

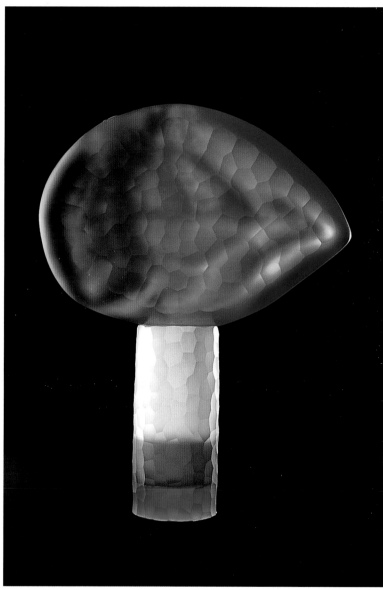

Brothers
2001
Glass
H 13 ¹/₂ x W 10 x D 3 ¹/₄ in.
Photo Richard Jolley
Collection Elton John

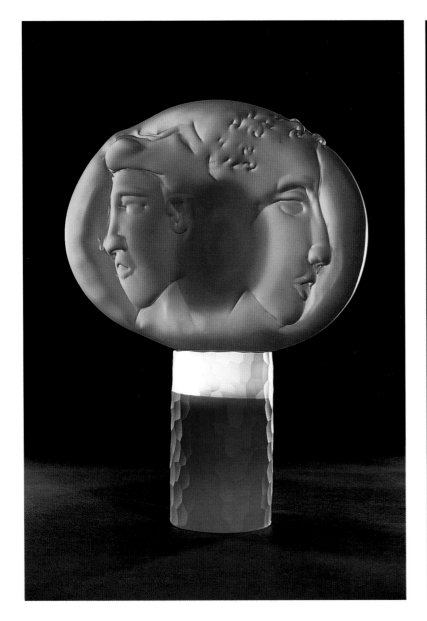
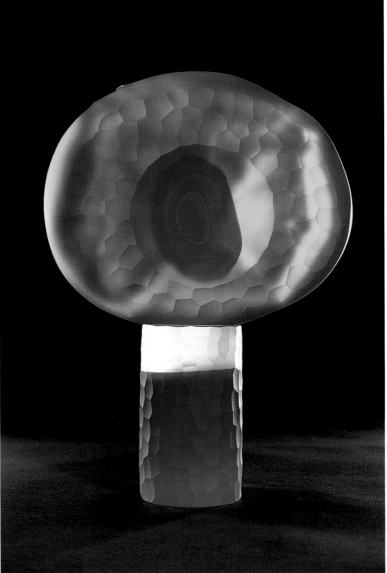

weight of history but also all its varied notions, implications, and expectations of beauty. And Jolley, in a marvelously jocular vein, reveals them – in some disarray, more than a little touched by mundane reality. Above the head of worried Atlas is a reclining river goddess, a contemporary translucent cousin of the Parthenon sculptures in the British Museum. Jolley's figure, however, isn't cool marble, frozen into fragmentary classical perfection; she is a Rococo odalisque, all tactile surface etching, with entreatingly, engagingly intertwining limbs that balance her swinging curls and full breasts as she frolics on pillowy blue waves or tumbles rather lasciviously on a cloud.

The same broadly humorous, self-deprecating wit enlivens the fragment above the reclining nude, this one a pneumatic take on the famous armless, headless Aphrodite that set the standard for Western art. Still, even though Jolley's nude has been preserved as a specimen in an airless gold-glass dome, her exuberant bounciness hasn't been snuffed. This Venus is a Golem that seems only momentarily frozen in place, ready at any time to finish a gesture that resembles a sporty and carefree dance motion. Above her, the male's face expressing a sense of shock at what appears to be his weird transmutation from merely a standing male to the pure embodiment of eternal desire, is the vibrantly animated bust, a superlative blend of dignified humanistic realism and virtuosity in glass.

The head alone, with its exquisite articulation of fine hot-worked features and the waving tendrils of exaggerated springy hair, underlines Jolley's early days in glass, with their casual reference to the *ad hoc* "hot bits" technique. It also persuades us of his mastery of his material and, more significant, his ability to both "reinvent the industrial revolution" in his studio, and then to "transcend the medium." The bust, alone or juxtaposed with other typical elements, is a form that Jolley has explored continually since the eighties, and it is one whose variations and implications he has not yet exhausted. Blue-line drawings like *Faun*, the most direct interpretation of his human portraits in glass, and his assertion of sculptural surface and contour evolved rapidly into the more emphatically sculptural monochromatic busts five years later.

Maxilla, a stern life-sized portrait in glass so dark and opaque that it appears to be carved from basalt or black marble, was nonetheless modeled by Jolley in 1990. He used a deep amethyst-hued glass, shaping the basic head-and-neck of *Maxilla* from the malleable mass before beginning the delicate, if also muscular task of pulling the warped, wound-

ed features from a surface that was reheated in spots when it cooled, a process that was repeated dozens of times before Jolley achieved his goal. While certainly glass, the piece is also just as surely sculpture, retaining the artist's touch and focusing attention on its solid, three-dimensional qualities; Jolley eliminated the line that in the "drawings" of the mid-eighties emphasized the work's surface, delineating details instead with formal massing, working the material, and adding external elements.

The transition represented by *Maxilla* paved the way for Jolley's further exploration into the sculptural bust, as well as into the depiction of the identical humanistic Everyman in *Straight Ahead* and other monoprints and paintings on paper of the mid-nineties. Their variety seems endless, as do their positions and attitudes, surface finishes, degree of clarity and colors. The sleekly polished glass surface that characterized *Maxilla* was translated into bronze in works like *Crescent* or *Flat Top*, sculptures from 1993 that were cast in staggered sizes that increased by a factor of four to achieve monumental scale.

The bust also changed into a female version, adorned with an elaborate floral garland in the glass sculpture *Beatific* 1993. The bust form gained a swaggering character that year as an Elvis-inspired country boy or punk character, the golden-glass *Ruddy*, whose absurdly upswept pompadour is the result of an amazingly adept and amusing application of exaggerated tube-like additive strands of glass "hair." And, typically, as Jolley worked and reworked the initially simple concept of a sculptural bust, the form evolved and took on a life of its own.

During his form's extended and ongoing evolution, the desire uppermost in Jolley's mind was to model and manipulate hot glass as directly as a sculptor would work in clay or stone, and also to leave on it his particular mark. This would both represent his individual presence and also suggest a collective human touch. He gave *Ruddy* an acid-etched surface that resembles a velvety "skin," and it also expresses his character in colors as brightly allusive as the sky, or the robin's egg-blue chroma of the lyrical *Beatific*. It also has a crystalline quality found in the sheer surfaces of *Same Skin, Different Color*, two figures created in 1994.

This pair of sculptures reflects stereotypical, popular expectations of class and race cleverly expressed in the distorted and exaggerated human forms. One clear-glass hollow bust is filled with a grainy white substance, while the other contains

Floating Blue
2002
Glass
H 14 x W 16 x D 4 $\frac{1}{2}$ in.
Photo Charles Brooks
Collection of the Artist

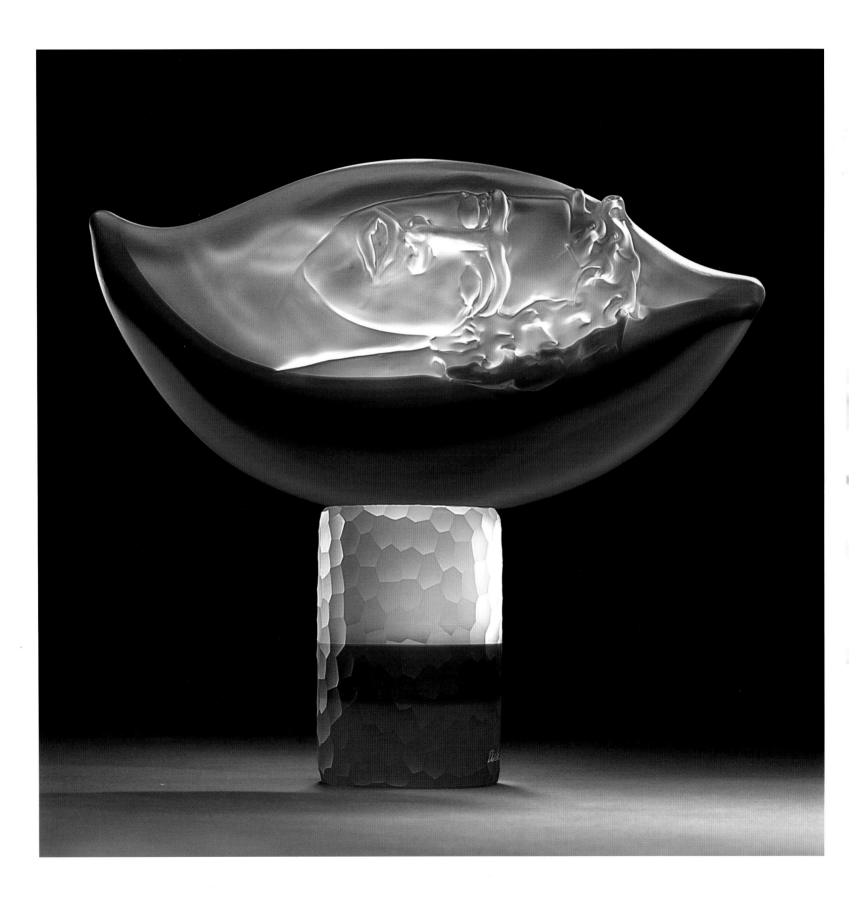

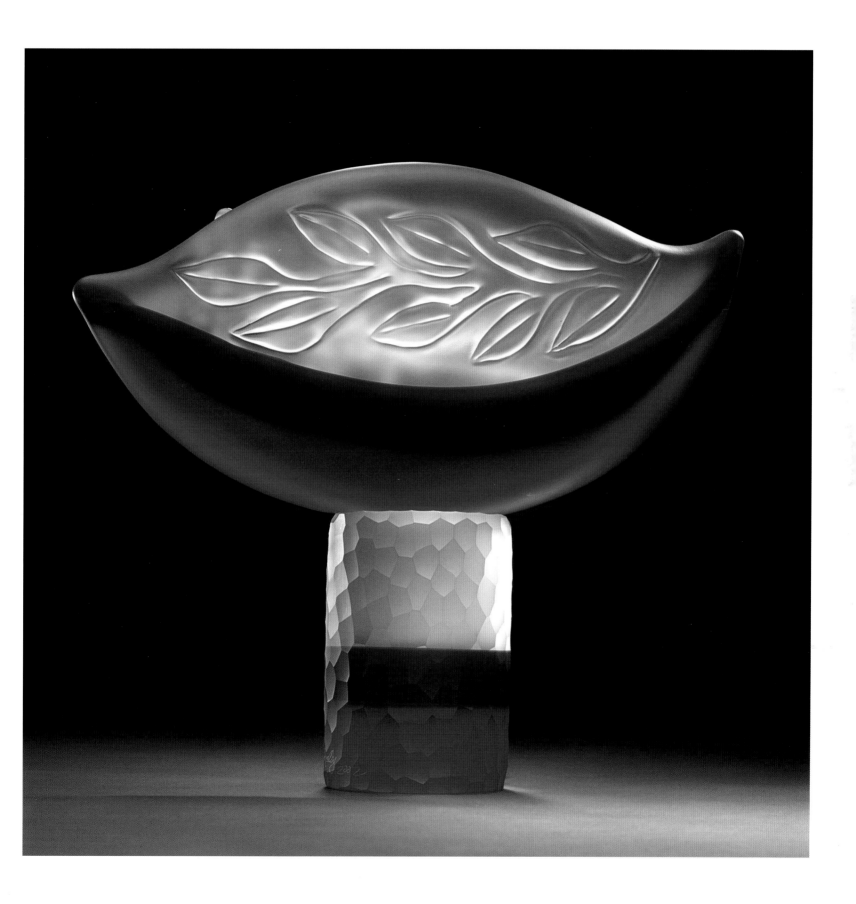

a granular black material. The message is as visible as the skillfully modeled glass, quite literally emphasizing racial differences that are merely skin-deep. Its terms, however, are as broadly good-natured and folksy as the commonplace objects the sculptures suggest: an oversized salt and pepper set, whose fundamental contents add taste and variety to life just as do multicultural or multi-racial experiences.

By the mid-nineties, Jolley's ability to express complex concepts in single figures, or in a grouping of figures whose roots lie in the blue-line drawings was assured. He had stacked five heads into a totem, *Listening Post*, by 1994; each of the heads is in a different color and they gradually diminish in size, with the largest rooted on a wide, flat disc-like base. Each head has large, projecting ears, features distorted to suggest intense concentration, and areas that are broadly treated, slightly bulging and flattened portions of the acid-etched face rather than eyes. The colors of the heads range from the light, luminous green of the largest to the airy, sky-blue of the head at the top of the totem which stands just over five feet high. It is an arresting compound image, simple in concept and execution but both sobering in its intimations of paranoia and pointed in its references to a listening post's natural denizens – gossips, empty-headed busybodies, people without depth – much like the transparent glass medium that forms Jolley's twisted, pastel-toned busts.

The formal concept and social message are similar to those underlying other "Totems," and they were both ideally suited to Jolley's non-traditional but starkly contemporary medium. He used glass to great advantage in another piece from 1994, the smaller *Simple Bond*. Just under three feet in height, the sculpture separated its two main elements – pale green glass head and dark green hound – with unadorned columnar forms that underline their crucial autonomy. The man's head, twisted as if by the intensity of his inner life, rests on a blue pedestal; above him, perched on a series of stacked discs that resemble flattened cushions, is the dog, tail at attention and ears thrown back from his head, contrasting with his alert, but static expression.

The link between the dog and his human companion, emphasized by the title, is an honorable and old tie, especially in a rural South that values hunting dogs highly. The dog has symbolized a bond with his master since distant antiquity, hence the classic canine name, Fido. The animal in combination with the oversized "gimme" or baseball cap worn by the man adds to the vernacular so wittily conveyed by Jolley. Here, Everyman and his faithful dog companion belong together quite naturally in our time, and each is perceived as a genuine and indispensable part of a team.

If man and dog are a natural, persistent team in *Simple Bond*, fused as solidly by southern or folk tradition as they are by Jolley's grinding and gluing at their joints, so are the more conventional forms that dominate his 1994 *Tour de Femmes* series. The nude torsos piled one atop the other, separated here by a shallow platter-like base or a blue-glass globe that suggests both Earth and atmosphere, are the opposite of the feckless country boy featured in *Simple Bond*. The work's five nudes, stacked in descending size to top out at more than six-and-a-half feet, are without faces – indeed, they are without arms, legs below the knees, here tightly pressed together, and even without any shoulders.

Like the *Venus of Willendorf*, that iconic Neolithic fertility fetish, the nudes cavorting on the "tower of women" are all fecundity and lust, with no individuality, no rationality, no ability or will to fend for themselves. They are the eternal ideal and target of the hunter in *Simple Bond*, their tumescent and generalized vessel forms as translucent and ethereal as the blue bubble that surmounts the columnar "tower" the nudes so literally embody. At the same time, Jolley infused the works of his *Tour de Femmes* series with a gentle humor and a feminist strength that transform them from pithy cultural commentary into an iconic composition asserting the folly of sexual stereotyping while at the same time innocently reveling in its endless, joyous allure. The female forms, like their columnar format, reflect what Jolley sees as woman's role in evolution: its backbone, the civilizing structure that lifts the other half of humanity from its "bestial" roots.

As the "Totems" proliferated, allowing Jolley to explore their potential on levels as varied as color, translucency and surface treatment, they also paved the way to an endless range of objects in combinations that could elicit multiple interpretations. Interestingly, while the techniques required to produce each element in the compound sculpture were demanding, Jolley's emphasis in the marvelously mature work that began to appear as "Totems" during the early nineties was firmly on the object itself, as pure sculpture.

The seamless blend of glossy white column, pink head, green head, sphere and birds randomly perched on the figures in *Paths of Flight* of 1994

Luminary
2002
Paper, paint, varnish and silver leaf
H 42 1/4 x W 42 in.
Photo Charles Brooks
Collection of the Artist

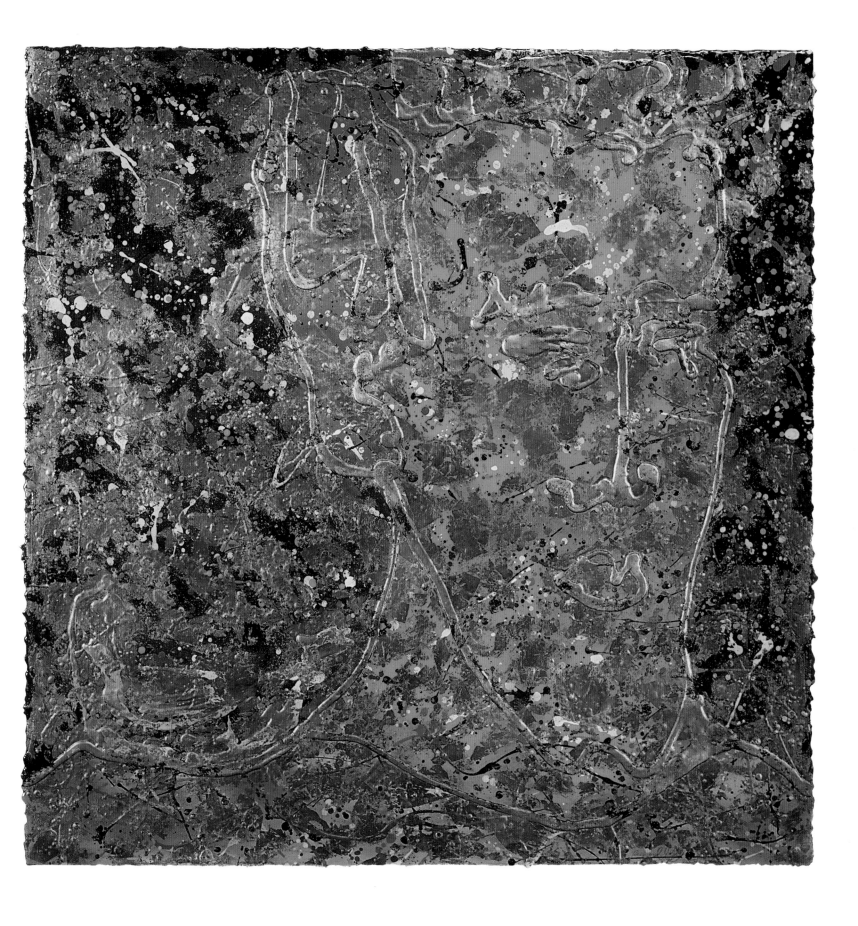

– as in the more complex works Both *Sides* and *Avian Dreams*, both from 1996 – acted as a unified statement, a formal composition whose essence was far greater than the sum of its parts. By the end of the nineties, as the series was reaching its peak and, simultaneously, giving way to new, more fertile areas of exploration for Jolley, the "Totems" resolved the tensions that underlie the artist's body of work, synthesizing divergent elements and allowing him to achieve his goal of "transcending the material."

Color, form, light and texture flow spontaneously up, down, around and beyond the slim glass elements in *Sense of Self* 2000, a sculpture that reprises the staggering Atlas from *Contemplating Beauty* and presents him as a rather sullen, startled figure who has been forced to scramble to support himself against a bulging acid-yellow column. Above him, separated by a luminous band of ruby-red glass, is a blue globe wrapped in atmospheric bands that resemble twine rolled into a ball or, more appropriately, wind, clouds, and weather streams over the face of the Earth. The globe supports a peculiar figure, the head of an orange-gold man whose expression of annoyed perplexity – possibly because he wears a crystalline orb around which two birds, each as vibrant as living, gracefully flying rubies, appear to hover and, fleetingly, come to rest.

The "Totems," maturing rapidly from the unadorned forms of stacked nude torsos or heads of men in worn, down-home baseball caps to such sublimely transcendent compound statements as *Sense of Self* and *Contemplating Beauty*, represent a remarkable stage in Jolley's career. Rich, full and masterfully poised between high seriousness and an entirely American, contemporary jocularity, they express in firm, vibrant form the complete, profoundly satisfying synthesis of a strong individual voice, an unconventional and thoroughly demanding medium and the spirit of a pivotal moment in history, at the turn of the millennium.

Towards The Future

In his latest series, Richard Jolley again has cleared the decks and returned to his simplest ideas and his most restrained imagery. The earliest of his *Tabula Rasa* series looked back to the seminal crystalline blue-line drawings for their figurative, translucent three-dimensionality but also ahead, beyond the compound articulation that made his "Totem" series so eloquent and his mixed-material assemblages so expansive and inclusive.

Tabulae Rasae – literally, "blank slates," although the Latin origins of their title factor in subliminally the element of antiquity that pervades Jolley's *oeuvre* – embed in glass lozenges the faces that rose above muscular torsos or formed key elements of the "Totems." And those faces – close relatives of such emotion-wracked antecedents as the one dominating Jolley's *Remembering the Night* 1996 – are flatter and more serene, in keeping with their placement on glass slabs that resemble weathered fragments of funerary sculpture from a distant past, perhaps Grecian, with overtones of lyricism.

And, indeed, more than any of the series that sprang from Jolley's fertile hand and mind, the *Tabulae Rasae* appear to be traditionally sculptural, to have been carved from a soft, malleable marble made more interesting by the presence of veining and luminous color. That's most evident in *Dual Nature*, the 2001 work made from a glass so dark that it appears to be opaque basalt and to lack luminosity. Its face, too, is an exceptionally crisp example of the genre, with its prominent unseeing eyes, classical features, dispassionate expression and surrounding crown or leafy garland whose lozenge-shaped form echoes that of Jolley's bas-relief sculpture.

Two birds, their generalized forms reminiscent of both Picasso's modernist doves and classical sacrificial animals, eroded to stark simplicity, appear on the reverse side of the somberly monochromatic piece, reinforcing its links to antique funerary forms. And, in a gesture whose restraint reflects that of the work's antique style as a whole, Jolley sets the two-sided composition on its own pedestal, a pyramidal form rising to a table-like disc that has been nicked repeatedly to suggest hammered metal. Both the wheel-ground, cold-worked pedestal and lozenge relief – whose sides took shape during a ritual dance between the artist and the blazing furnace where its surface was heated repeatedly – are in dusty-gray tonalities. They emphasize the sculptural play of light and shadow over the image rather than the radiant, luminous colored glass, and the confusion of bleed-through images it not only permits but encourages.

It's precisely that interplay of light and color, of luminosity and overlapping form that is Jolley's concern in other works of the new series. Unlike the overtly sculptural *Dual Nature* or the relaxed, Pop-influenced pieces from the robust "Totem" series which drew the eye to the works' contours and surface imagery, the smaller, more intense and vivid *Tabulae Rasae* act as brilliant, fleeting haiku, as

whispered impressions that blaze briefly into an eye-popping existence before melting away.

Two faces that appear joined in the back look in opposite directions on the flattened oval of *Brothers*, a lollipop-like study whose buttery yellow intensifies to a startling blood-red at the center. The same hot hue simmers in the columnar base that, unsettlingly, resembles a drinking glass full almost to the brim, and the blurred forms of the two men can be seen from the work's reverse side, into which countless miniscule marks have been cut on the grinding wheel.

Each *Tabula Rasa* invites the viewer to reflect on some aspect of the humanism that has always informed Jolley's work. The conjoined brothers could hardly be more different from one another, despite their blood ties, and the tranquil, Archaic-influenced features on the slumbering figure of *Floating Blue* express a dream-like weightlessness. The various strands that Jolley explored in earlier series take on new, more evanescent and wistful tones in the concentrated flash-points that are his *Tabulae Rasae*. It's as if he wipes his slate clear and begins weaving his continuing story of man – especially his Everyman – as the measure of all things with a familiar, but freshly inflected language.

Yet the language of the *Tabulae Rasae*, powerful despite the works' shorthand notation, retains Jolley's characteristic vocabulary. It's all here: his concern for the telling gesture – which he sustains throughout the long and labor-intensive process of marking molten glass with his spontaneous touch – and his delight in visceral, serendipitous effects of translucency, color, contour, and form. In addition, compressed into a fresh, open-ended compositional format, the series stands with the metaphysical mixed-media works in vivid contrast to the Pop-tinged vernacular jocularity that gave such "Totems" as the 1994 *Same Skin, Different Color* and the 1996 *Dog Time in Real Time World* such a distinctive voice, at once eloquent and broadly witty.

The strong-featured male figure silhouetted in *Idea Amphora* and elsewhere may well be taken as a stereotypical self-portrait, and yet we cannot be sure. The haunting image has an air of mystery, irony and ambiguity that is central to the piquant postmodernist quality underlying and animating all of Jolley's work. He clearly is an artist with a sharp, singular vision and focus. But he has expressed his ongoing fascination for what the word "humanism" can only roughly approximate in a variety of mediums, and in a constantly evolving series of overlapping, closely related gestures and approaches.

His monumental "Totems," sequential statements juxtaposed vertically as if to emphasize an ascending or descending visual hierarchy while giving each equal emphasis, revel in their diverse tones, textures, sizes and scales. Jolley creates "paintings" on paper by applying translucent layers of varnish to a vibrantly colored image that, in turn, is buried beneath a thin surface application of shimmering, opaque silver leaf. The process of accretion is painstaking, though open to accidents such as a shift in humidity that causes "crawling" in the varnish. And, as it progresses, Jolley's methodical process transforms his original painterly impulse into an artifact as complexly layered and evocative as any object or wall painting excavated at Pompeii, and equally intriguing and mysterious.

Shadows, reflections, encrusted meanings and hidden, long-lost human features abound in the multifaceted works that have emerged from Jolley's constantly expanding studio, set in the Tennessee countryside, in the Smoky mountains. Jolley celebrates his Modernist ethos and his adherence to the figure in a medium whose vast potential as a modern material for expressing not only form but also the metaphysical overtones it permits. His career has been marked by a steady, if not always linear, progression. Jolley reduced his elements to the most basic at the start of each new body of work, then gradually increased individual works in size, complexity and range of allusion as he developed his initial concept.

Jolley's unique tendency to elaborate, to expand, to push his material to its limits as he explored the visual implications of the concepts that underlay each productive series has been a constant. His variable methods and tireless invention give fresh definition to an organic process that flowed spontaneously from Jolley's very first introduction to glass as a viable material for the modernist sculptor. The all-embracing, no-holds-barred experimentation of his early, free-wheeling days in his first hot shop experience provided the informal, intensely creative launching pad for a career that has now spanned a quarter century and still remains fresh and always compelling.

[1] Unless otherwise noted, all of Richard Jolley's statements are from interviews with the author in his Knoxville, Tennessee studio in July and November 2001 and in New York City in December 2001.
[2] Cited in George Savage, *Glass*, (G.P. Putnam's Sons, N.Y., 1965, p. 97.

Works

Reclining Female
1989
Solid hot formed glass, direct drawing,
etched
H 5 x W 13 $\frac{1}{2}$ x D 8 in.
Photo Charles Brooks
Collection Ann and Steve Bailey

Sleeping Male
1990
Solid hot formed glass, direct drawing,
etched
H 16 $\frac{1}{4}$ x W 9 $\frac{1}{2}$ x D 4 in.
Photo Charles Brooks
Collection of the Artist

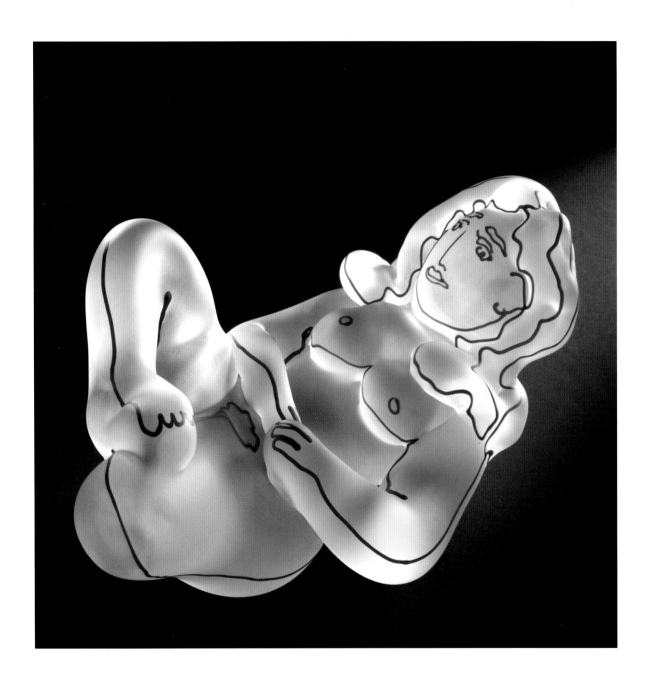

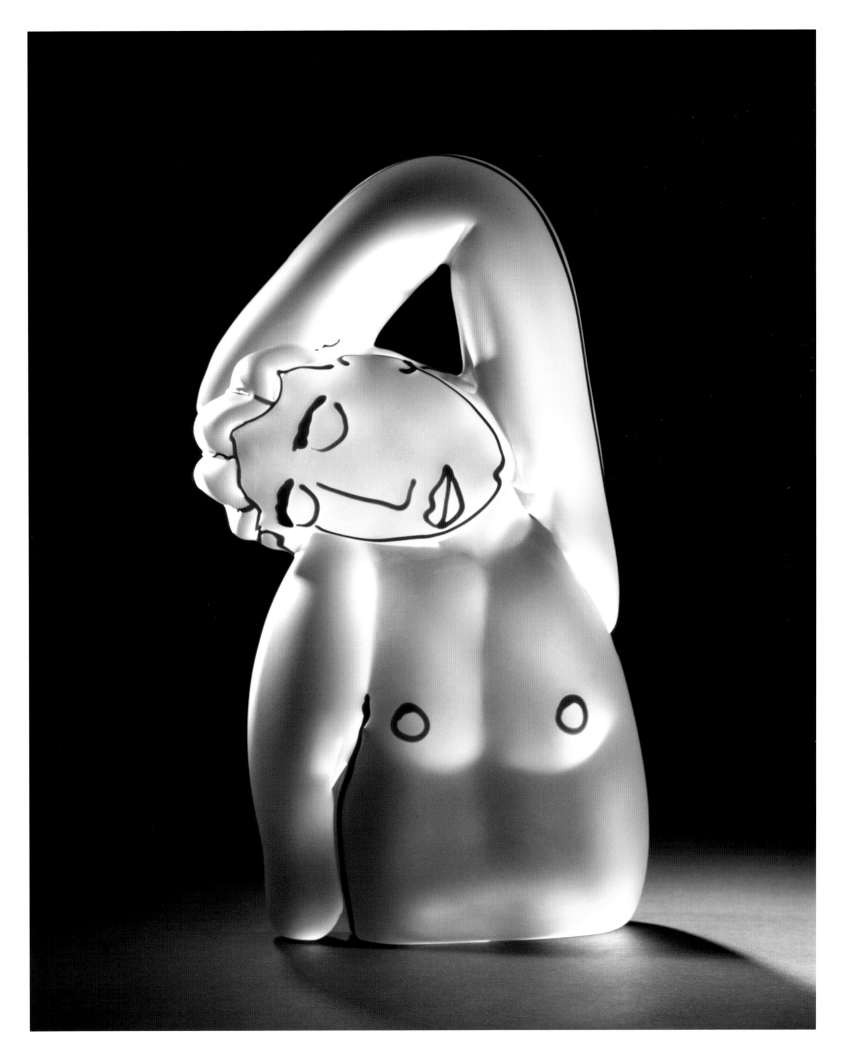

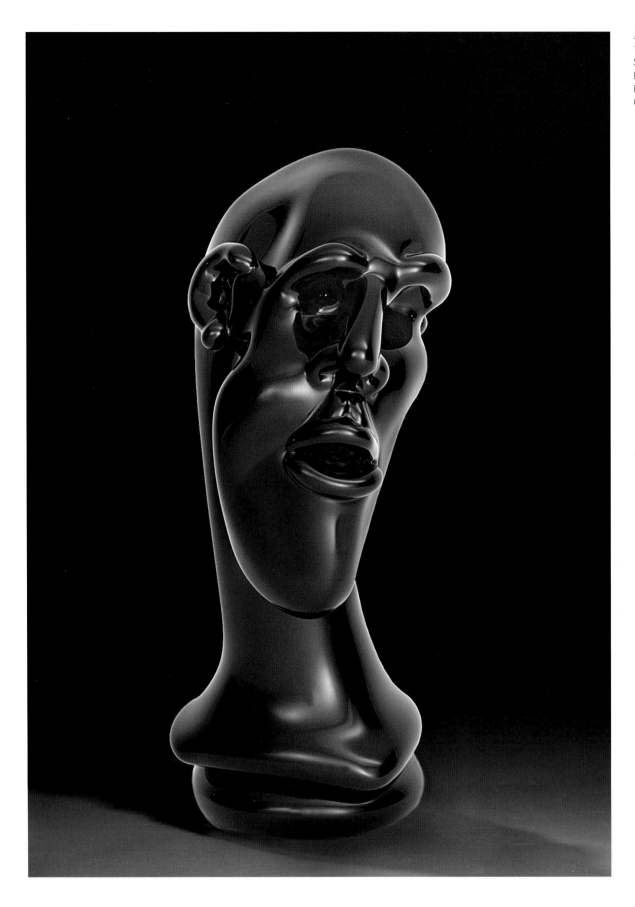

Rogue
1991
Solid hot formed glass
H 15 x W 6 x D 7 $\frac{1}{2}$ in.
Photo Charles Brooks
Collection of the Artist

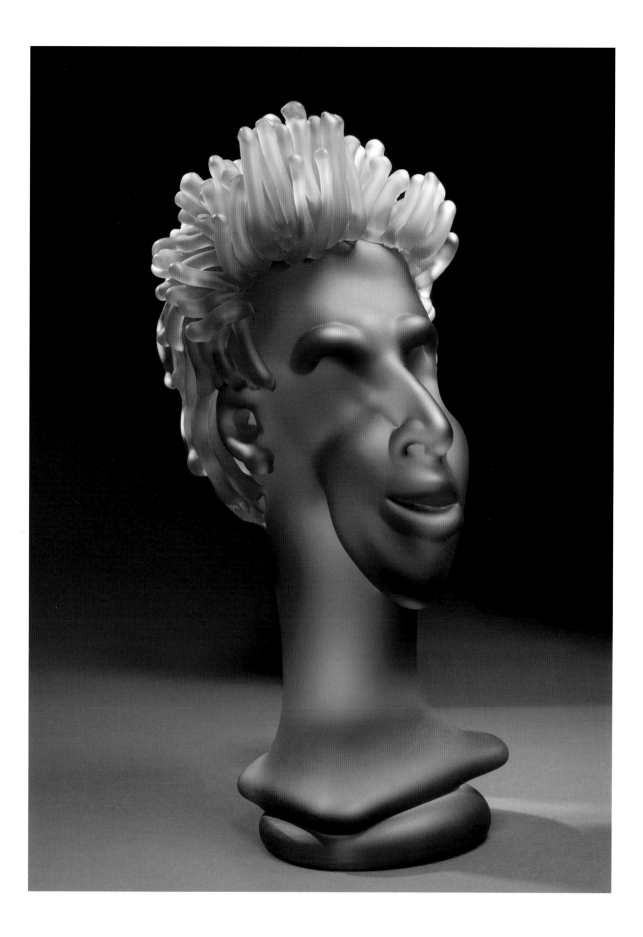

Lucky
1991
Solid hot formed glass, acid etched
H 16 x W 8 x D 8 $\frac{1}{2}$ in.
Photo Charles Brooks
Collection Glady and Ross Faires

Extravagant
1993
Solid hot formed glass, acid etched
H 14 ½ x W 10 ½ x D 9 in.
Photo Charles Brooks
Collection of the Artist

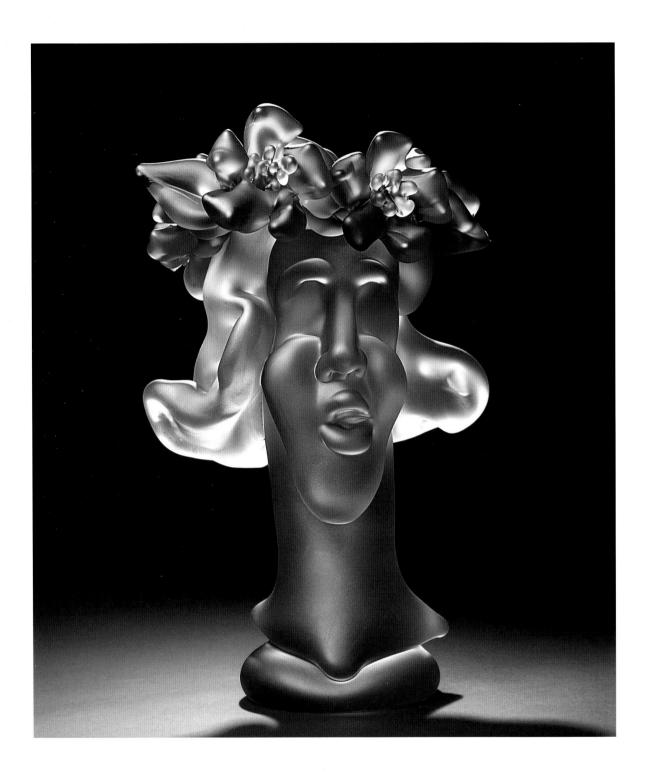

Rogue
1994
Bronze
H 17 ¹/₂ x W 7 x D 8 in.
Photo Charles Brooks
Collection Jeannie and Rick Bennett

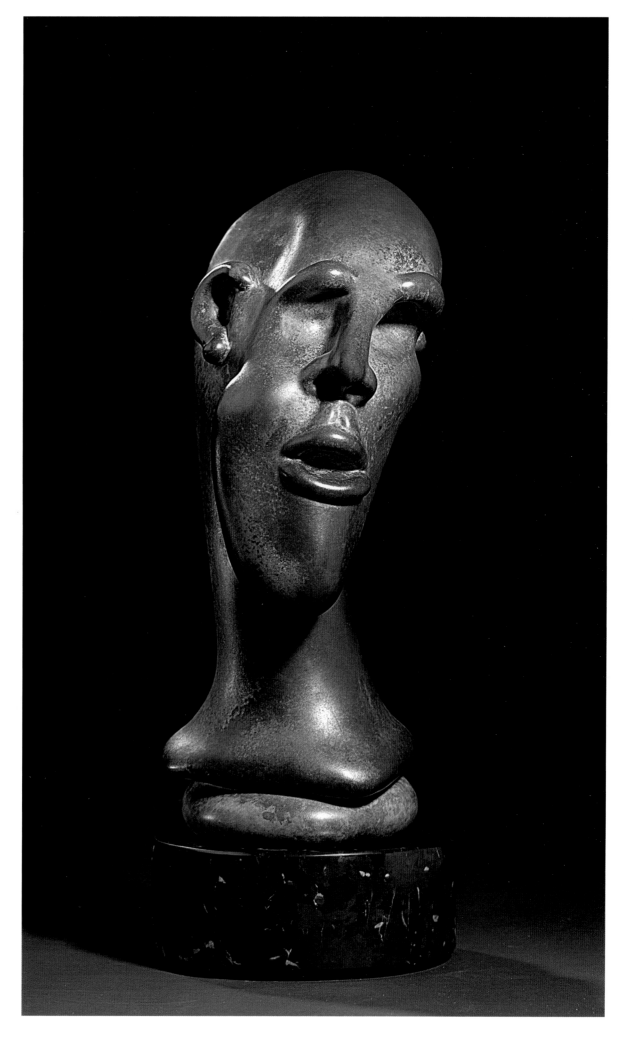

Day and Night
1994
Monotype
H 30 x W 22 in.
Photo Charles Brooks
Collection of the Artist

Upswept
1994
Monotype
H 30 x W 22 in.
Photo Charles Brooks
Collection of the Artist

Traveler
1994
Bronze
H 18 x W 6 ½ x D 7 ½ in.
Photo Charles Brooks
Collection Ann and Steve Bailey

Torso
1994
Hot formed glass, acid etched
H 15 x W 11 ½ x D 5 in.
Photo Gary Heatherly
Private Collection.

Tour de Femmes V
1995
Blown and hot formed glass,
fabricated and acid etched
H 110 x W 16 x D 16 in.
Photo Don Dudenbostel
Collection of the Artist
(*opposite page: detail*)

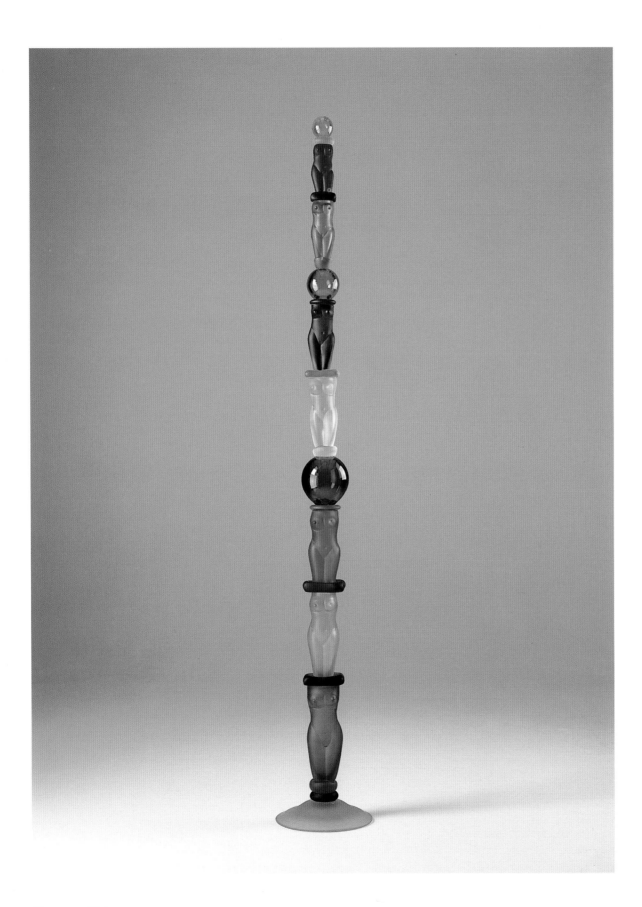

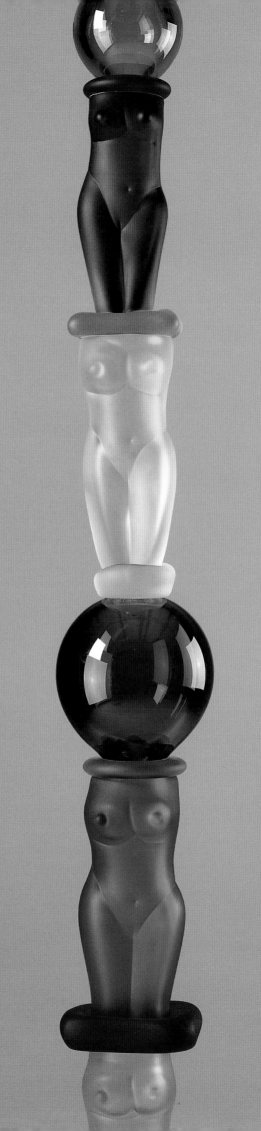

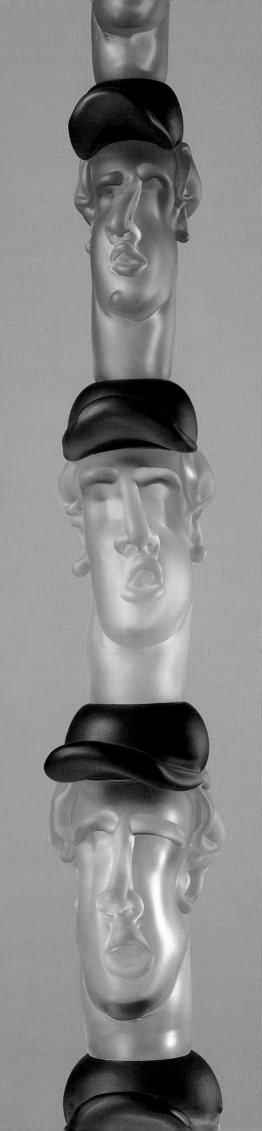

Nine Views
1995
Blown and hot formed glass,
fabricated and acid etched
H 86 x W 15 ¹/₂ x D 15 ¹/₂ in.
Photo Don Dudenbostel
Collection Renwick Gallery, Smithsonian
Institute, Washington, D.C.
(*opposite page: detail*)

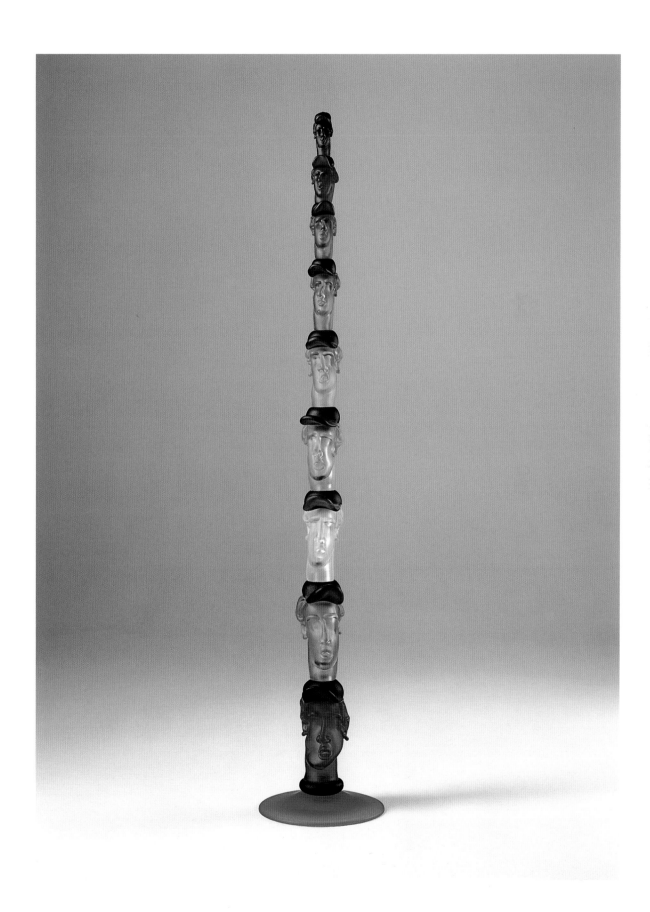

Circling Thoughts
1995
Blown and hot formed glass,
fabricated and acid etched
H 24 x W 10 x D 10 in.
Photo Don Dudenbostel
Collection Roberta and Gerald Franklin

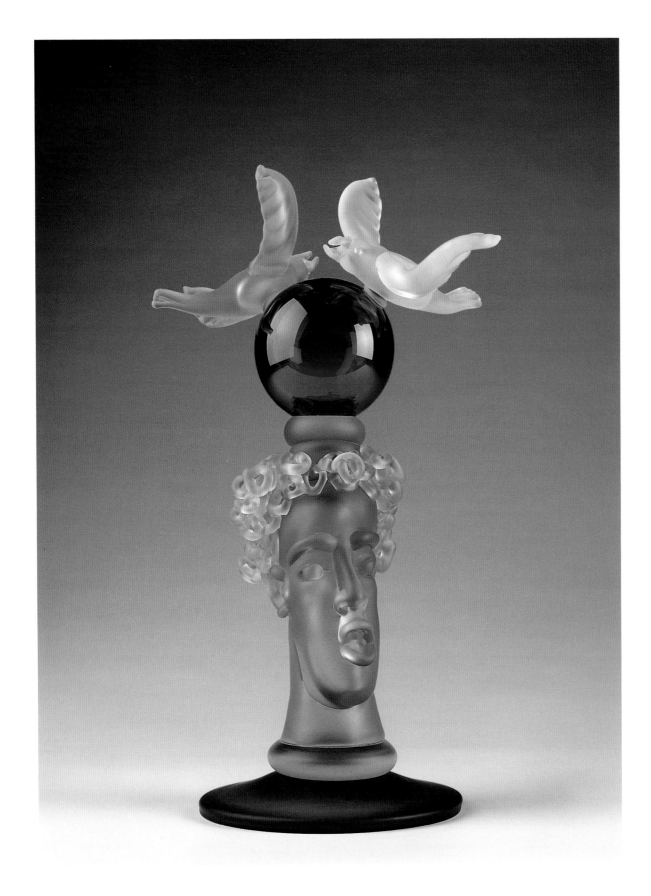

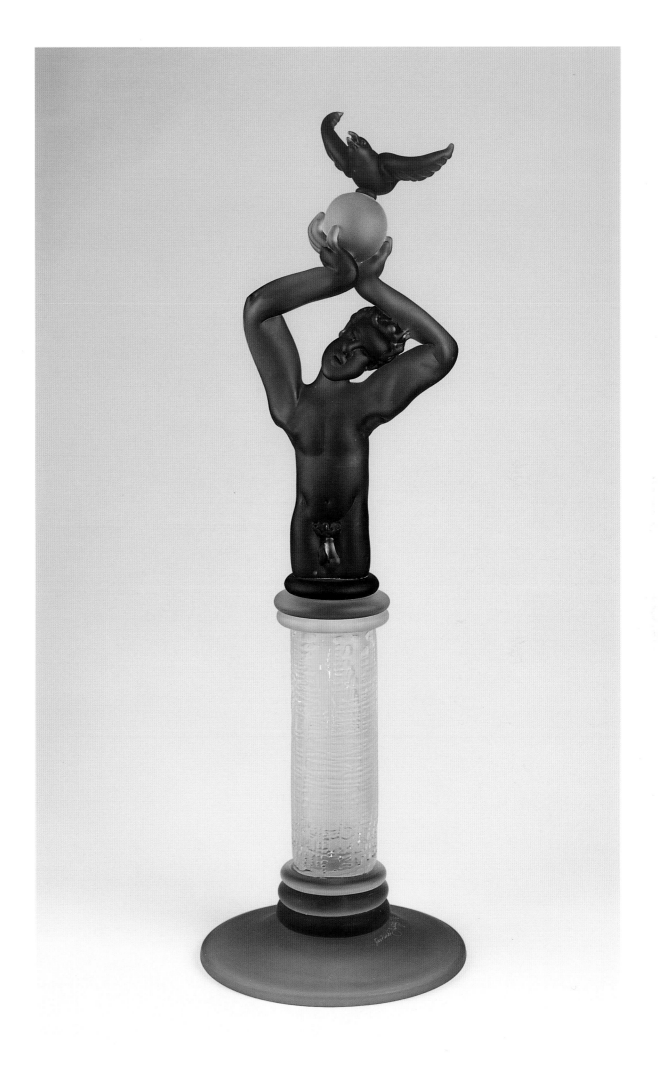

Release
1996
Blown and hot formed glass,
fabricated and acid etched
H 41 x W 12 x D 12 in.
Photo Gary Heatherly
Collection Rick Moore

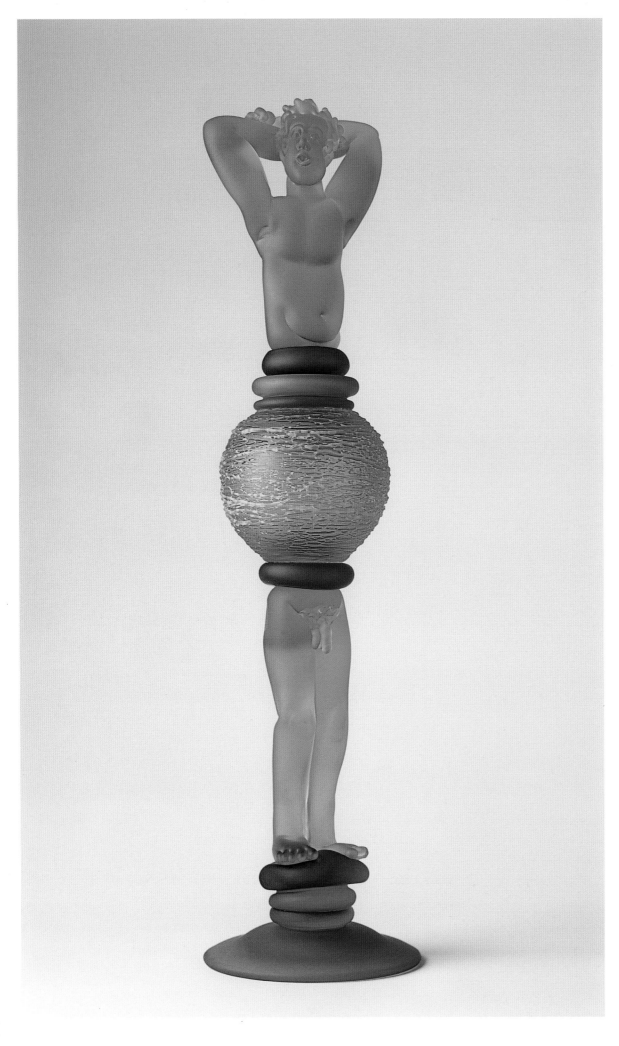

Middle Ground
1996
Blown and hot formed glass,
fabricated and acid etched
H 34 x W 10 ½ x D 10 ½ in.
Photo Gary Heatherly
Collection Elton John

Dream State
1996
Blown and hot formed glass,
fabricated and acid etched
H43 ½ x W 14 ½ x D 14 ½ in.
Photo Charles Brooks
Collection of the Artist

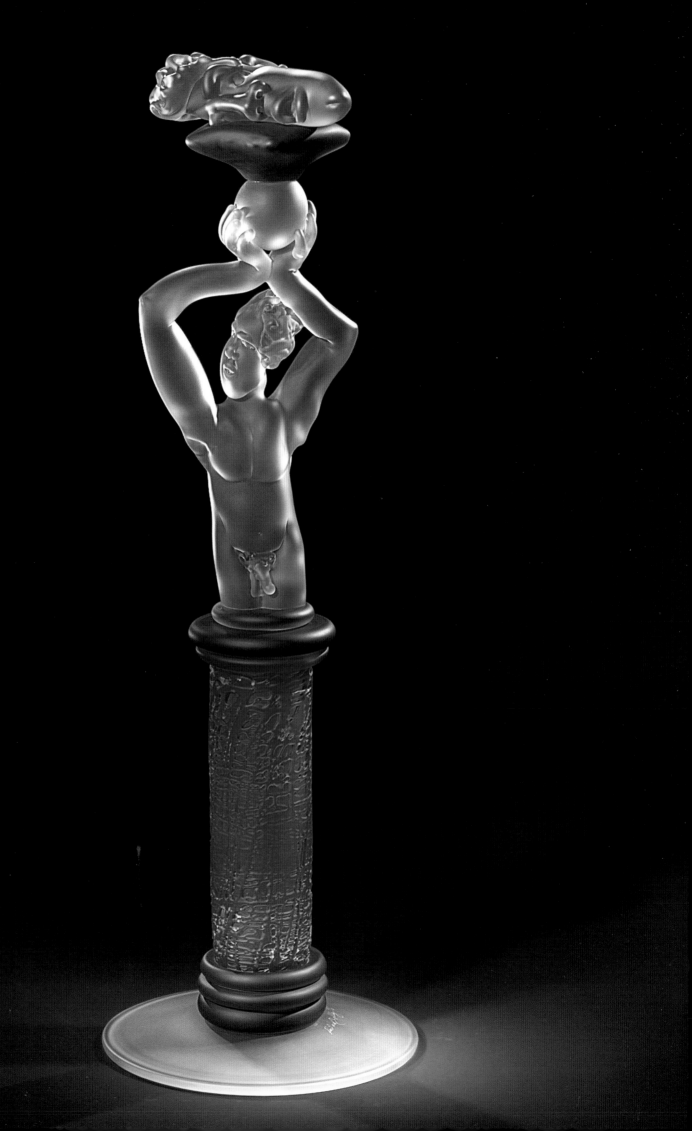

Solstice
1999
Steel, glass, copper and aluminum
H 32 x W 48 x D 40 in.
Photo Charles Brooks
Collection of the Artist

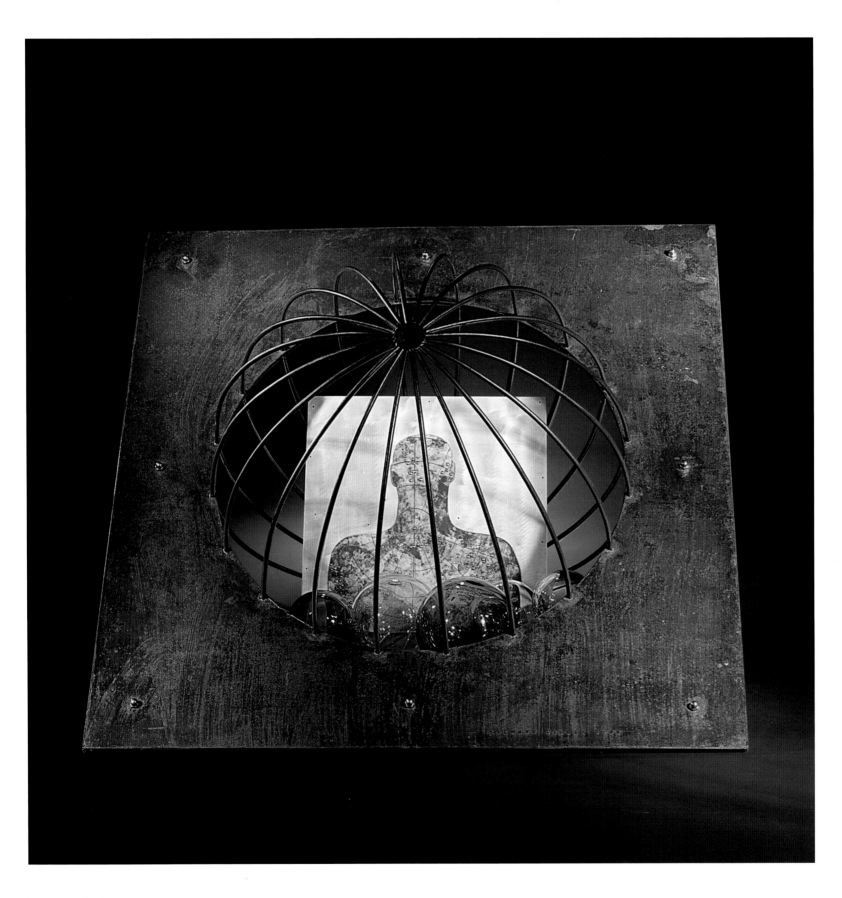

Stellar
1999
Steel, glass, copper and aluminum
H 18 x W 24 x D 18 in.
Photo Charles Brooks
Collection Deb and Tony Clancy

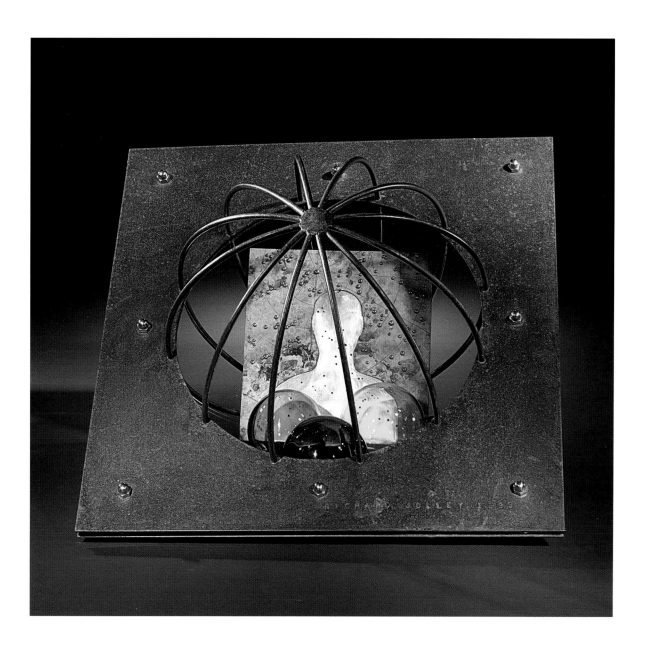

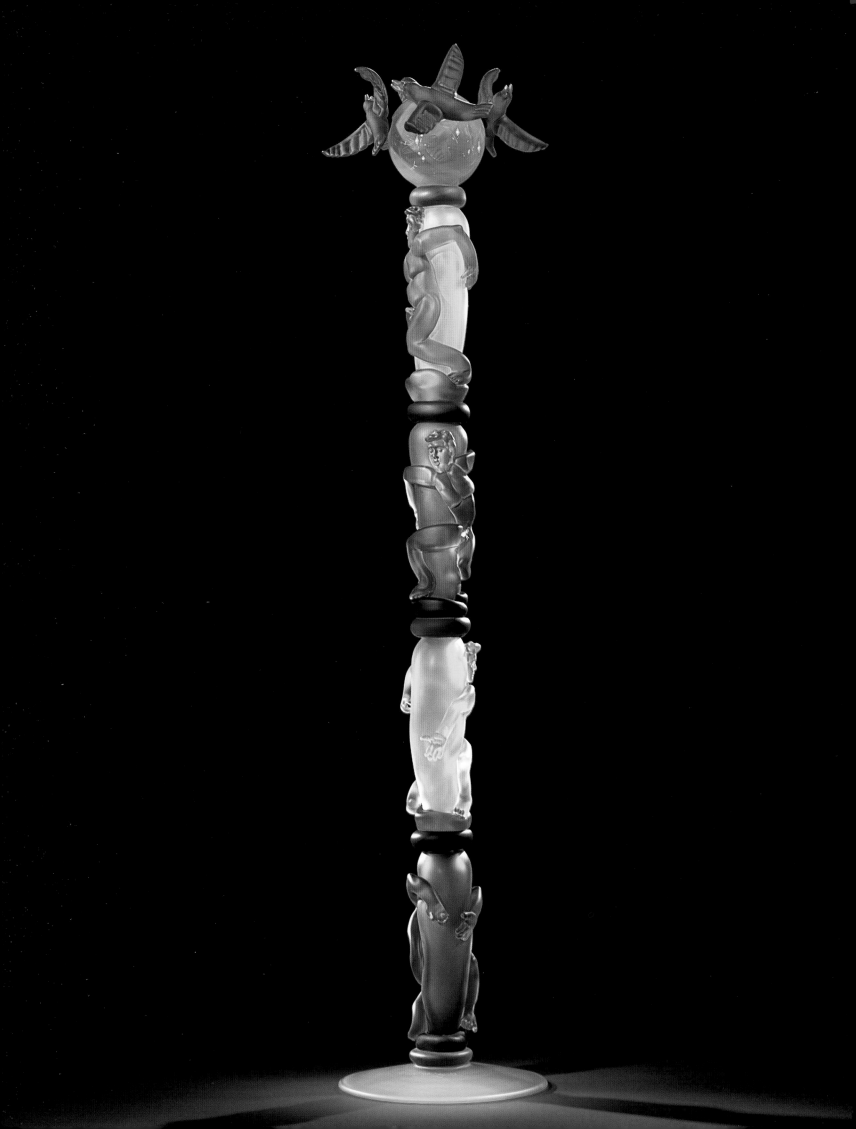

Four Seasons
1999
Blown and hot formed glass,
fabricated and acid etched
H 79 x W 16 1/4 x D 16 1/4 in.
Photo Charles Brooks
Collection of the Artist

Affinity
1999
Blown and hot formed glass,
fabricated and acid etched
H 54 x W 16 1/2 x D 16 1/2 in.
Photo Charles Brooks
Collection Dawn and Adam Schloss

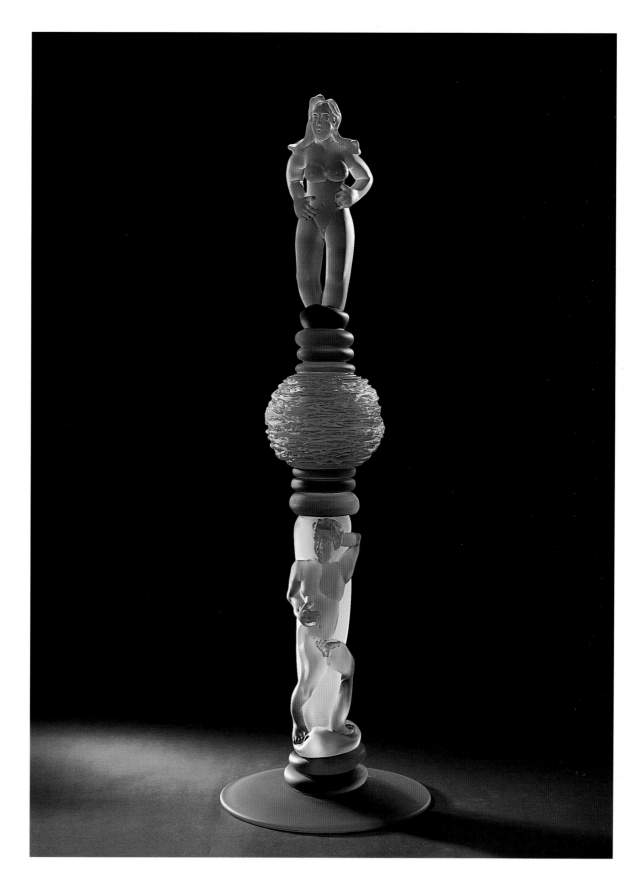

Polarity
1999
Glass, copper and aluminum
H 29 x W 28 x D 8 in.
Photo Charles Brooks
Collection of the Artist

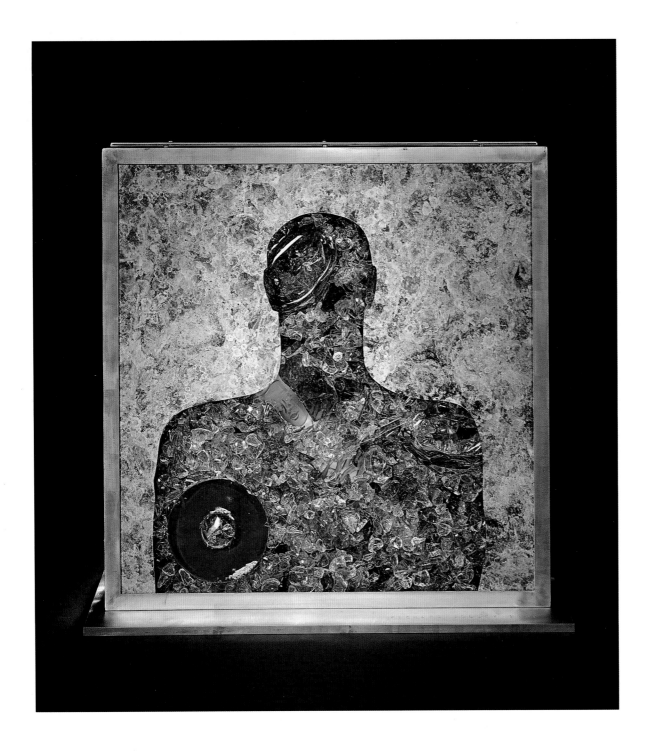

Similarity of Change
2000
Glass, aluminum, silver leaf and paint
H 7 x W 74 x D 3 in.
Photo Noel Allum
Collection Doron and Marianne Livnat
(*pages 98-99: detail*)

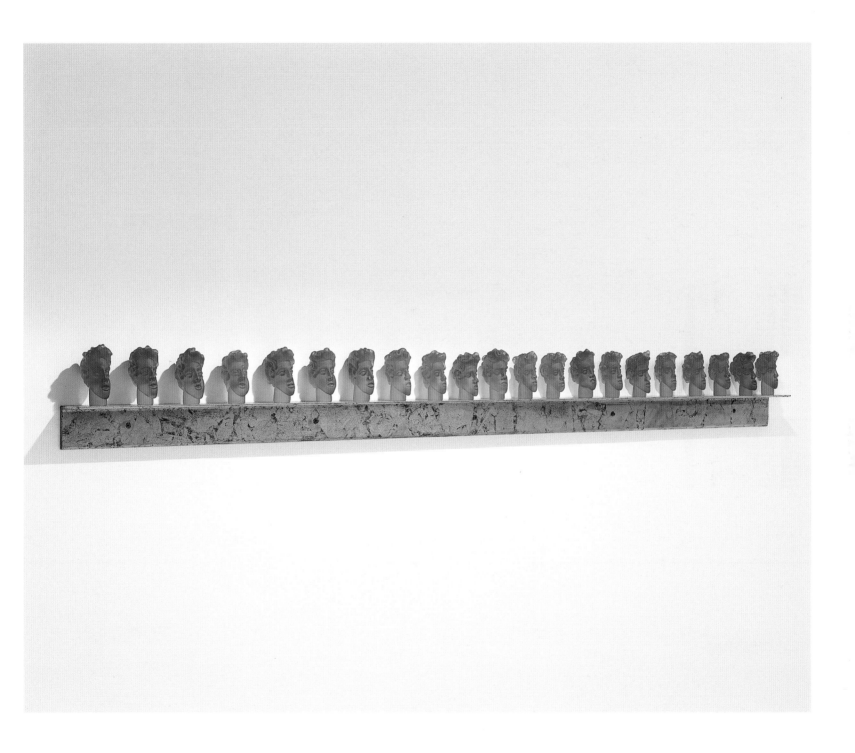

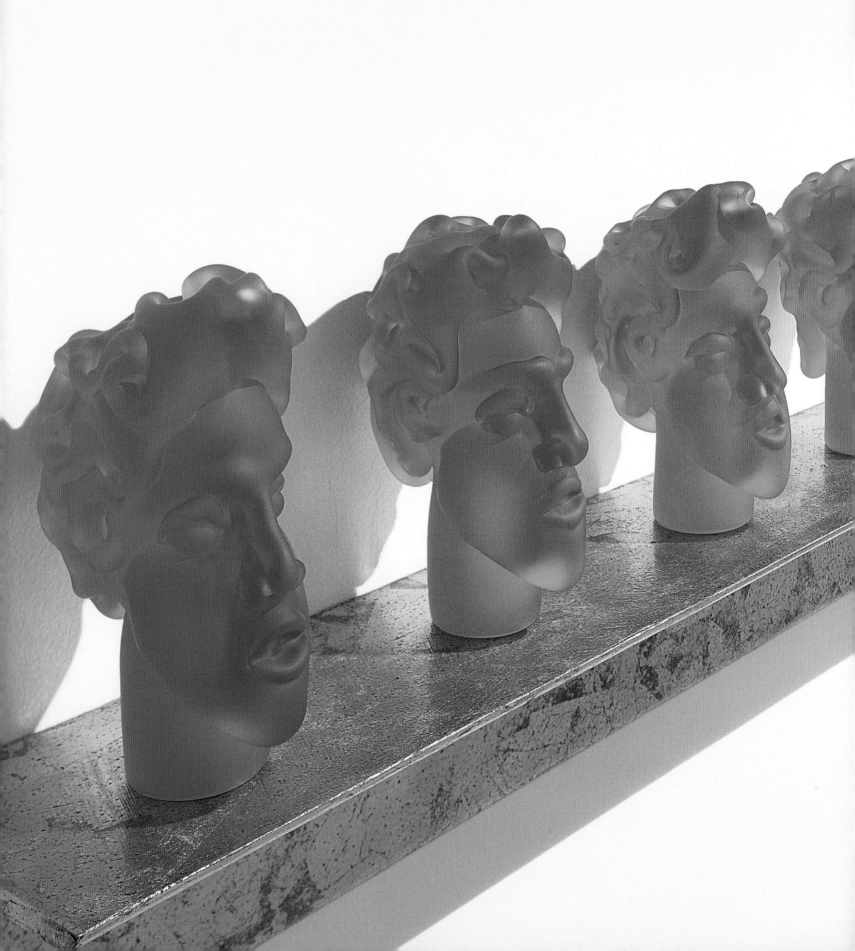

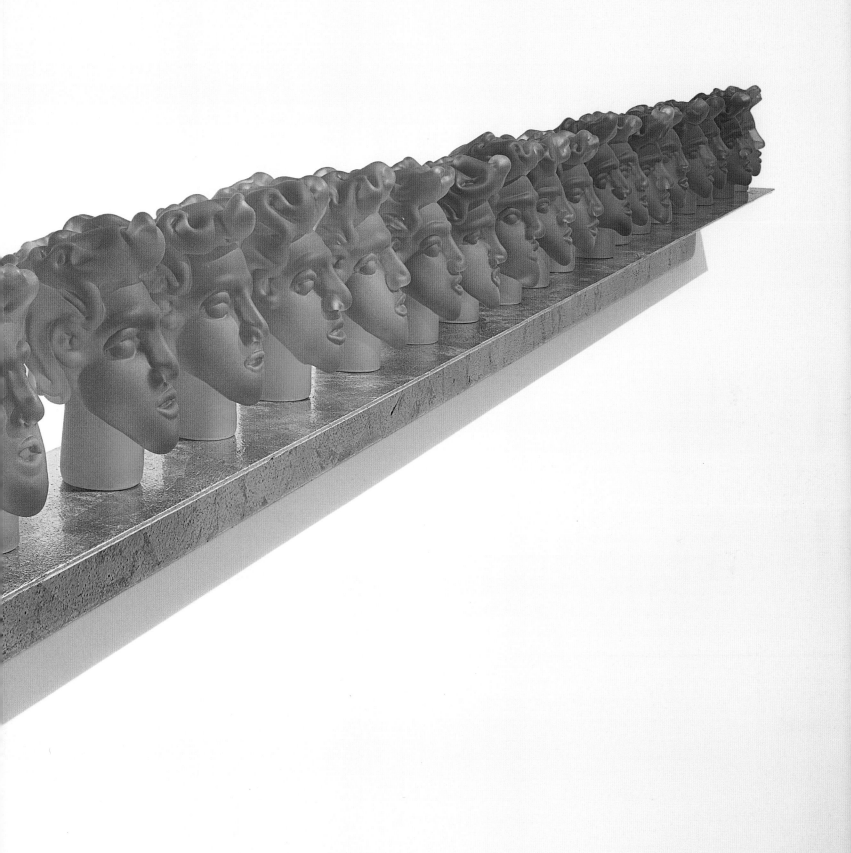

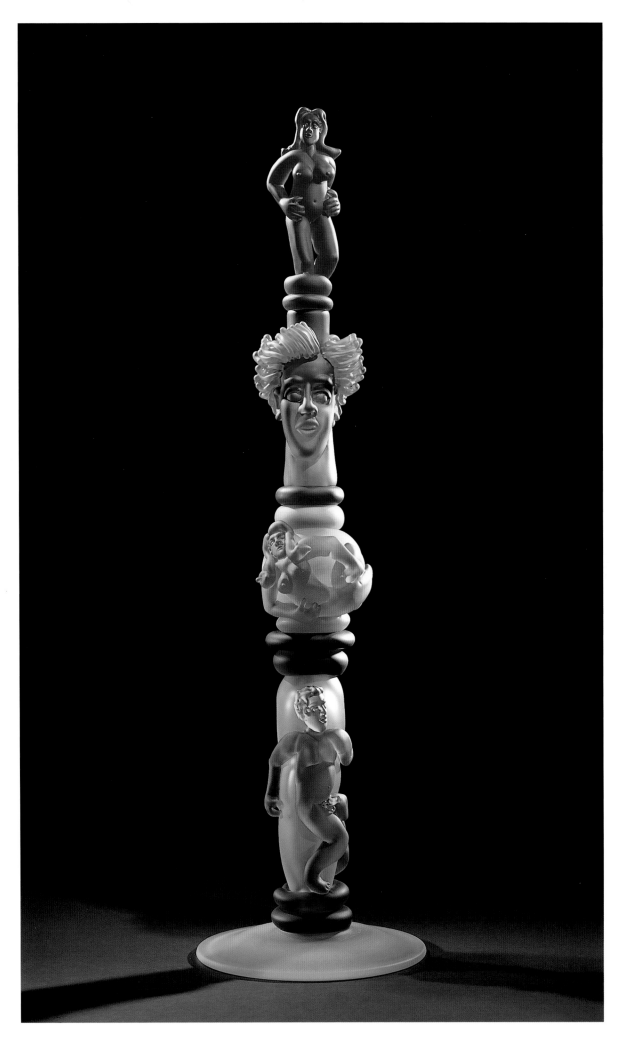

Intimate
2000
Blown and hot formed glass,
fabricated and acid etched
H 59 x W 16 x D 16 in.
Photo Charles Brooks
Collection of the Artist

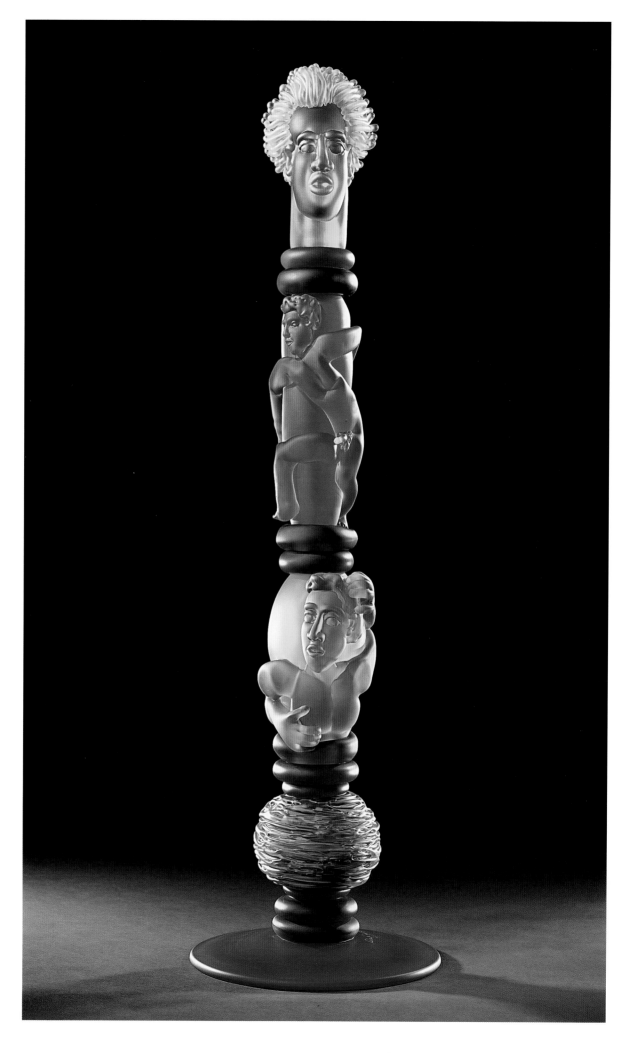

Mind Over Matter
2000
Blown and hot formed glass,
fabricated and acid etched
H 57 $\frac{1}{2}$ x W 16 x D 16 in.
Photo Charles Brooks
Collection Corning Museum, New York

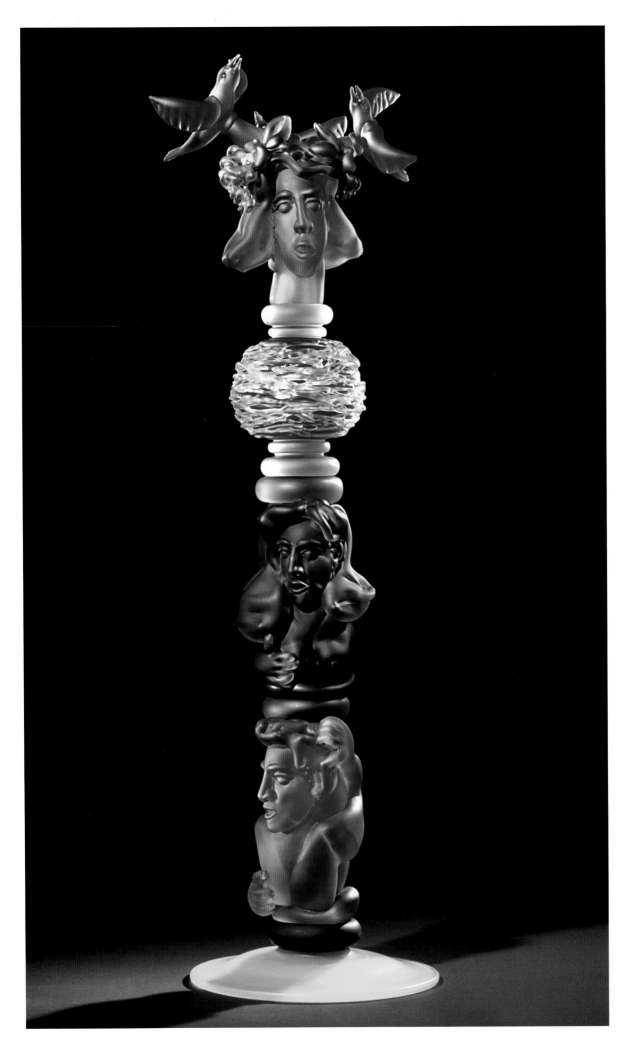

Taking Time
2001
Blown and hot formed glass,
fabricated and acid etched
H 57 $\frac{1}{2}$ x W 17 x D 17 in.
Photo Charles Brooks
Collection of the Artist

Enduring
2001
Blown and hot formed glass,
fabricated and acid etched
H 58 x W 17 x D I9 in.
Photo Charles Brooks
Collection of the Artist

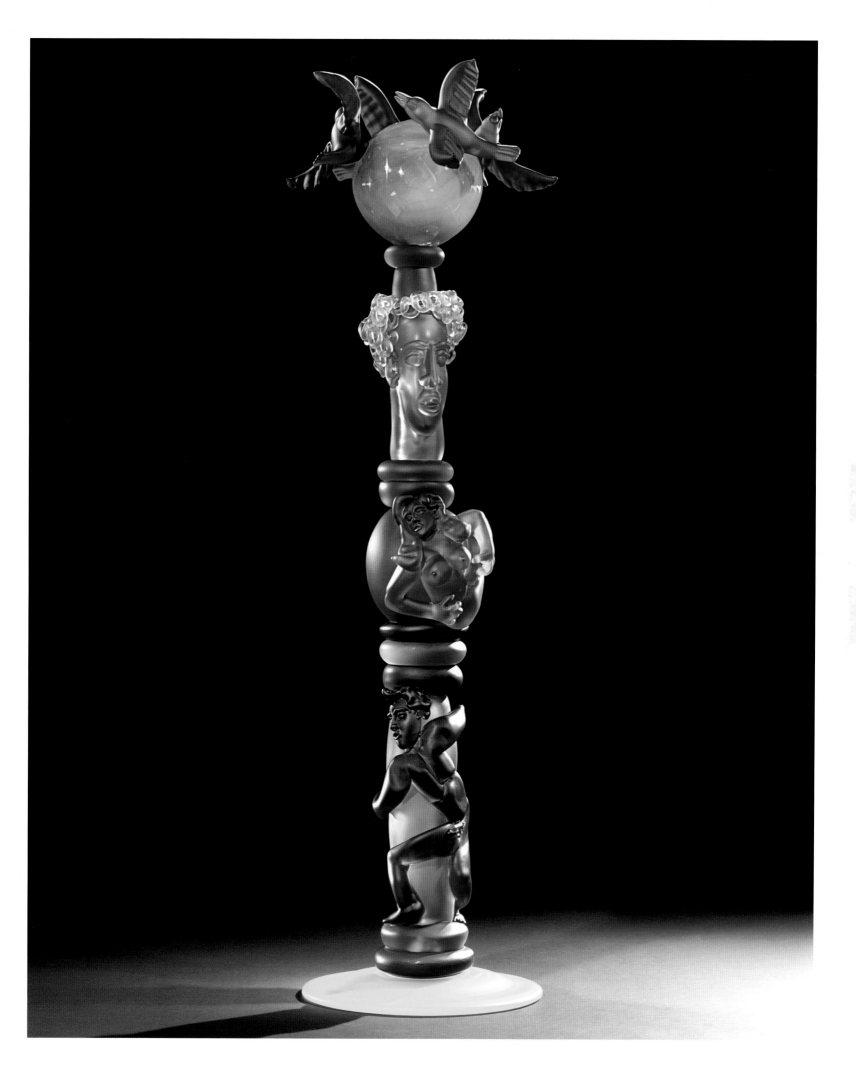

Crow Suite
2001
Monotype
H 20 $\frac{1}{4}$ x W 20 $\frac{1}{4}$ in. each
Photo Charles Brooks
Collection of the Artist

Tabula Rasa I
2002
Paper, paint, varnish and silver leaf
H 42 1/4 x W 42 1/2 in.
Photo Charles Brooks
Collection of the Artist

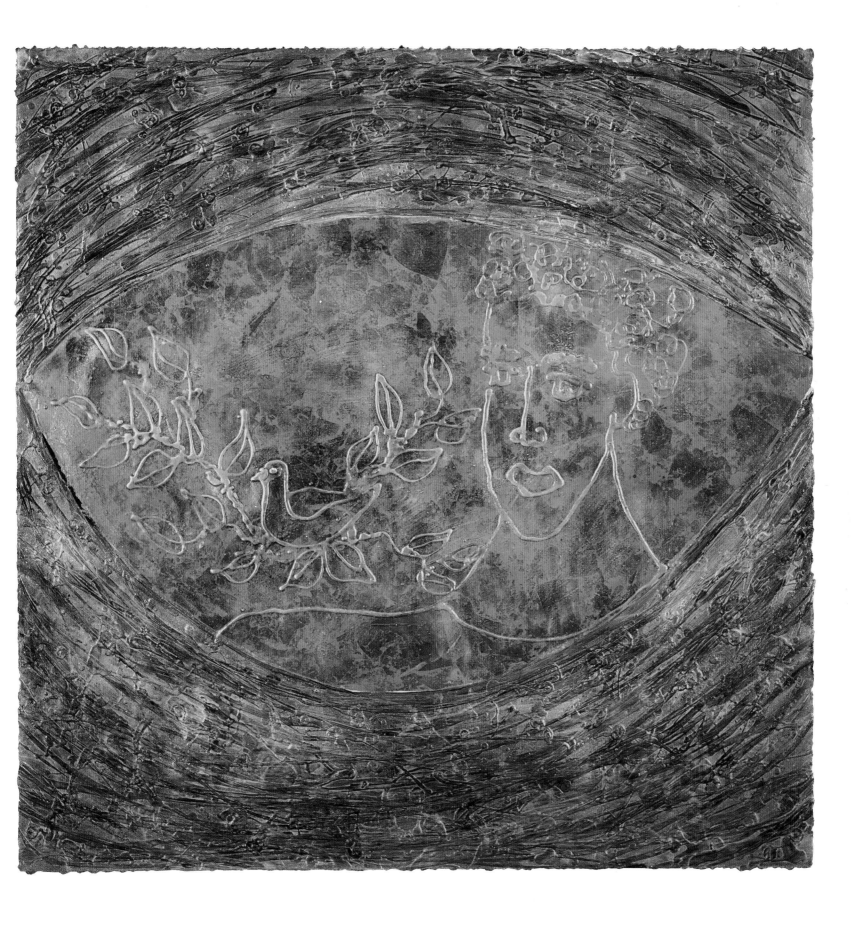

Edges of Light
2002
Glass
H 15 $\frac{1}{2}$ x W 9 $\frac{1}{2}$ x D 4 $\frac{1}{2}$ in.
Photo Charles Brooks
Collection of the Artist

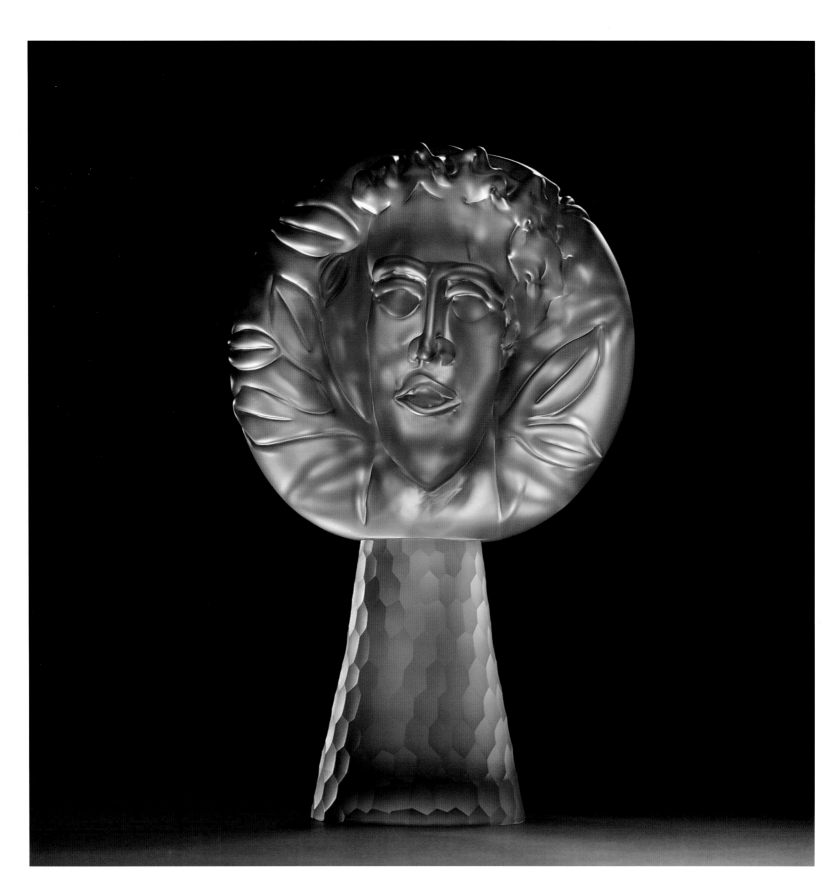

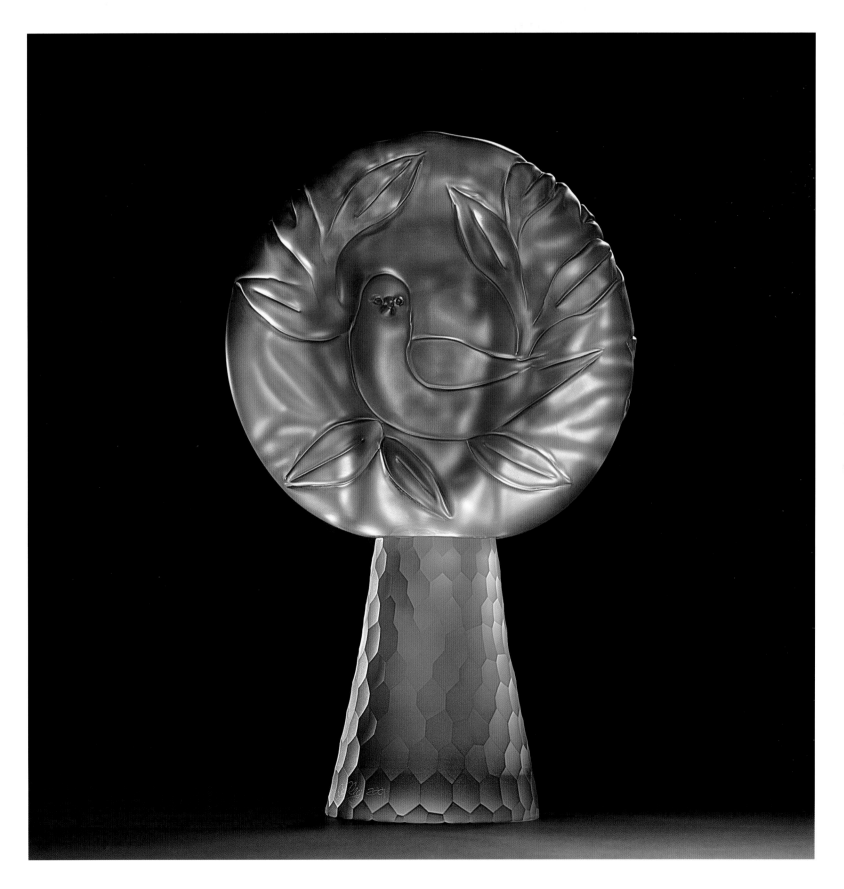

Male Bust
2002
Mixed media on paper
H 20 $\frac{1}{4}$ x W 20 $\frac{1}{4}$ in.
Photo Charles Brooks
Collection of the Artist

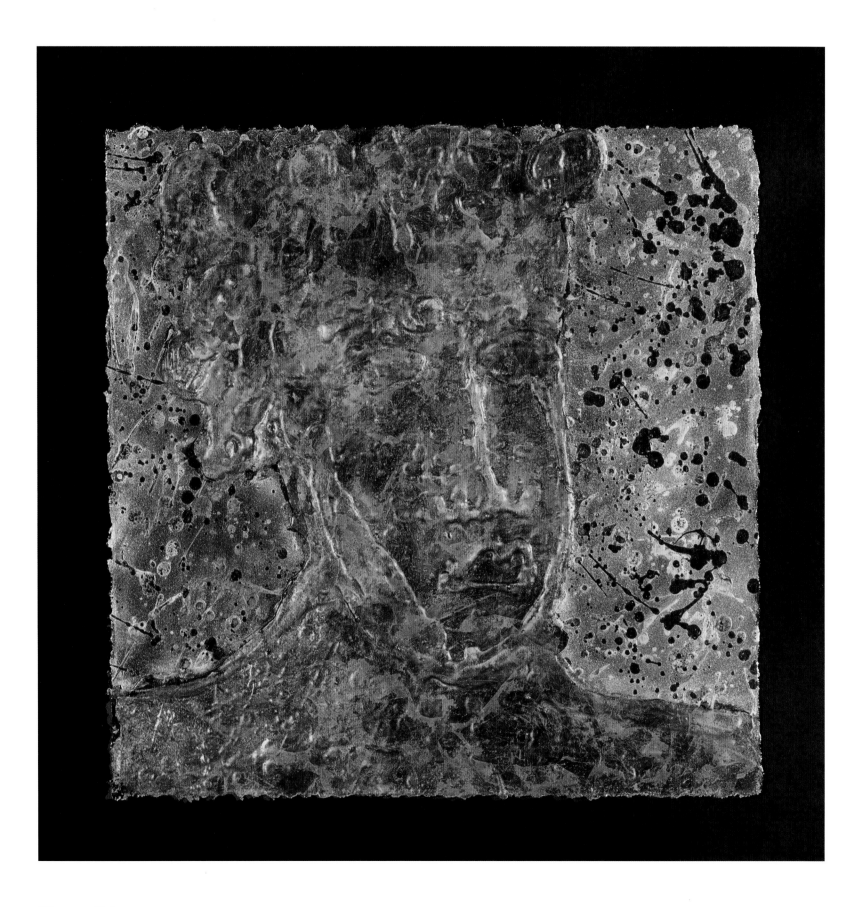

Shadow
2002
Mixed media on paper
H 20 $\frac{1}{4}$ x W 20 $\frac{1}{4}$ in.
Photo Charles Brooks
Collection of the Artist

Double Figure
2002
Paper, paint, varnish and silver leaf
H 42 x W 94 $^1/_2$ in.
Photo Charles Brooks
Collection of the Artist

Suspended
2002
Aluminum, glass, copper and gold leaf
H 24 x W 96 x D 4 in.
Photo Charles Brooks
Collection of the Artist

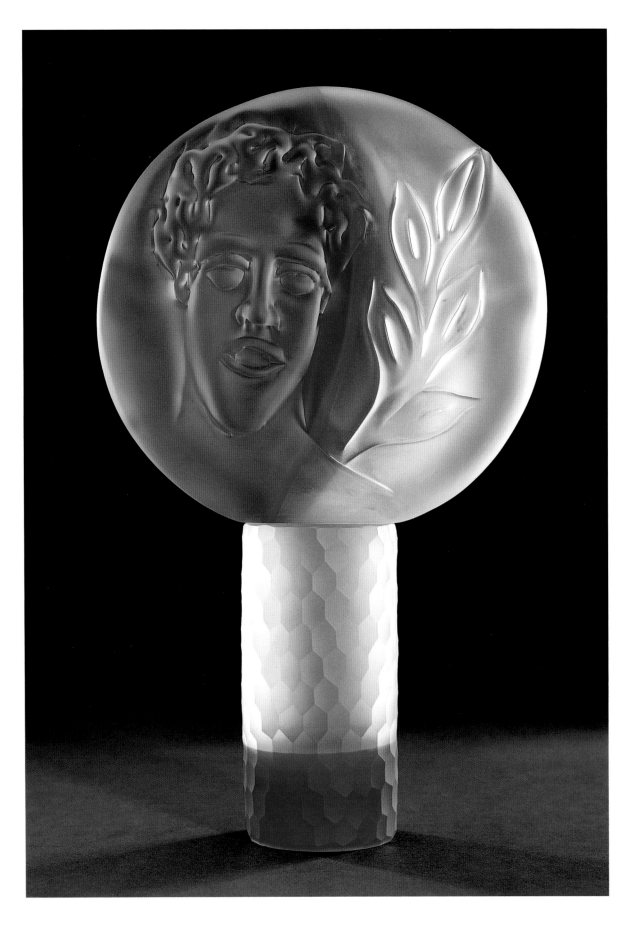

Crescent
2002
Glass.
H 16 ¹/₂ x W 10 x D 3 ¹/₂ in.
Photo Gary Heatherly
Collection of the Artist

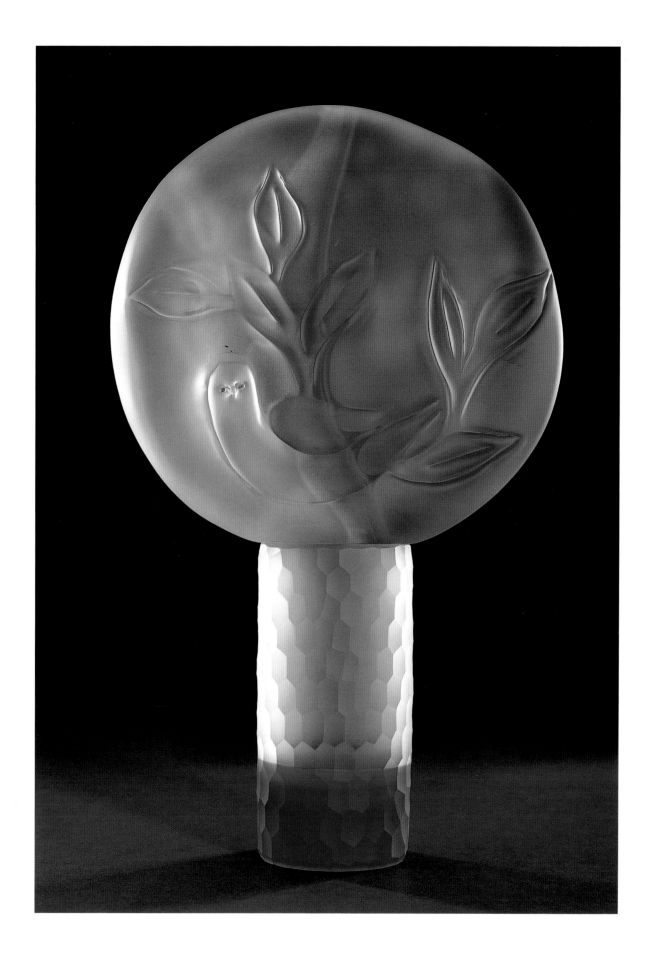

Into the Light
2002
Glass
H 16 $\frac{1}{4}$ x W 15 $\frac{1}{2}$ x D 4 in.
Photo Gary Heatherly
Collection of the Artist

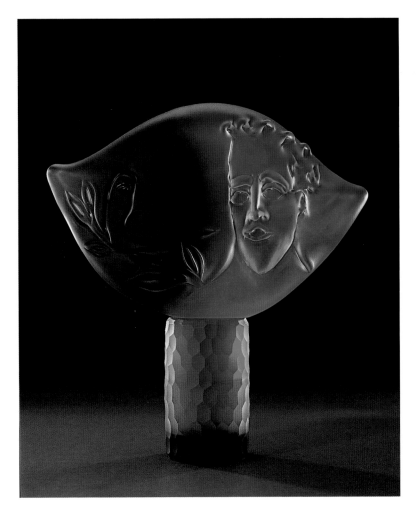

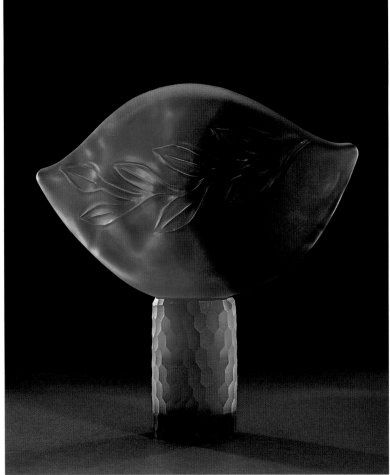

Essence
2002
Glass
H 16 $\frac{1}{2}$ x W 16 $\frac{1}{2}$ x D 4 in.
Photo Gary Heatherly
Collection of the Artist

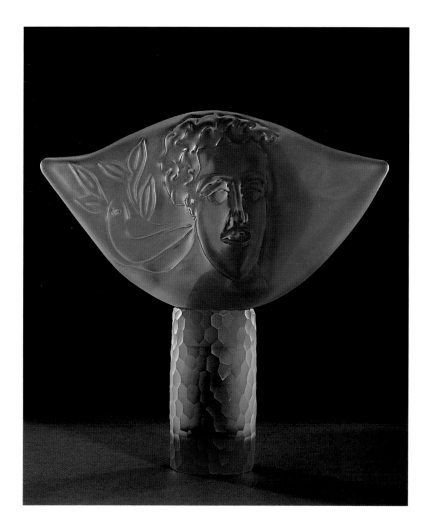

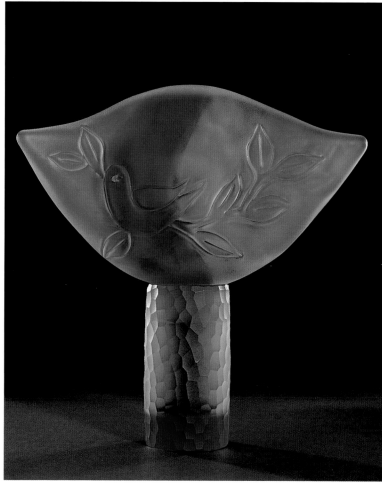

Serenity
2002
Glass
H 15 ³/₄ x W 16 ³/₄ x D 4 ¹/₄ in.
Photo Gary Heatherly
Collection of the Artist

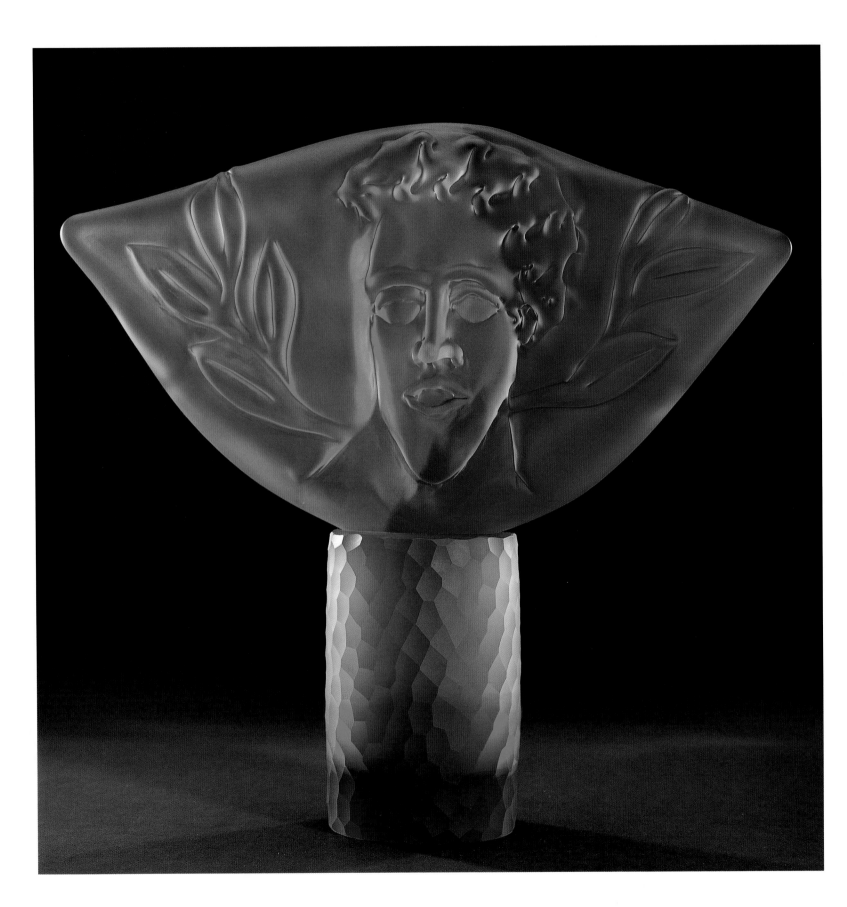

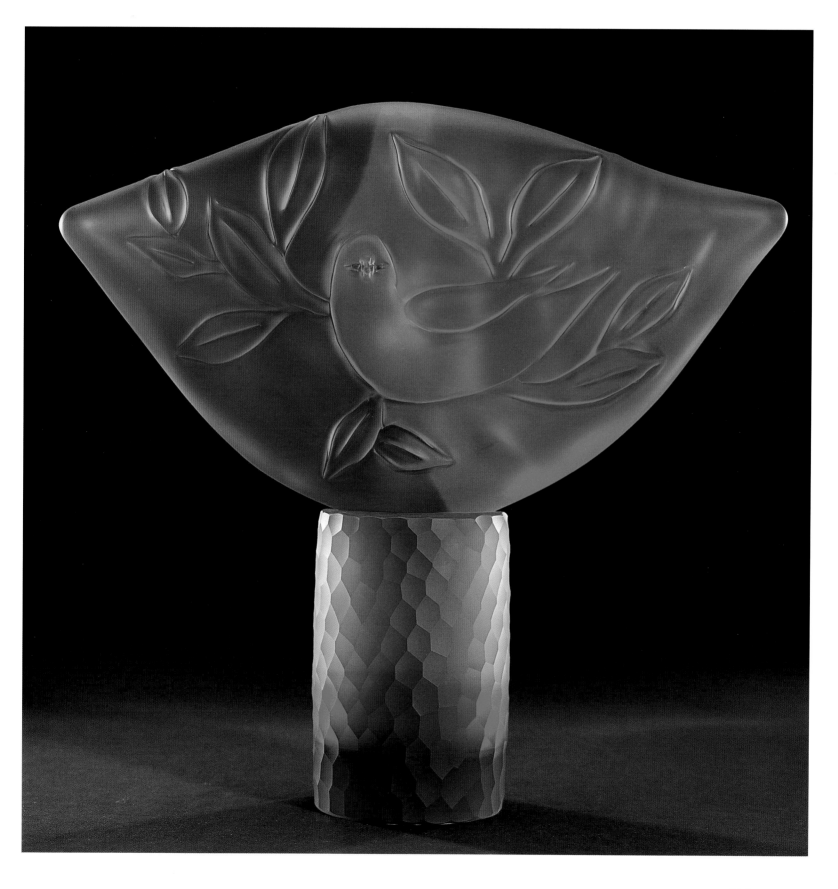

Appendix

Biobibliography

1952
Born in Wichita, Kansas, November 21
Lives and works in Knoxville,
Tennessee

1970-1973
Undergraduate studies, Tusculum
College, Greeneville, Tennessee

1974
BFA, George Peabody College,
Vanderbilt University, Nashville,
Tennessee
Graduate Studies, Penland School,
Penland, North Carolina

Public Collections

Asheville Museum of Art, Asheville,
North Carolina
Atlantic Foundation, Princeton,
New Jersey
Baton Rouge Art and Humanities
Council, Baton Rouge, Louisiana
Carillon Importers Ltd., Teaneck,
New Jersey
Chrysler Museum at Norfolk, Norfolk,
Virginia
Coburg Museum, Coburg, Germany
Corning Museum of Glass, Corning,
New York
Frederick Weisman Art Foundation,
Los Angeles, California
Hokkaido Museum of Modern Art,
Sapporo, Japan
Hunter Museum of American Art,
Chattanooga, Tennessee
Huntington Museum of Art,
Huntington, West Virginia
Indianapolis Museum of Art,
Indianapolis, Indiana
International Glasmuseum, Ebeltoft,
Denmark
Knoxville Museum of Art, Knoxville,
Tennessee
Künstmuseum, Düsseldorf, Germany
Los Angeles County Museum of
Modern Art, Los Angeles, California
Mint Museum of Craft & Design,
Charlotte, North Carolina
Mobile Museum of Art, Mobile, Alabama
Museum of Contemporary Arts and
Design, New York, New York
North Carolina State University
Museum of Art and Design, Raleigh,
North Carolina
Renwick Gallery of the Smithsonian
American Art Museum, Washington,
D.C.
Rhone-Poulenc Rorer, Collegeville,
Pennsylvania
Rockford Art Museum, Rockford,
Illinois
Tennessee State Museum, Nashville,
Tennessee
The Ogden Museum of Southern Art,
University of New Orleans, New
Orleans, Louisiana
University Hospital of Cleveland,
Cleveland, Ohio

Selected Solo Exhibitions

2002
Knoxville Museum of Art, "Richard
Jolley: Sculptor of Glass", Knoxville,
Tennessee
Leo Kaplan Modern, New York,
New York

2001
Fay Gold Gallery, "Tabula Rasa",
Atlanta, Georgia

2000
Habatat Galleries, Chicago, Illinois
Leo Kaplan Modern, New York,
New York
Gallery Camino Real, Boca Raton,
Florida

1998
Fay Gold Gallery, "Meridian", Atlanta,
Georgia
Arthur Roger Gallery, "Cairn",
New Orleans, Louisiana

1997
Gallery Camino Real, Boca Raton, Florida
Gail Severn Gallery, Ketchum, Idaho
Mint Museum of Art, "Art Currents 22:
Richard Jolley", curated by Mark
R. Leach, Charlotte, North Carolina
Emory and Henry College, Emory,
Virginia

1996
Fay Gold Gallery, "Totemic Tales",
Atlanta, Georgia
Sanske Gallery, Zurich, Switzerland

1995
Arthur Roger Gallery, New Orleans,
Louisiana
Maurine Littleton Gallery, Washington,
D.C.

1994
Fay Gold Gallery, Atlanta, Georgia
Gail Severn Gallery, Ketchum, Idaho
Cumberland Gallery, Nashville,
Tennessee
Helander Gallery, Palm Beach, Florida

1993
Arthur Roger Gallery, New Orleans,
Louisiana
Maurine Littleton Gallery, Washington,
D.C.

1992
Arthur Roger Gallery, New York,
New York
Fay Gold Gallery, Atlanta, Georgia

1991
Arthur Roger Gallery, New Orleans,
Louisiana
Maurine Littleton Gallery, Washington,
D.C.

1990
Sandra Ainsley Gallery, Toronto,
Canada
Gail Severn Gallery, Ketchum, Idaho

1989
Maurine Littleton Gallery, Washington,
D.C.
Kurland/Summers Gallery,
Los Angeles, California

1988
Arthur Roger Gallery, New Orleans,
Louisiana
Zimmerman/Saturn Gallery, Nashville,
Tennessee

1987
Kurland/Summers Gallery,
Los Angeles, California
Mobile Museum of Art, Mobile,
Alabama
Maurine Littleton Gallery, Washington,
D.C.
Galeria Angela Hollings, Hameln,
Germany

1985
Portfolio Gallery, "Narrative Imagery",
Atlanta, Georgia
Kurland/Summers Gallery,
Los Angeles, California

1982
Alliance Museum, Indianapolis
Museum of Art, Indianapolis, Indiana

1979
Spring Street Gallery, New York,
New York

1976
Alpha Gallery, Knoxville, Tennessee

1974
Centennial Art Center, Nashville,
Tennessee

Artist in drawing studio.

Artist in print studio.

Two sculptures from the Tabula Rasa series in the foreground of the finishing area of the studio.

Selected Group Exhibitions

2002
"Contemporary Directions", The Maxine and William Block Collection, Carnegie Museum of Art, Pittsburgh, Pennsylvania (Catalogue)
2001
"The Best of Tennessee", Tennessee State Museum, Nashville, Tennessee (Catalogue)
"Passionate Collectors", Gallery of Art and Design, North Carolina State University, Raleigh, North Carolina (Catalogue)
"The 29th Annual International Glass Invitational", Habatat Galleries, Pontiac, Michigan (Catalogue)
2000
"Contemporary Works from the Palley Collection", Lowe Art Museum, University of Miami, Miami, Florida (Catalogue)
"Millennium Glass: An International Survey of Studio Glass", Kentucky Art and Craft Gallery, Louisville, Kentucky; Traveled (Catalogue)
1999
"XX/MM", Fay Gold Gallery, Atlanta, Georgia
"Inaugural Group Exhibition", Imago Gallery, Palm Desert, California
"Glass Glorious Glass", Renwick Gallery of the National Museum of American Art, Smithsonian Institution, Washington, D.C.
"International Glass Masters Invitational", A.N. Bush Gallery, Salem, Oregon (Catalogue)
1998
"Venezia Aperto Vetro 1998", Murano-Venezia, Italy
1997
Hsinchu Cultural Center, Hsinchu, Taiwan

"Glass Today by American Studio Artists", The Boston Museum of Fine Art, Boston, Massachusetts
"Masters of Contemporary Glass: Selections from the Glick Collection", Indianapolis Museum of Art, Indianapolis, Indiana (Catalogue)
"The 25th Annual International Invitational", Habatat Gallery, Pontiac, Michigan
1996
"The 24th Annual International Invitational", Habatat Galleries, Pontiac, Michigan
"Figurative Sculpture", Laumeier Sculpture Park, Saint Louis, Missouri.
1995
"East Tennessee Art Currents", Knoxville Museum of Art, Knoxville, Tennessee, Curated by Jeff Fleming
"Glass: A Regional Survey From Maryland to Louisiana", Asheville Art Museum, Asheville, North Carolina, Curated by Frank E. Thomson III
"A Touch of Glass", Explorers Hall, National Geographic Society Museum, Washington, D.C.
"Dancing in a Sea of Light", Virginia Beach Center for the Arts, The Luski Collection, Virginia Beach, Virginia
1994
Grounds for Sculpture, Johnson Atelier, Mercerville, New Jersey
"The Landscape", Arthur Roger Gallery, New Orleans, Louisiana
"The Aesthetics of Athletics", Charles A. Wustum Museum of Fine Arts, Racine, Wisconsin (Catalogue)
"Dancing in a Garden of Light", Asheville Museum of Art, Asheville, North Carolina; Traveled (Catalogue)
"A Passionate Perspective", The Spiezer Collection of Art, Rockford Art Museum, Rockford, Illinois

1993
"Spirit House", Sculpture Center, New York, New York
"Figurative Sculpture", Helander Gallery, Palm Beach, Florida
1992
Hokin Kaufman Gallery, Chicago, Illinois
"The International Exhibition of Glass Kanazawa '92", Kanazawa, Japan (Catalogue)
"Glass Now '92", Tokyo, Japan (Catalogue)
1990
Chicago International Art Exposition, represented by Arthur Roger Gallery, New Orleans, Louisiana
Stockholm International Art Exposition, represented by Nielsen Gallery, Malmö, Sweden
Los Angeles International Art Exposition, represented by Arthur Roger Gallery, New Orleans, Louisiana
"Fishman Collection", Institute of Visual Arts, University of Wisconsin, Milwaukee, Wisconsin (Catalogue)
1989
Huntington Museum of Art, Huntington, West Virginia
Joan Robey Gallery, Denver, Colorado
Robert Kidd Gallery, Birmingham, Michigan
"Glass Now '89", Tokyo, Japan (Catalogue)
1988
"World Glass Now '88", Hokkaido Museum of Modern Art, Sapporo, Japan; Traveled (Catalogue)
"Erlesenes Künsthandwerk Museum im Schloss", Bad Pyrmont, Germany (Catalogue)
Robert Kidd Gallery, Birmingham, Michigan
1987
"Glass '87 in Japan", Odakyu Grand Gallery, Shinjuku, Tokyo, Japan

Artist in print studio.

Artist at bench tooling glass with knife to sculpt image.

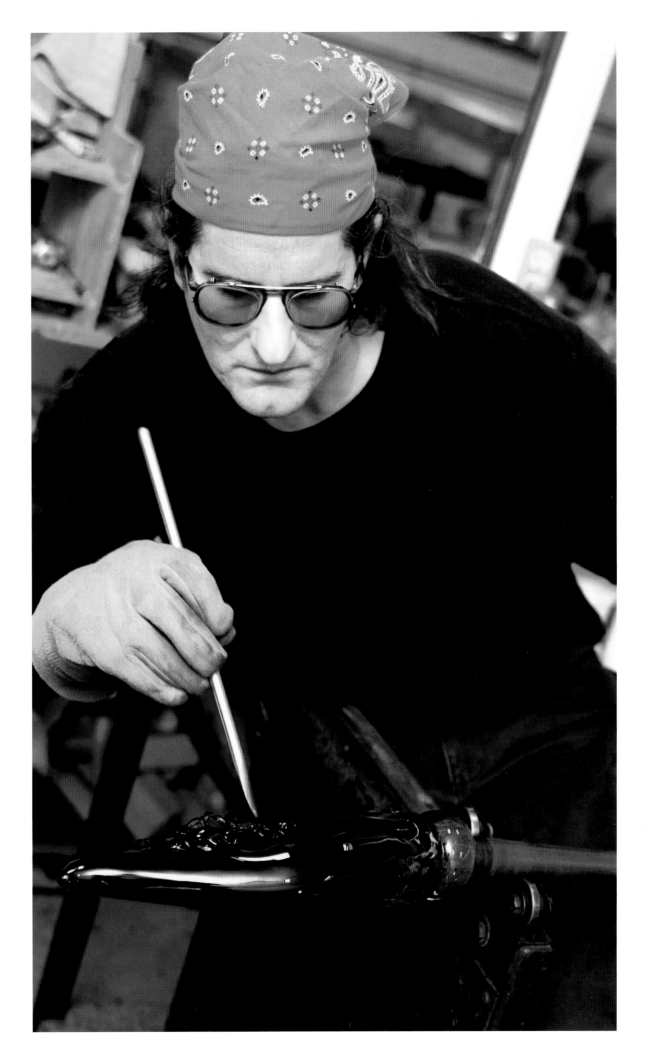

"Glass America '87", Heller Gallery, New York, New York
"Liquid Light", Piedmont Gallery, Winston-Salem, North Carolina
Robert Kidd Gallery, Birmingham, Michigan

1986
"Special Editions", American Craft Museum, New York, New York
"Art and Function", Public Art Trust, Washington, DC (Catalogue)
"Glass and Wood Invitational", Southeastern Center for Contemporary Art, Winston-Salem, North Carolina
"New American Glass Focus 2 West Virginia", Huntington Museum of Art, Huntington, West Virginia (Catalogue)
"Glass America '86", Heller Gallery, New York, New York
Robert Kidd Gallery, Birmingham, Michigan

1985
"Exhibition 280", Huntington Museum of Art, Huntington, West Virginia (Catalogue)
"Glass America '85", Heller Gallery, New York, New York
"Southern Studio Glass: New Directions", Kingsport Fine Arts Center, Kingsport, Tennessee; Traveled (Catalogue)
"The Figure in Glass", Snyderman Gallery, Philadelphia, Pennsylvania

1984
"Glass America '84", Heller Gallery, New York, New York
"Earth, Wind, and Fire: Contemporary Works", The Bruce Museum, Greenwich, Connecticut
"Gather of Glass", Mindscape Gallery, Chicago, Illinois

1983
"Rebirth of a Medium", The Gallery of the University of Texas, San Antonio, Texas
"Five Approaches to Glass", Kurland/Summers Gallery, Los Angeles, California
Perception Gallery, Houston, Texas

1981
"The Early Eighties Exhibition", Tennessee State Museum, Nashville, Tennessee, (Catalogue)
"American Crafts '81", The Currier Gallery of Art, Manchester, New Hampshire, (Catalogue)

1980
"For the Tabletop", American Crafts Museum, New York, New York (Catalogue)
The Elements, New York, New York
"Rare Color/Surface Design", The Hand and The Spirit Gallery, Scottsdale, Arizona

1979
"13 State Exhibition", Appalachian Center, Smithville, Tennessee (Catalogue)

1978
"Seventh Annual National Glass Exhibition", Habatat Galleries, Dearborn, Michigan

1976
"Exhibition 280", Huntington Museum of Art, Huntington, West Virginia (Catalogue)

1975
"Mississippi River Show", Brooks Memorial Gallery, Memphis, Tennessee
"Glass Gems International", Tusculum College, Greeneville, Tennessee
"Middle Tennessee State University Invitational", Middle Tennessee State University, Murfreesboro, Tennessee

1974
"Fifth Bicentennial Art Show", Memphis, Tennessee

Grants

1988
Tennessee Individual Artist Grant

Public Commissions

1996
"Aviary", Park Grill Restaurant, Gatlinburg, Tennessee
Bombay Sapphire, Carillion Importers Ltd., Teaneck, New Jersey

1993
Absolut Statehood: Tennessee, Carillion Importers Ltd., Teaneck, New Jersey, (Book, "Absolut Statehood 51 Painters")

1992
Atlantic Foundation, Princeton, New Jersey

1988
Governor's Awards, State of Tennessee
James Agee Society Awards, East Tennessee Foundation, Knoxville, Tennessee

Selected Catalogue Essays

Nichols, Sarah and Taragin, Davira S., *Contemporary Directions, Glass from the Maxine and William Block Collection*, Carnegie Museum of Art, Carnegie, Pennsylvania, April-July 2002, Toledo Museum of Art, Toledo, Ohio, November 2003-February 2004
Morgan, Robert C., *Richard Jolley: Dream Narratives, Diversions, Anatomies* Richard Jolley: Sculptor of Glass, Knoxville Museum of Art, Knoxville, Tennessee, December 2002
Gruber, J. Richard, *Richard Jolley: A Critical Balance*, Richard Jolley: Sculptor of Glass, Knoxville Museum of Art, Knoxville, Tennessee, December 2002
Lynn, Martha Drexler, *Masters of*

Contemporary Glass: Selections from the Glick Collection, Indianapolis Museum of Art, Indianapolis, Indiana, September 1997
Leach, Mark R., *ArtCurrents 22: Richard Jolley*, Mint Museum of Art, Charlotte, North Carolina, January 1997.
Knowles, Susan W., *Richard Jolley: Sensual Articulator*, Richard Jolley, Fay Gold Gallery, Atlanta, Georgia, November 1994
Pepich, Bruce W., *The Aesthetics of Athletics*, Charles A. Wustum Museum of Fine Arts, Racine, Wisconsin, June 1994
Hayes, Jeffrey, *The Collection of Janet and Marvin Fishman*, University of Wisconsin at Milwaukee Art Museum, March 1990
Lynn, Martha Drexler, Los Angeles County Museum of Art, *Richard Jolley: A Rural Sophisticate*, Richard Jolley, Maurine Littleton Gallery, Washington, DC, May 1989
Pintauro, Joe, *Richard Jolley: Recent Glass Sculpture*, Maurine Littleton Gallery, Washington, DC, May 1987
Hollister, Paul, *New American Glass*, Huntington Museum of Art, Huntington, West Virginia, June 1986

Selected Bibliography

Angel, Donna. "Richard Jolley," *Opulence*, November 2001
Waggoner, Shawn. "Mysteries of Human Experience," *Glass Art*, September-October 2001
Leir, Peters, Wallace. *Contemporary Glass, Color, Light and Form*, 2001
Yelle, Richard W. *Contemporary Art from Urban Glass*, 2000
Byrd, Joan Falcomer. "Richard Jolley: Reflection of a Classical Ideal," *American Craft*, June-July 1997
Rodgers, Joan S. "Figuring It Out," *Winston-Salem Journal*, January 19, 1997
Layton, Peter. *Glass Art*, Publisher A & C Black LTD., London, University of Washington Press USA, 1996
Knapp, Rebecca. "November Looks Awash in Color," *Art & Antiques,* November 1995
Purcell, Janet. "Grounds a Winter Wanderland," *Trenton Times*, January 6, 1995
Barrett, Chris. "Bearable Lightness," *Metro Pulse*, November 16, 1995
Wibking, Angela. "Art Under Glass," *Nashville Business Journal*, March 21, 1994
Knowles, Susan W. "Works by Richard Jolley," *Nashville Scene*, April 7, 1994
Leonard, Pamela Blume. "Artist Manages to Elevate Ordinary," *Atlanta Journal-Constitution*, November 1992

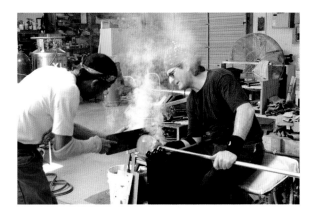

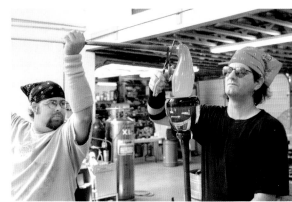

Artist forming glass with assistant Calvin Nicely.

Artist applying hot bit of glass with assistant Chris Szaton.

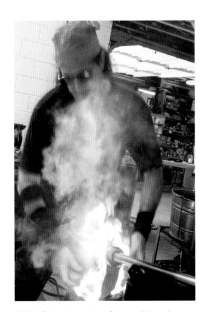

Artist flattening glass form with cork paddles.

Simak, Ellen. "Collection Focus: Richard Jolley," Hunter Museum of American Art publication, Chattanooga, Tennessee, September 1992

Parker, Lin C. "Museum Talk at Hunter," Chattanooga News Free Press, August 11, 1992

Shea, Al. "Proscenium," Gambit, June 1988.

Green, Roger. "Arthur Roger has a Birthday," The Times Picayune, June 19, 1988

Siegal, Roslyn. "Art of Glass Explored," The New York Times, January 15, 1987

Del Sisto, Cristina. "A Modern Twist," The Washington Post, May 14, 1987

Teaching and Public Lectures

2001
Cleveland Institute of Art, Cleveland, Ohio, Student Workshop and Public Lecture
Pratt Fine Art Center, Seattle, Washington, Student Workshop
Seattle Asian Art Museum, Seattle, Washington, Public Lecture

2000
University of Miami, Coral Gables, Florida, Student Workshop
Urban Glass Studio, Bridge to the Future, Brooklyn, New York, Public Demonstration
Knoxville Museum of Art, Knoxville, Tennessee, Public Lecture
Lowe Art Museum, Coral Gables, Florida, Public Lecture

1998
Penland School, Penland, North Carolina, Student Workshop

1997
Mint Museum of Art, Charlotte, North Carolina, Public Lecture

Emory and Henry College, Emory, Virginia, Public Lecture

1996
Penland School, Penland, North Carolina, Student Workshop

1995
Creative Glass Center of America, Millville, New Jersey, Public Lecture
Sculpture Objects Functional Art, Chicago, Illinois, Public Lecture
Glass Art Society, Asheville, North Carolina, Public Demonstration
Sculpture Objects and Functional Art, Miami, Florida, Public Lecture

1994
Penland School, Penland, North Carolina, Student Workshop

1992
Hunter Museum of American Art, Chattanooga, Tennessee, Public Lecture
Penland School, Penland, North Carolina, Student Workshop

1991
Dixon Museum, Memphis, Tennessee, Public Lecture
Tulane University, New Orleans, Louisiana, Student Workshop

1989
Kansas University, Lawrence, Kansas, Student Workshop

1988
Tokyo Art Institute, Kanagawa, Japan, Student Workshop

1987
Santa Monica City College, Santa Monica, California, Student Workshop
Renwick Gallery, Smithsonian Institute, Washington, DC, Public Lecture
Mobile Museum of Art, Mobile, Alabama, Public Lecture

1985
California College of Arts and Crafts, Oakland California, Student Workshop

Residency

1999
University of Sydney, Sydney College of the Arts, Sydney, Australia

1998
Israeli Cultural Artist Exchange, Israel

1986
Galeria Angela Hollings, Hameln, Germany

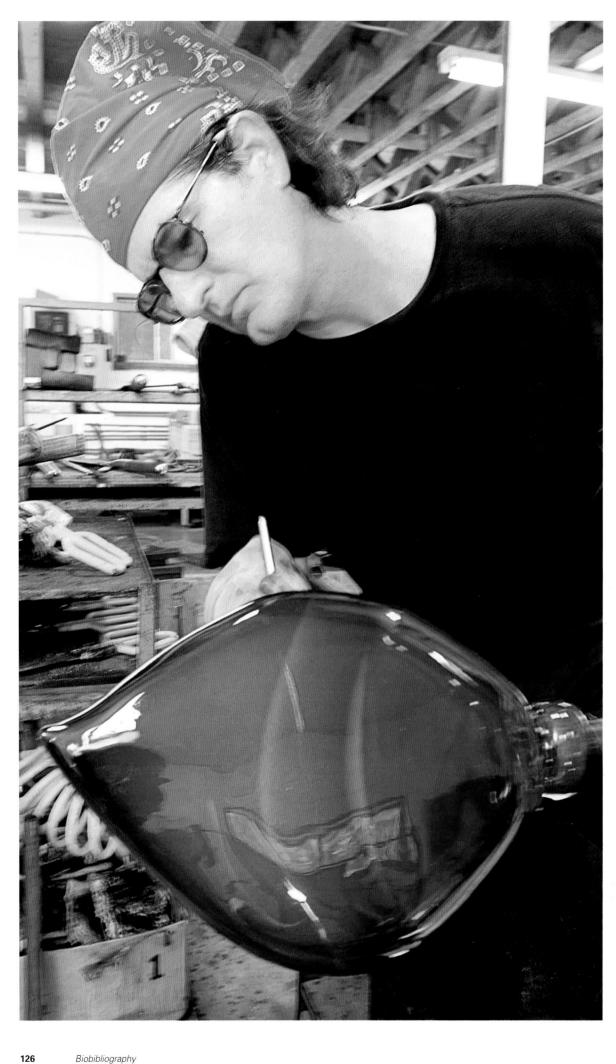

Artist at bench executing direct carving technique on glass form.

Close-up view of artist's hand carving bust image on glass.

Close-up of glass sculpture being re-heated in the glory hole.

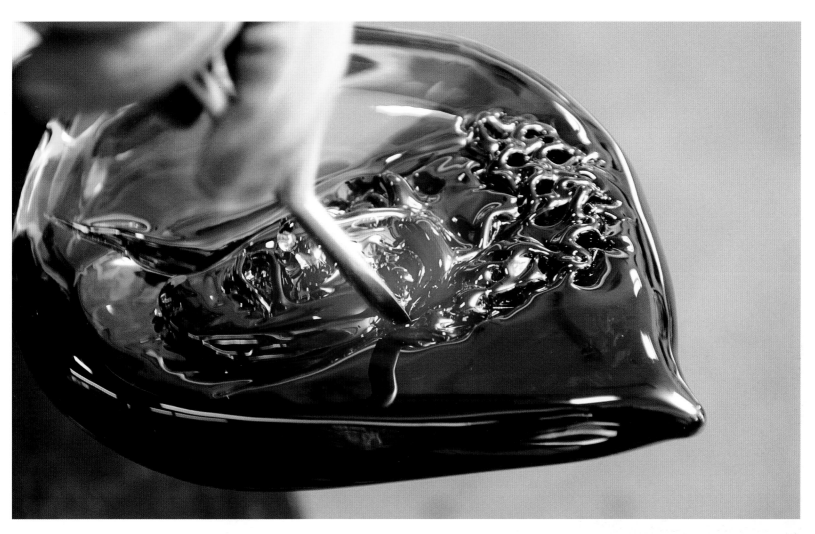

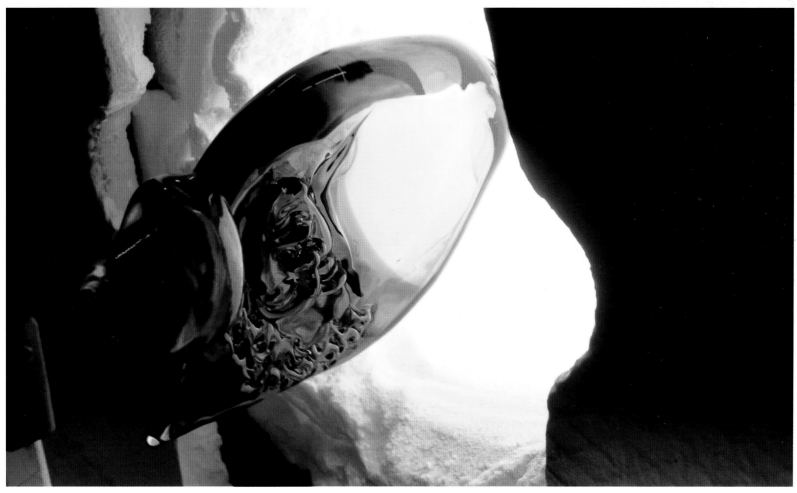